# Contemporary International Basketmaking

Mary Butcher

MERRELL HOLBERTON

PUBLISHERS LONDON

in association with the
**Crafts Council**

For Alice, Andrew, Emily and Matthew

Published on the occasion of the exhibition *Contemporary International Basketmaking* organized by the Crafts Council, London, and the Whitworth Art Gallery, Manchester

**Exhibition Itinerary**
Whitworth Art Gallery, University of Manchester
16 April – 6 June 1999
Crafts Council Gallery, London
17 June – 15 August 1999
Hove Museum and Art Gallery/Brighton Museum and Art Gallery
28 August – 17 October 1999
Cartwright Hall, Bradford
8 January – 5 March 2000
Shipley Art Gallery, Gateshead
11 March – 7 May 2000

First published 1999 by Merrell Holberton Publishers Limited
© 1999 Crafts Council and the authors

British Library Cataloguing-in-Publication Data
Contemporary international basketmaking
1.Basketmaking 2.Basket work
I.Butcher, Mary
746.4′12
ISBN 1 85894 078 8

Produced by Merrell Holberton Publishers Limited
Willcox House, 42 Southwark Street, London SE1 1UN

General Editor: Dr Jennifer Harris
Designer: Karen Wilks

Printed and bound in Italy

# Contents

# Preface

*Contemporary International Basketmaking*, the major national touring exhibition which this publication accompanies, encourages visitors to shed their 'brown-tinted specs' and be inspired by the diversity of baskets and basketmaking. It opens with a thought-provoking section entitled 'What is a Basket?' and then leads the viewer through an international selection of forms, techniques and their contemporary applications, which occur in fields as diverse as sport and interiors. This is the first exhibition of its kind staged in Britain and an opportunity for the Crafts Council to open up the field for re-evaluation. The curatorial team has included the Crafts Council, the Whitworth Art Gallery, Lois Walpole and Mary Butcher.

Different craft disciplines have developed in the UK during the twentieth century at different paces. New practitioners and contexts have emerged and new audiences have evolved in response to declining demand among traditional ones. While critical discourse is rich and sustained in studio ceramics, and textiles have found a confident language and network of supporters, studio glass has only recently gained its first dedicated, publicly funded, national centre in Sunderland. Baskets and basketmaking are further behind.

"Basketry is, after all, one of the craftier crafts", wrote Alison Britton in March 1987, showing how the battle was, and is, largely one of image. She continued "… until fairly recently baskets have been Cinderellas overlooked by the great sweep of craft revivalist experiment". The hopes for a thoroughgoing redefinition of basketmaking in the UK at that time, signalled by work of influential ex-students of the course, run first by Lois Walpole and then Mary Butcher, at the London College of Furniture, were not sustained. By 1994, when the course was threatened with closure, Walpole observed, "new makers pushing at the boundaries of the discipline who are exhibiting regularly can be counted on one hand …. If there is no place in Britain's education system for potential basketmakers to learn it is difficult to see where future boundary pushers will come from." ('Taking Stock', *Crafts*, March 1994, p. 22)

The groundswell of interest in basketmaking has continued through individual touring exhibitions around the country; there are projects to revive, document and renew skills run by organizations such as the Scottish Arts Council, Craftspace Touring, the Greenwood Trust, Projects Environment, and individuals such as Paul Hand in Shropshire; the basketmaking research fellowship at Manchester Metropolitan University; and membership organizations such as The Basketmakers' Association.

The situation is different elsewhere, and this accounts for the international basis of the selection in this exhibition. In America, pioneers such as Ed Rossbach have developed the 'new basketry' since the 1960s, a movement which now sustains a network of galleries, collectors, patrons and hundreds of makers.

*Contemporary International Basketmaking* addresses these issues by representing the work of twenty-seven contemporary British makers, not only established figures such as Maggie Henton, Dail Behennah and Shuna Rendel, but also newer names including Tim Johnson, Lizzie Farey and Alex Bury. This British vanguard is set in an important and broad international context, from the indigenous baskets of India and Hungary to the objects more regularly seen in the influential specialist galleries of Japan, Finland and America.

The aim of this exhibition is to give a boost to practice in the UK and to stimulate activity. The Basketmakers' Association, established in 1975, now has over one thousand members, but how many of these craftspeople are finding opportunities to show their work and to see inspirational examples? *Contemporary International Basketmaking* is a survey, covering many countries across the globe where basketmaking takes place both for daily use and as an artistic practice. As such, the selection is wide and does not allow detailed review of individuals' work: this is a challenge to be taken up by other galleries in the future.

The objects are grouped by technique, not by type, context or use. This is intended to play with our expectations of baskets as containers and to show how three-dimensional, woven forms are at once exceptional and everyday, desirable and essential in our lives. It also suggests that there are opportunities for the development of contemporary basketmaking in circles beyond the dedicated galleries and collectors, helpful as these are, and how valuable

basketmaking skills are when combined with other disciplines – not to mention the importance of specialist courses. The exhibition therefore makes explicit links with textiles; with interior and furniture design; with architectural construction. Alongside vessel forms, functional baskets and free-standing sculptures is work by Michael Brennand-Wood, finalist for the Jerwood Applied Arts Prize: Textiles in 1997; new furniture and lighting by Tom Dixon and Michael Sodeau; a wire mesh shopping basket and basketball net; and a model bridge constructed in metal using basketry techniques by Peter Rogers, an engineer. Imagination is the only limit.

There will be surprises, such as the realization that handmade cane signals are still used by fishing boats. How many other new and unusual applications of basketmaking techniques may be suggested to makers by such examples?

Touring to six venues, it is estimated that over 200,000 people will see a wider selection of objects than in any other previous basketmaking exhibition organized in the UK. Practical workshops and seminars will teach practical skills to young people and adults, students, amateurs and professionals alike.

Related Crafts Council initiatives in 1999–2000 include new purchases in basketmaking and a small exhibition drawn from the Collection, *Interwoven – Objects, Baskets, Forms, 1980–1999*, which will tour the UK.

There are many people to thank for their involvement in making this exhibition and publication a reality. Achieving development is about creating opportunities as well as the dedication of individuals. This project has both factors. We are delighted to have worked with Lois Walpole and Mary Butcher, practitioners who have each, in different ways, been key influences in the development of basketmaking in Britain. Lois Walpole's conception of the project was the spark that lit the flame. As curators they have brought specialist knowledge of the forms and functions of basketmaking and a network of contacts enabling us to represent rare and unusual examples. Thanks are due to them both for sharing their expertise and giving time away from making, and indeed for their modesty in not exhibiting. Particular thanks are due to Mary for lending objects from her personal collection and for imparting her knowledge in this publication to a wide audience. It has been an enormous pleasure to collaborate with Jennifer Harris of the Whitworth Art Gallery. I should like to thank her for her instant interest in the project and her thoughtful contributions, which have helped to shape the exhibition with audiences in mind. This publication is all the more coherent and valuable through her editorship.

Our warmest gratitude goes to the craftspeople and artists represented in this exhibition, whose work demonstrates technical ingenuity, imagination and artistic commitment at the highest level. Thanks go to Laurel Reuter for her reflective essay from the American perspective, to Gyöngy Laky for her editorial advice and to Richard Schofield for collating the bibliography. Grateful thanks are due to North West Arts Board for financial assistance in staging the exhibition at the Whitworth Art Gallery and to the British Museum, the Worshipful Company of Basketmakers, the Basketmakers' Association, Linda Mowat, David Drew, Tessa Katzenellenbogen, Kristina Korpela and Commander Guy Brocklebank, who have all assisted with research and loans. Congratulations and thanks go to Merrell Holberton for collaborating with the Crafts Council on this publication: we are glad they shared the vision and that the fruits will be a much wider readership. We are grateful to Ushida Findlay for the exhibition design, to Karen Wilks for the catalogue design and to Pentagram for the design of publicity material. Finally, this has been a team effort and I should like to thank the exhibitions team at the Crafts Council, particularly Beatrice Hosegood, for co-ordinating such a huge project with charm, attention to detail and patience.

Louise Taylor
Director of Exhibitions and Collection
Crafts Council

February 1999

# What is a Basket?

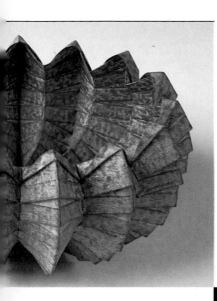

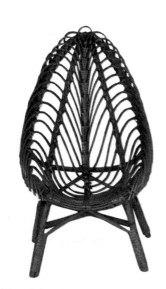

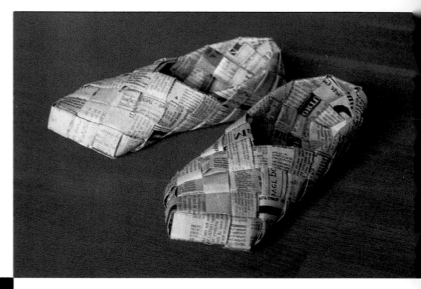

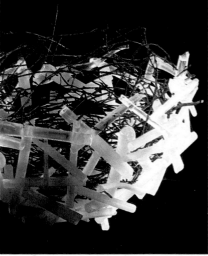

From left to right

**Paul Jackson**
Untitled
1998
Paper, dry pastel, glue,
starch
24 x 24 x 30cm

(top)
**Z. Wcislo**
Miniature chair
1992
Whole and skeined willow
20 x 24 x 19cm

**Emily Jackson**
Nest
1997
Glass canes with real twigs
20 x 30 x 30cm

**Birgitta Wendel**
Little newspaper shoes
1998
Newspaper
6 x 10 x 22cm

(top)
**Fiona Bullock**
Fine wire cage
1999
Steel hoop and steel wire
100 x 50ccm

**Celestino Valenti**
Zig zag
1998
Galvanized wire
40 x 60cm

Supermarket basket
1999
Wire
22 x 35 x 49cm
With thanks to Sainsbury's

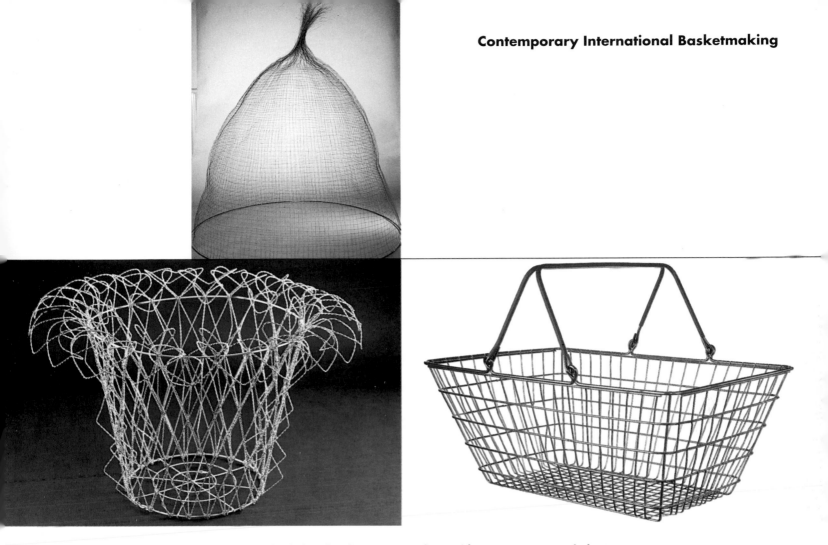

"I sometimes think that the objects I am making with my newspaper and plastic
tubing *etc* are not baskets at all. And I wonder why I am concerned about designations.
If the new materials can be made to say something about traditional baskets, OK. Or,
if they can be made to say something else that seems important, or amusing, OK. If all
the evocations that surround traditional baskets can accrue to my work, why not?"[1]

Ed Rossbach

# The Origins of Contemporary Basketmaking

## What is a basket?

In the high-tech world in which we live, low-tech baskets are still around us, even if we fail to see them. A rich diversity of baskets is in everyday use in all our lives, for bread, soap, shopping, babies, hot plates on the table, flower arrangements, kitchen implements, logs, bicycles, waste paper, clean and dirty clothes, cutlery, instead of drawers in designer kitchens, as stationery folders, the covers of notebooks, floor mats, decorative fans, wreaths, magazine racks …; in and beyond the domestic sphere, in every country, the list is virtually inexhaustible. Their very adaptability and variety, indeed, has led to their being taken for granted. They are essential but disposable. We use them in their hundreds of thousands, yet we rarely look at them closely or give a second thought to their makers.

Far older than Christendom, baskets have been and continue to be made all over the world. They reach the West today, for example, as colourful plaited objects of split palm from Mexico; fine, brilliant *shigras* (shoulder bags) of Agave fibre from Ecuador; trimmed grass baskets from Kenya; willow work from China and the Philippines; rattan work from Indonesia – the descendants of centuries of basketware bringing traded goods from Europe, the eastern Mediterranean and beyond. They embrace an astonishing range of materials and techniques of construction, and a modern consumer culture demands a huge volume of production. Invited recently, as an independent expert, to evaluate the quality of a consignment of imported Chinese baskets, I was confronted by a quarter of a million oval, white-willow baskets, 9 cm long, from the small area of the North East, where they had been made by two hundred basketmakers in just six weeks, and were destined for just one of our large supermarkets, to be sold full of Christmas toiletries.

If basketry itself is widely undervalued, then basketmaking and basketmakers have traditionally been accorded a low status, especially in Britain. In modern Japan, functionality and technical virtuosity have been combined in basketmaking to create an aesthetic that attracts pride and respect, and has led to a few Japanese basketmakers being esteemed as 'National Living Treasures'. In the USA, the quality of native American basketwork has lent recognition to other contemporary work in this field. Even so there are lingering hierarchical distinctions within the fine arts and crafts which tend to separate audiences and foster prejudices. John McQueen, a North American and one of the finest contemporary basketmakers alive today, trained as a sculptor but chooses to call himself a basketmaker, and as such "made a generous gift to the world of crafts".[2] He has not been constrained by traditional practice, although he has used traditional materials, including the native grasses, leaves and barks of New York State; his concern with ideas of containment and inner spaces has determined his self-imposed title. As a basketmaker, however, his work has not been exhibited in galleries that show sculpture, and he has, perforce, reached different and more restricted audiences.

**John McQueen**
Detail of *Vigil*
1996

**John McQueen**
*Vigil*
1996
Tulip poplar bark
148 x 86.5 x 46cm

In Britain, the traditional craft has long been given scant recognition. Not until the exhibition in 1986 of David Drew's work at the Crafts Council in London was serious acknowledgement given to the technical and aesthetic merits of traditional basketmaking in willow and rush, of willow hampers, crates, sieves and bushels – functional, short-lived, 'working-class' objects associated with menial labour. This lack of recognition engenders insecurity and a sense of inferiority among many and may even have induced uncertainty in such practitioners as Lois Walpole and Maggie Henton; Walpole now prefers to call her baskets "woven objects",[3] while Henton has come to regard herself as a sculptor.

The problem of definition, indeed, has exercised many contemporary basketmakers. "Basketry," we are told, "is often considered a troublesome, if not negligible class of artefacts", and, "Although basketry clearly is part of material culture, the importance of this class of artefact as a potential source of information has yet to be generally accepted".[4] Recently, at the Pitt Rivers Museum in Oxford, Felicity Wood and David Nutt have been examining and reclassifying the collection, in particular baskets and basketry. Assistants have offered definitions. For some, a basket was a container and for others it was not, though it might enclose space; for all, it was a woven structure, perhaps three-dimensional, using natural or synthetic materials, sometimes rigid or semi-rigid, sometimes functional, sometimes decorative. All were clear about the existence of special weaving techniques, though these might overlap with practices in other crafts.[5]

In the light of this work, Wood made her own definition of basketry as "Using basket-making techniques or other forms of interlacing to make baskets in the original sense and also other objects, forms or surface coverings. Material used, though traditionally of plant origin, may also include material of animal origin, metal, plastics *etc*."[6] The elusiveness of the subject is manifest. Nor is it clear that simpler, more reductive, definitions are of any greater help. This "textile art without machinery"[7] deserves to be better understood in its diversity and complexity. Smith writes, "Basketry is, basically, an artefact-construction technique in which strands of fibres of various types are interwoven".[8] The problem with this permissive elegance, as with so many definitions, is that it conveys nothing of the historical, cultural and aesthetic significance of the basket to an audience for whom such objects and their makers have been at best invisible and unknown, and at worst disregarded and despised. More important than definition, perhaps, is understanding. The implications of the open-minded tolerance of Ed Rossbach's remarks in the epigraph to this essay are far reaching. What is needed is a thorough re-evaluation of the craft and the establishment of a proper status for contemporary baskets and basketmakers at all levels of production. As Julian Stair said recently, we must make efforts to explain what is significant about our work and why it should be more highly regarded.[9] The responsibility rests ultimately with the makers, those who write about the crafts and those who arrange their exhibition.

**Notes**
1 Rossbach 1997 in *The Tenth Wave*, Brown/Grotta Gallery 1997, p. 48.
2 Halper 1991, p. 11.
3 Chelsea Craft Fair, 1998.
4 Wendrich 1991, pp. 1 and 4.
5 Information Wood 1998.
6 Information Wood 1998.
7 Otis Mason 1904.
8 Smith 1997, p. 1.
9 Craft Futures conference, Victoria and Albert Museum, November 1998.

**Frank Philpott**
Herring swill
Unpeeled willow, hazel
46 x 81.5 x 53.5 cm

## Basketmaking before and after the Industrial Revolution

In the 1911 edition of the *Encyclopaedia Britannica*, Thomas Okey described basketmaking as follows: "… essentially a primitive craft, its relative importance is in reverse ratio to the industrial development of a people".[1] He should have known better. Okey was a founder, with Ashbee, of the Art Workers' Guild; associated with Morris, Crane and other participants in the Arts and Crafts Movement, he became Professor of Italian at Cambridge University in 1919. In 1912 he wrote *The Art of Basketmaking*, which was to become a classic manual, reprinted many times into the 1930s and most recently in 1994, inspiring many generations of basketmakers. Subsequently, his autobiography, entitled *A Basketful of Memories* (1930), revealed the early struggles of a working-class childhood and self-education: born in 1852, he was educated at a school in Bethnal Green from the age of eight or nine years and became apprenticed to his father as a basketmaker at twelve, before going on to evening classes at Toynbee Hall. He described the basketmaker's workshop, in which he spent fifteen hours a day, as rat infested, with a brick drain running through it, lit with a tallow candle or rush light thrust into the brickwork, without a fire even in the coldest weather, and with only elm boards on the earth floor for seating. The business supplied baskets, on an industrial scale, to the traders at Smithfield and Billingsgate markets in London. His own experience, thus, directly contradicted his apparent endorsement of the myth of basketmaking as a craft expressing and sustaining the rural idyll of traditional society.

The ancient origins of basketmaking undoubtedly lie in the earliest developments of agrarian society. The infinite adaptability of the technique gave it a range of applications which provided a vital role within subsistence economies, trading communities and pre-industrialized societies. Indeed, within pre-industrialized societies the very pervasiveness of basketry resulted in its low economic value and its absence from the written record. Even communities, such as medieval fishing and trading communities, often left little evidence of production and use in the surviving official documentation, although nets were frequently mentioned and occasionally baskets were identified as containers for imported goods. Complex winnowing fans might be mentioned in agricultural inventories but not the numerous other working baskets. Fish traps and weirs might be recorded as seigneurial assets but little reference made to their structural character or their makers. It seems likely that there was little specialization in basketmaking but that baskets would be made for specific purposes by members of the appropriate trades, skills being passed on within occupational groups and families. By the sixteenth and seventeenth centuries in England, the survival of personal inventories taken at death do indicate that large numbers of baskets survived in individual households, although this evidence has yet to be fully investigated. The pictorial record, however, reveals their omnipresence. Medieval illuminated manuscripts, for example, show the presence of

baskets in every conceivable occupational and domestic activity, and woodcuts from early printed books are equally informative. There can be no doubt about the importance of baskets in rural and urban society and in the households of the aristocracy, but only with industrialization do they become more fully documented.

With the onset of the Agrarian and Industrial Revolutions, the scale and organization of production began to change. The increasing need for the transport of raw materials, foodstuffs and manufactured goods, in national and international distribution and marketing, meant that larger numbers of people became employed in the basketmaking industry in collective workshops in town and country. The earliest surviving records for such a workshop are those of G.W. Scott & Sons in the Charing Cross Road, London, founded in 1661. Documentation goes back to 1703 and the order books show a steadily increasing trade through the eighteenth and nineteenth centuries, and a considerable diversification in the kinds of goods in demand. On 7 January 1796, for example, the orders taken were: "a kitchen basket with legs, 5 large half-bushels, 4 hampers, a little nite basket, 63 pecks, 7 large half-bushels, 1 and a half dozen trenchers, 2 half moons, a square basket for the scullery, and a chair." By the 1870s, in addition to considerable volumes of regular items, Scott's were producing large numbers of cheese and butter baskets, sausage hampers and other specialized food and bottle baskets for Morell's, the Piccadilly grocers, as well as frameworks for dummy horses for a London theatre and even cradles for Queen Victoria's children. A daughter of one of the Scott brothers was to design a lunch basket, the original picnic hamper, of which the firm made at least one hundred thousand.[2]

Scott's were not alone: in the early 1900s there were 125 basketmaking businesses in London alone.[3] The rapidly developing trade was sustained, in the second half of the nineteenth century, by willow grown mainly in Somerset, the Trent Valley, East Anglia and the Mawdesley district of Lancashire, though many local firms had their own extensive willow beds. Sellars of Peterborough first planted their beds in 1825 at the beginning of the Industrial Revolution.[4] In the north-west, the most important industrial basket was the 'skip', and in the cotton town of Bolton, for example, there were fourteen skip-making factories between 1890 and 1900. One of these, W.T. Coward, employed eighteen to twenty men, so there may have been in excess of two hundred basketmakers working in the town in these years. These craftsmen used whole cane to make the skips, which lasted for forty years but were regularly sent back for repair.[5] On the east coast, swills were made in increasing numbers for the fishing industry to accommodate the great catches of herring from the North Sea, providing exclusive and full-time work for a professionally apprenticed labour force. New techniques of basket-willow preparation were developed, such as 'buffing' by Mr Marshall in Sutton-on-Trent in the 1840s; this spread rapidly and

**Notes**
1 *Encyclopaedia Britannica* 1911, vol. 3, pp. 481–83.
2 G.W. Scott & Sons Records, Greater London Record Office.
3 London Trade Directories.
4 Information Len Wilcox 1994.
5 Information C. Driver 1995.

**Colin Manthorpe**
Herring cran
1995
White and buff willow,
cane, hazel and wood
36 x 56 cm
(outside measurements)

was further developed in Somerset in the 1850s, as the Somerset Levels increased their volume of willow production and became a major centre of basket manufacture.[6] In other areas, such as Carmarthen, local initiatives resulted in the development of industries based on willow: in 1901, local evening-classes were started as a means of creating work, and willow was planted; a total of 1000 baskets were made in 1906, and by 1910 a factory had been founded and a relatively modest 4300 baskets produced.[7]

Symptomatic of the growing scale of production and the expertise required to manage it was the work of William Scaling. Scaling was a nurseryman in Basford, Nottinghamshire, who published a series of papers entitled *The Salix or Willow* in 1872 and seems to have been not only expert as a grower and basketmaker, but also to have known all aspects of his trade in England. He was fully aware, moreover, of the role of botanic gardens, both here and in mainland Europe, having travelled widely collecting and exchanging cuttings. He also had a wide knowledge of the relevant literature, from the Bible and Latin authors to the journals of many explorers. His own collection of willows contained over three hundred varieties, including *Salix basfordiana*, and he wrote to encourage the related crafts of willow-growing and basketmaking. He saw the botanic garden as central to the survival of the willow industries across Europe and to the development of new varieties with improved features. His own experiments with varieties and methods of willow-growing were important steps towards the improvement of growing techniques. For good baskets, made at speed and therefore cheaply, it was important to have a high-quality crop of long, fine rods, disease-free and of a good colour, all factors dependent on the quality of cultivation and handling. In the 1860s, although there were about 7000 acres of willow grown specifically for basketmaking, England still imported 4500 tons of willow and £46,000 worth of baskets, all of which, as Scaling recognized, might have been made in England if the economic climate had been right. The huge increase in demand for English baskets, despite high labour costs, had led to severe shortages of raw materials. Indicative of the growth in consumption, it was observed that market gardeners in the immediate neighbourhood of London alone bought 10,000 bundles of willow twigs annually, at 5s. per bundle, for tying up vegetables for the London markets.[8]

"Spire Top Cages, Arch Top Cages, Dove Cages, Floral Trays, Knife Baskets, Straw Baskets, Bonnet Baskets (Upright), Hand Baskets, Strong Hand Baskets, Hawker's Cap and Shoe Baskets, Hat Baskets, Box Baskets (Covered), Mantle Baskets (Covered), Strong Shoulder Baskets (Upright), Shoulder Baskets (Upright), Wheelers, Paper Baskets, Travellers' Hampers (Fine Randed), Linen Hampers (Covered, without Trunk), Trunk Covered Hampers, Light Randed Trunk Covered Hampers, Pea Baskets (Coarse Slewed with Rand On Top), Watercress Hampers (Cane), Railway Truck Baskets (Coarse Randed), Chalk Baskets (Cane, Made Light), Cotton Seed Baskets (Cane), Lime Baskets (Close Randed),

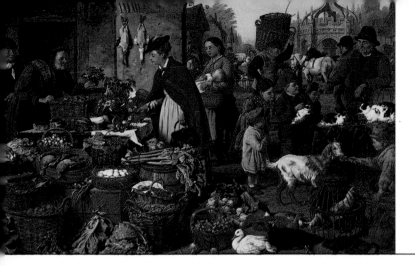

**Henry Bryant**
*Market day*
1877
Oil on canvas
51 x 76 cm

Housing Baskets (Tuck Randed), Prickle (Cane, Strong), Coke Baskets (Cane) …": these few examples begin to suggest something of the variety of functions, techniques and volumes of late nineteenth-century production, even more so when it is recognized that, for each basket, several sizes would have been available simultaneously. They are just a few of the types recorded in the *Trade List* (1896) of the London Union of Journeymen Basket Makers, established in 1816. Significantly, the introduction to the list, in the form of an open letter to members, records that the necessity of producing a new list, the first since 1877, was all the more urgent since the change in basket types had been so marked in the intervening years.

Remarkable as this proliferation was, its significance is all too often ignored or unknown, even among contemporary basketmakers. In part, the lack of awareness is a consequence of poor survival. Very few of these baskets from the age of the Industrial Revolution still exist, as woodworm consumes willow very quickly. Equally, their very ubiquity made them objects too commonplace to keep or to deserve written record in surviving historical documentation. The visual evidence, however, is very revealing. Victorian paintings and photographs give clear examples which often show not only contemporary forms but also the details of particular weaves. This evidence and that of contemporary illustrated lists suggests, moreover, that European basketmaking may have reached a climax of creative invention in this period, one which has not only never been surpassed but is also now all but lost to makers of the late twentieth century, and with it many of its important links to textile, leather and metalwork crafts. The impoverishment of this loss may reflect the hazards of aesthetic transmission in the popular crafts, but in this case it may also be the result of the decline in basketmaking that took place during the first half of the twentieth century.

## Basketmaking in Britain in the twentieth century: decline, renaissance and tradition

In the 1920s the British basketmaking industry entered a period of decline, reaching a nadir after the Second World War. The number of basketmaking firms in London declined from 125 early in the century to 82 by 1929 and to only four in 1976, of which three were workshops for the blind and the fourth a cane importer.[1] The Trent Valley, the largest willow-growing and basket-producing area in England in the 1920s, had had over 1000 acres devoted to supplying the industry. From this peak, however, production fell away sharply.[2] Sellars of Peterborough closed in 1932 and firms which replaced it suffered from a steadily contracting demand.[3] The initiatives in Carmarthen foundered on the shortage of labour brought about by the First World War.[4] Agricultural depression and especially technological change worked to destroy traditional markets.

Notes
6 Fitzrandolph & Hay 1926, repr. 1976, vol. 11.
7 A.M. Jones 1926, repr. 1978.
8 W. Scaling 1868.

Notes
1 London Trade Directories.
2 Fitzrandolph & Hay 1926, repr. 1976.
3 Information Len Wilcox 1994.
4 A.M. Jones 1926, repr. 1978.

Both World Wars, however, provided a major stimulus for industrial basketmaking, the industry responding, as always, to specialist needs. In the First World War, huge numbers of basketry shell cases were needed for ammunition.[5] In the Second World War, almost the entire willow crop went for work required by the Ministry of Defence, in particular for the making of the airborne pannier, an especially resilient basket used for dropping supplies, some two million of which were made before D-Day.[6] Thereafter, however, demand fell away and many workshops decreased in size or even closed. The experience of the Wilcox brothers, who had set up their own business in the Nene valley after the closure of Sellars, was not untypical: they had made themselves specialists in the making of baskets for British Rail, the General Post Office and Smithfield meat market, and of laundry baskets for London hotels. This work was in addition to the making of agricultural baskets, and, in the 1940s, it was by no means unusual for two men to make 2000 potato baskets in six weeks. As British Rail needed fewer baskets and the Post Office decided to use canvas bags, the specialist trade shrank.[7] Similarly, Yarmouth Stores (later taken over by Stanley Bird), which was a primary supplier to the fishing industry, had supported at least forty workers in the 1950s and 1960s but had reduced its workforce to eighteen by 1978, and now has only nine, three of whom are coming up to retirement age.[8]

Those who have survived this contraction have, furthermore, experienced a drastic reduction in the range of traditional baskets required. Frank Philpott, who trained at Yarmouth Stores, regularly made some 320 different types fifteen years ago but now he and his son make only about fifty.[9] Colin Manthorpe, with a similar background, no longer makes thirteen different kinds of trawl baskets; seven types of basket for the kippering industry; huge numbers of potato baskets; bushels and half-bushels; pea gatherers; apple, raspberry and cabbage crates; or asparagus squares.[10] Cheaper, non-returnable containers, such as net bags, replaced many of the fruit and vegetable baskets, and boxes, made at first of wood and later of cardboard, became more readily available. Wire came to replace willow in the manufacture of the potato basket, first for the bottom of the basket and then in its entirety. As wire proved too expensive, a mixture of pink plastic base and willow sides was tried, only to give way to a completely plastic basket, made to size and so still usable as a measure, until this, too, was replaced by boxes. Even lobster pots came to be made of wire and net as younger fishermen failed to learn to make willow ones.[11] Cardboard, plywood and fibreglass were increasingly preferred for transportation. By the time that Muriel Rose and Dorothy Wright were photographing and collecting baskets for the Museum of English Rural Life at Reading in the 1960s, many types had disappeared and as a result their examples are far from comprehensive.[12] Despite the persistent decline, however, the basket has proved to possess a remarkable cultural tenacity.

Plastic potato baskets,
Cambridgeshire style,
Peterborough
1994

**Notes**

5  D. Wright 1983.
6  D. Wright 1983.
7  Information Len Wilcox 1994.
8  Information Andrew Bird 1994.
9  Information Frank Philpott 1995.
10 Information Colin Manthorpe 1994.
11 Information Don Bailey 1994.
12 Information Dorothy Wright 1989.

In the first place, the traditional craft and its practitioners have not entirely died out and a few are still entering it. If the traditional markets have shrunk or even disappeared, this has not prevented inventive adaptation and a change from purely functional to decorative and artistic purposes. From the 1970s, moreover, there has developed in Britain a movement among individual makers, not apprenticed but with a range of skills and strong aesthetic awareness, towards making individual baskets for members of a dedicated audience which was rejecting the mass-produced and showing a new interest in natural materials. Two developments gave momentum to this. The first was a course in Contemporary Basketmaking developed at the London College of Furniture in the early 1970s, which recognized the need to improve the routine cane baskets and trays being produced in adult studies courses. It was felt that there was a need to bring back a sense of design innovation and exploration of technique and use of colour. The course, now at the City Literary Institute in London, has aided many British basketmakers, whether they work in willow or more contemporary materials, or employ British native techniques or those from around the world, and has done much to change the view of basketmaking in this country. This course was led, until 1983, by Barbara Maynard, then by Lois Walpole, and is currently led by the present author. The first group of its students formed The Basketmakers' Association to further all aspects of the craft, and in the last five years its membership has risen from 400 to over 1000, many of whom are actively engaged in craft work, and an increasing number of whom have an art training. Britain has become known as a centre of excellence for the teaching of basketmaking of all kinds. The Association's summer schools are fully subscribed and teach traditional as well as contemporary and experimental techniques. Professional basketmakers are attracted to its classes from Europe and the USA; teachers and students come from Denmark, the Netherlands, Germany, Poland, Canada and North America; and an extensive network of makers and students looks to Britain for guidance and expertise, and requests its teachers to teach abroad.

At the same time, there has developed in British art schools an increasing demand for basketmaking skills in textile, wood and other three-dimensional studies courses. Well known makers, such as Lois Walpole, Dail Behennah, Maggie Henton, and Shuna Rendel, have been invited to teach in a number of faculties of Art and Design, and student work is beginning to reflect this input, even though, as yet, it lacks the financial support to permit progression and development. Manchester Metropolitan University has been at the forefront of such activities. The appointment of Joanne Segal Brandford to a Research Fellowship in Basketmaking in 1986 was a landmark and was followed by the appointment of the present author (1994–97). Both of us taught throughout the Faculty of Art and Design, researching traditional practice and developing our own work. Alongside this rise in interest within faculties of Art and Design there have been

increasing opportunities to see finished work on exhibition. Senior contemporary basketmakers have taken part in temporary exhibitions at the Barbican Art Gallery, London; at Bankfield Museum and Piece Hall, Halifax, where there are extensive ethnographic collections; with Craftspace Touring, Birmingham; in Crafts Council exhibitions; and at many regional art galleries and museums. The Crafts Council exhibition of David Drew's work in 1986 marked a turning point. In 1989, the Ruskin Craft Gallery, Sheffield, put on a show of contemporary baskets. This was followed by Craftspace Touring's *Brilliant Baskets*, organized by Wendy Shales, and then by Blackburn Museum's *Baskets Galore* in 1991. At Poole Heritage Centre, Dorset, Garry Topp has also organized some important exhibitions since 1992. In 1992, *Weaving Willow: Traditional Baskets in Poland and Britain* was set up by the present author, in conjunction with South East Arts and Kent Arts and Libraries, and was seen by record numbers at many locations. In 1996 this exhibition travelled with a group of basketry students to Kwidzyn, Poland, home of the Polish Basket School. More recent exhibitions have included *Beyond the Bounds* in Manchester, *Threads* at the Barbican Art Gallery and *Making Weaves* at the Royal Museum of Scotland, Edinburgh. A large-scale exhibition is planned for Bury St Edmunds Art Gallery in 2001.

## Traditional and modern in British basketmaking

At first sight it may appear that basketmaking, having lost its primary role, has become the subject of exotic curiosity in public exhibitions, of artistic experimentation and of historical research and connoisseur collection. But this would be greatly to underestimate the resilience of traditional production. All over Europe today basketmaking is still to be found being practised in ways that are essentially derived from conditions prevailing in the nineteenth century, to say nothing of forms derived from ancient methods: in Ikervar in north-west Hungary, for example, groups of ten to twenty basketmakers work in traditional workshops.[13] And although everywhere in Europe traditional practices are threatened and transmission is breaking down, and Eastern suppliers are replacing Western bulk producers, there are nonetheless those seeking to build bridges between the traditional and the modern, trying to invigorate the latter through a greater knowledge of the former. Such a movement might be seen as part of the changes in perception of the crafts and the desire to return to natural materials and ecologically renewable resources.

In Britain, the tradition had many strands: straw, rush, cane and willow, to name only a few, each with its own techniques. Few makers would have been skilled in both hard and soft materials, though some would have incorporated cane into other work. To take willow as an example, there would seem to have been two distinct kinds of basketmaker: local specialists and apprenticed professionals. The local specialists wove structures which were often designed for very specific functions, making baskets for themselves, perhaps to

**Roger Brown**
of Swanage
completeing the base
of a lobster pot
Brown willow

**Sue Morgan,**
basketmaker, with
former and lobster pot
of the Hope Cove type
Brown willow

**Ernie James,** fen man,
and **Len Wilcox,**
basketmaker, examining
two eel hives and an eel
grig at Welney, Norfolk
1995
Brown willow

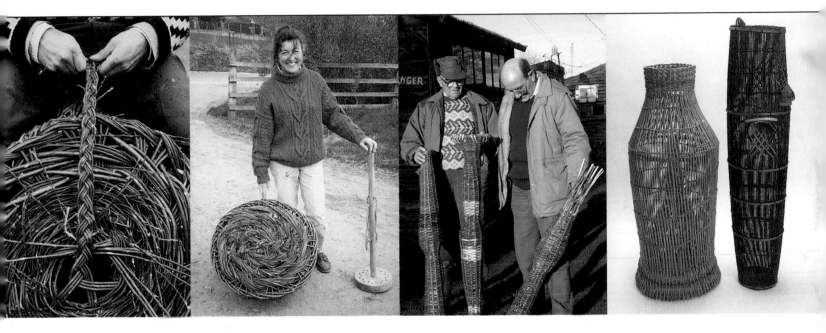

catch their own food, and for their immediate neighbours, in small quantities as a part-time business alongside other occupational activities. This aspect of traditional practice is probably very old, reflecting the dominant nature of production in the pre-industrialized period. Such makers are now of considerable interest for the particular and often unusual skills and techniques embodied in their work, many of which may be of ancient origin. The existence of a body of apprenticed professionals, however, seems to have been a product of the growth in demand for baskets during the period of industrialization in the eighteenth and nineteenth centuries. These makers were trained in workshops to produce a wide range of goods, working full time and usually in groups.

Many of the baskets central to the British tradition are of great antiquity. The herring swill, for example, a unique frame basket, is known from illuminated manuscripts of the fourteenth century.[14] The lobster pot is, similarly, a basket that is highly sophisticated in its specialist adaptation. It was made by fishermen for their own use, of green willow, and was highly regional, even local, in the details of its designs. Each village seems to have had a different pattern, distinctions that had no bearing on the functioning of the trap. The eel-trap, too, made and used all around the world, possessed considerable local diversity of production in Britain, being adapted to local environmental conditions and expressing the design skills of individual craftsmen.[15] Of the specialist makers who produced such work in Britain, the makers of the eel-traps might be used as an example: Ernie James, Walter Small, Terry Bensley and his partner Jim Humphries, all of Norfolk; and Arthur Payne of Gloucestershire. These are among the last representatives of traditions reaching back deep into the Middle Ages.

left:
**Terry Bensley**
Norfolk eel trap
1996
White willow, cane
90 x 36 cm
right:
Cambodian fish trap
1998
Split rattan
101 x 31 cm

Notes
13 M. Butcher 1993.
14 D. Wright 1970.
15 M. Butcher, in T. Harrod (ed.) 1997.

19

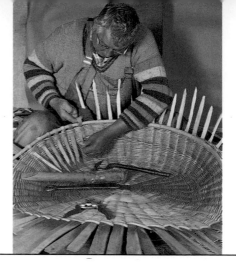

One other such ancient basket was the winnowing fan, used for separating chaff from grain. This was a large, complex structure with split wood stakes and tight willow weaving. Always the object of specialist production, it is nonetheless frequently to be found listed in the inventories attached to medieval manorial accounts in the thirteenth, fourteenth and fifteenth centuries. It also appears on the memorial brass of Sir Richard de Septvans in Chartham Church, Kent, symbolizing the name of the family whose motto was "The enemies of my king will I disperse like chaff". Today, the weaving of a winnowing fan is a skill known to probably no more than one or two basketmakers in Europe. One of these, Emilien Metezeau, is one of a family of basketmakers at Villaines-les-Rochers, France. His grandfather must have made dozens of these fans, but Gustave, Emilien's father, who died in 1998 in his early nineties, had never made one and had never seen one made, although there were old ones in the village to which reference might be made. Emilien made his first in 1991, reviving rather than maintaining a tradition, in response to a request from Dr Maurice Bichard, a British basket collector.

The last generation of apprenticed professionals in Britain may also provide some indication of the nature of the British apprenticeship tradition. Don Bailey, for example, was trained under a master at Wisbech, and, on becoming a journeyman following his articles of apprenticeship, was obliged to set up shop at least two miles away. He moved to Grundisburgh at the age of about twenty and worked there until his retirement in about 1993. He reckoned to make about 4000 potato baskets a season, as well as domestic wares, duck nests etc.[16] Frank Philpott and Colin Manthorpe both trained as apprentices at Yarmouth Stores and spent much of their working lives on quarter crans for the herring boats. Every Friday afternoon and Saturday morning were spent cutting out the stuff for a week's work. That meant at least 160 hazel rods cut to length, as well as all the stakes, bye stakes etc. It represented eight or nine hours' work. They then made six quarter crans a day, but the rate was so low they could barely exist on the wage, so they had to increase it to eight a day. Philpott, who is still a very fast worker, annoyed everyone by starting at 5.30 am and making ten a day, but no one else could manage such a rate. Each boat had six baskets on board and there were 11,000 boats; the baskets lasted only two or three trips – even the heaviest, known as the 'Samson'.[17]

For Hubert Pilkington, of the Mawdesley district, Lancashire, it is a matter of some importance to remember the dying tradition to which he belongs. He has his own small museum with baskets from his family firm and as many documents as he can find about the trade. One of these is a Third Class Certificate of Proficiency, being a special commendation for Class 4 Fancy Basketwork in the section for apprentices in the competition instituted by the Worshipful Company of Basketmakers of the City of London. The competition was held at the Clothworkers' Hall in London on 20 November

**Emilien Metezeau,**
basketmaker, in
Villaines-les-Rochers,
France, making a
winnowing fan
1991
Split oak, white willow,
hazel rod

**Notes**
16 Information Don Bailey 1994.
17 Information Colin Manthorpe 1994.
18 Information Fred Rogers 1992.
19 Information Lluis Grau 1998.
20 Information Garbor Torjan 1994.

1923 and the certificate was awarded to the apprentice John Pilkington of Wickerworks, Smithy Lane, Holmeswood, near Ormskirk, Lancashire, on 17 December in the same year. The certificate is signed by the nine examiners, the Prime Warden and the Clerk to the Worshipful Company. The name of the Clerk is H.H. Bobart, the same Bobart who wrote the *History of British Basketmaking* (1936), while among the other examiners is the father of Fred Rogers, who, in 1929, apprenticed his son to the great London firm of Scott's. The same Fred Rogers recently served as adviser to The Basketmakers' Association and trade adviser to the Worshipful Company of Basketmakers, and, in speaking of his time at Scott's, would recall another notable figure, Joe Brown, the best basketmaker in the trade and brilliant at skein work.[18] In such detail is found the precious means of preserving the continuity of the basketmaking tradition and of recovering information about the structure and organization of the industry, as well as the names of its practitioners, from apprentices to masters.

## European traditions of basketmaking

All over Europe the last generation of apprenticed professional basketmakers is disappearing and it is often only in their oral testimony that evidence of traditional practice survives. What is being lost is a knowledge of materials, techniques and processes, especially at a local and regional level, to say nothing of the place, more generally, of basketmaking in agricultural and industrial society. This loss is all the more serious in that the baskets themselves have such short lives – there is not even a coherent archaeological survival. Furthermore, across the period of decline and contraction and the restructuring of production, vital traditions of community, family and the individual have also been lost.

Across mainland Europe, when villagers are asked if they remember professional basketmakers in their district, they reply that so many people could make them that there had been no need for professionals. Lluis Grau, a Catalan basketmaker, says that while fishermen and mountain people tended to make baskets for their own requirements, there were other specialist makers who worked from their homes and sold to the surrounding population, much as he does today. There were also itinerant workers who would make baskets using the customers' own willow.[19]

In 1993, during a visit to Ofalu, a German-speaking village in southern Hungary, I found that a comparable situation had prevailed there until relatively recently.[20] A retired small farmer I talked to, Link Antol, told me that he and his brother were the only remaining two in the village who made baskets. He used willow and a dogwood (*Cornus*) variety, which he cut locally, dried a little and then used for weaving. They learnt as teenagers at a time when all the boys learnt. At that time, everyone used baskets daily for carrying

21

# The Origins of Contemporary Basketmaking

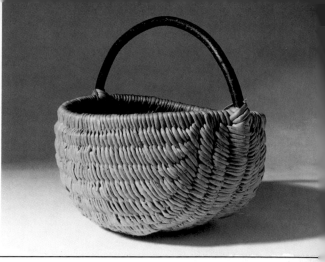

**Stanislaw Kumanrowicz**
Frame basket,
1991
Split pine root, juniper
36 x 36 x 34 cm

**Notes**
21 Information Michael
   Thierschmann 1996.
22 M. Butcher 1991.

wood, potatoes and other vegetables and fruit, and made them for their own needs. The girls of the village learnt to weave chair seats of great reed mace (*Typha sp.*) or maize bracts, and also made coiled baskets of rye straw, which were sewn with split lime bast. The technique used for weaving the bases of these baskets suggests that this way of working – each family for itself, and learning the craft within the family – might have continued for at least two hundred years. Ofalu village was founded by a small group of German immigrants, who arrived there in the 1750s. It remains German-speaking today and retains basketmaking techniques along with other craft designs (pottery and house building) unlike those found in the surrounding Hungarian villages. The basket base seemed to use a weave I have seen only once elsewhere, on German brides' baskets, a speciality of one small area of southern Germany.[21] From this evidence it seems likely that the original German immigrants of the 1750s brought this technique with them and it has remained unchanged, even though it is rather more extravagant in its use of materials than other possible weaves, as well as highly decorative, to a degree unnecessary for a functional basket. Modern transmission has now seen it incorporated into the work of Susie Thomson in England, who learnt it from the German basketmaker Michael Thierschmann, who himself had found it during his investigation of the bride's basket.

Research in Eastern Europe, especially in Poland, in the early 1990s revealed the presence everywhere of locally made, highly regional frame baskets, many with a wide range of functions.[22] Much garden and farm produce was still moved about in these baskets, with designs very different from the British tradition and technically distinct. A frame basket is built on a hoop, or pair of hoops at right angles, the weaving starting at the top rim or where the two hoops cross. Stanislaw Kumanrowicz is a typical maker of one of these baskets. He uses his local material, pine root, for weaving, and juniper for the frame, there being forests of these trees surrounding his smallholding. The pine root is collected, peeled of outer bark, prepared by splitting with a knife and stored until needed. The juniper is formed into handles and ribs. Weaving a whole basket, after all this preparation, takes ten hours of concentrated work, the weaving being as tight as possible and the ribs inserted in a special way. Further hours are spent putting in small pieces of root to fill gaps, so that the basket, once sealed, can be used to carry water to the livestock, as well as for feedstuff, washing, peeling potatoes and many other things. They are made only for the family's use on the farm, two or three a year at most, and the skill will die out with the current maker, as only one of his sons has ever made baskets and does not intend to keep the tradition alive. Such baskets used to be commonly made, particularly in Kashubia in the north-west; the Ethnographic Museum in Warsaw contains some fine examples of water-carrying jugs from this region.

Detail of a willow farm
basket from Ofalu,
Southern Hungary

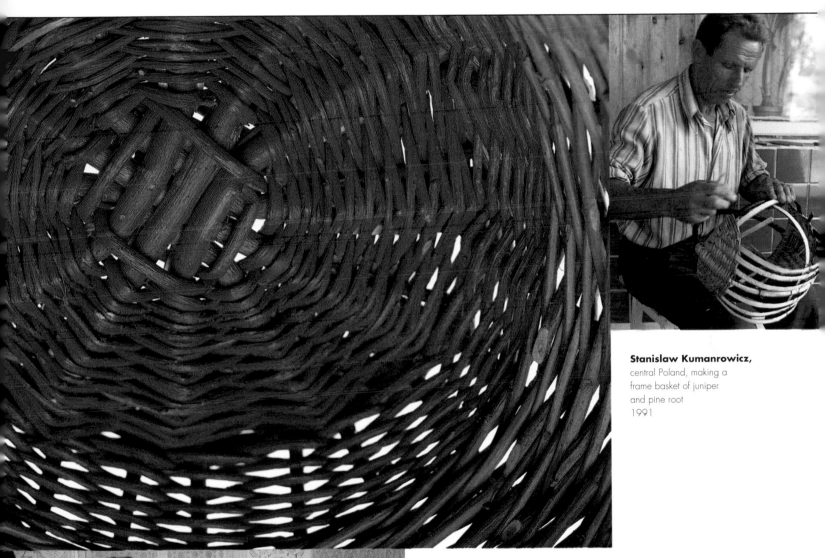

**Stanislaw Kumanrowicz,**
central Poland, making a
frame basket of juniper
and pine root
1991

**The Karoly brothers**
weaving multi-purpose
black maple frame
baskets, Szentrölad,
Hungary
1993
25 x 47 cm

In Latvia and Hungary, peasants going to the central markets in Riga and other cities continue to use large numbers of frame baskets, just as they have done for many hundreds of years. These are made of split pine, roots, willow and sometimes plastic packing, and are used on their own smallholdings as well as for transporting their livestock and produce for sale. Among the gypsies in Hungary, back baskets, traditionally made with maple that has been roasted on an open fire in the woods immediately after felling and which is then split while still warm, commands a higher barter price when woven with plastic packing tape (still a rare commodity in the small villages of north-east Hungary) and saves some days of preparing the materials.[23]

In Central and Eastern Europe, the scale of the basketmaking trade and industry, beyond local production for local needs, has been enormous and highly organized, and is still large even today. Until 1991, for example, the small village of Rudnik, in south-east Poland, contained over four hundred basketmakers, working at home and supplying baskets regularly to two 'factories' or wholesalers. These had their own rail lines to Gdansk on the Baltic, and container loads went several times a week for export to Germany, Denmark and the USA. In Poland, parts of Hungary, the former Yugoslavia and Romania, willow production and basketmaking have been major sources of foreign exchange, although, with the move towards a capitalist economy since 1989, severe pressures have been put on the industry. Many factories have not been able to raise capital to buy land and buildings from the state, and the inflation rates have meant that goods have become expensive relative to those from East China and the Philippines. However, *The Warsaw Voice*, in a review of the industry in 1996, indicated that there had been a recent upturn in its fortunes, and the export market was again increasing.

The European tradition in all its variety has been maintained by several major schools of basketmaking, at Fayl-Billot in France, Lichtenfels in Germany and Kwidzyn in Poland; and by smaller schools within industrial enterprises in Hungary and other central European countries. These schools have provided full training in technical skills, technical drawing and design, business management, and in the growing of raw materials (in these cases, willow). Go anywhere in Poland, and the men and women running wholesalers, export firms and willow-growing concerns, and those making the baskets, are likely to have been trained at the school in Kwidzyn, a secondary school with pupils from the age of fifteen to twenty-one and still with a strong basketmaking stream. The teachers are willow masters, and some, such as Marian Gwiazda – the 'Star' – trained when the school first opened in 1948 in a move, after World War II, to provide employment. In Britain there has been no school system for the teaching of basketmaking and, until the last twenty-five years, the most common way for a professional to acquire the necessary training was through an apprenticeship.

The stripped stems of
*Beribedopsis corallina*
being woven into a
coiled basket by a
Mapuche Indian
1996

Notes
23  M. Butcher 1993.

Despite decline, transformation and adaptation, basketmaking has re-emerged at the
end of the twentieth century with a new vigour. If the old tradition has been radically
undermined in Europe, there is a new determination to draw upon the achievements of
the past and on the diverse creativity of other cultures to produce exciting art forms.
Furthermore, both traditional and more modern baskets are being received
enthusiastically by new and far larger audiences.

## Basketmaking and its cultural meanings worldwide

Baskets have a complex cultural significance derived from their traditional roles in
society, in which a variety of functions are simultaneously present. These meanings are
related to local ecological, social, economic and metaphysical factors and are expressed in
a highly adaptive symbolic system. Contemporary artistic transformations of traditional
basketmaking incorporate these factors, gaining fresh inspiration from indigenous
responses to critical conditions across the globe and expressing that inspiration most
frequently in individual rather than collective terms.

All over the world people have made baskets from their own local materials – roots,
stems, leaves or fruits – harvesting them in such a way that they could find replenished
supplies annually. The Mapuche people from the southern highlands of Chile use an
endemic liane (*Beribedopsis corallina*) found now only in secondary forests, and their
basketmakers have to travel to collect the climbing stems, especially those which give
a dark colour for patterning the baskets. The Mapuche cut only enough to allow for
regeneration, soak them before use, and split them with a cleave. They make coiled
baskets, with the whole stem as core and split material for stitching.[1]

In 1996 a joint Chilean–British expedition of botanists attempted to find the last
remaining wild population of *Beribedopsis corallina*, using details of an expedition of 1862
that returned with material now growing in botanic gardens in Britain. One population
was found, after the expedition was directed to it by the Mapuche, who are extremely
anxious to preserve supplies. Seed is now being grown in a Chilean tree nursery at
Edinburgh Botanic Garden, but restoration in Chile will depend on land purchase and on
the determination of the basketmakers to take only what they need. There is a real threat
that Monterey Pine (*Pinus radiata*), and Eucalyptus species will replace native forests, and
there is the very recent possibility of an export market of Mapuche baskets to Argentina.
Both of these factors may have major implications for the local culture. Expedition
members are faced with a dilemma: either to teach the Mapuche to grow new bushes of
*Beribedopsis* in order to be less dependent on the native forest, or to allow changes to take
place without such interference. It is highly likely that the traditional basket will have to
change to accommodate environmental change.

Notes
1  Martin F. Gardner 1997.

A grass and bark basket from Mali, West Africa, stitched with split bark in the traditional way

A grass and bark basket from Mali, West Africa, which has been stitched with strips of rice sack

In the West African state of Mali, too, traditional, functional baskets are still made and used regularly by the makers' families and the local community as grain containers and onion stores, and in smaller form for condiments and peanuts.[2] Women collect the tall, hollow-stemmed grasses, often for their husbands, the basketmakers. The baskets are twined with a flat, flexible grass, with bark strips added to the outside surface to provide colour and pattern. These are an essential feature of the traditional basket, but the bark is now in short supply. The severe droughts of 1973 and the early 1980s have permanently changed the ecology of the Sahel. The resulting rural exodus has diminished the local market for baskets, and women must travel 50 km or more by donkey to collect bark from over the border in Burkina Faso, where the ecological change is less marked. This journeying is also a response to a small export market created by Caroline Hart of Joliba, a fair trade arts and crafts shop in Bristol. For their own markets, the people have turned to another locally available material for the external decoration, using split sections of aid-agency white-plastic rice sacks for stitching.

These examples show how the move to the use of new, locally available materials, often man-made, have allowed the form, function and technique of the original basket to be maintained. The South African *Imbenge* basket has been altered, not in form, but in technique, materials and therefore function.[3] The *Imbenge* is a basket traditonally used to cover the clay pots in which beer is brewed and stored. Beer and the items associated with it are a central part of this African culture, the sorghum-based drink being part of daily life as well as important in ceremonial, where it serves to bind people together as a sign of hospitality. The original basket had a core of grasses, coiled and stitched, usually with ilala palm. Because the method of harvesting destroyed the tree, the weavers had to make progressively longer journeys and production became very difficult.

In the 1980s, many Zulus who moved to the cities continued to make *Imbenge*, but only out of locally available material. Employed as the nightwatchmen, they turned to telephone wire, brightly covered with bright plastic. The baskets gained a high profile as a result of photographs in a design magazine, and tuition was arranged for a group of Mozambican refugees. Tessa Katzenellenbogen set off in a lorry with half a ton of telephone wire, one of the nightwatchmen basketmakers, pairs of gloves, the necessary tools and enamel dishes as moulds. This teaching programme spread to other areas. As a small industry developed, innovation of colour and design created a wide range of patterns and very striking baskets. The first London exhibition at the Chelsea Crafts Fair in 1990 quickly sold out.

In these baskets, only the original form of the *Imbenge* remains intact. The new *Imbenge* are not waterproof and not suitable for covering beer pots. The colours and designs are

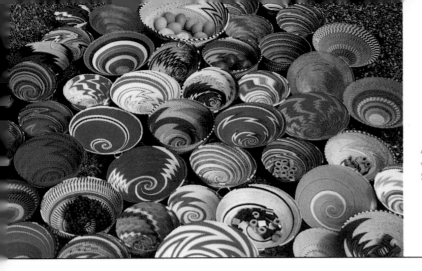

A group of telephone
wire *Imbenge* from
South Africa

Notes
2 Information Caroline Hart 1998.
3 Information T. Katzenellenbogen
  1994.
4 N. Thompson and C. Marr 1983.

changing all the time and so, now, has the technique. The first wire baskets used the original coiling method but, more recently, long lengths of wire are worked out from the centre. In the late 1990s, this new production also began to be threatened by a shortage of material. Fibre-optic telephone systems and cell phones have meant that scrapyards are without suitable wire. It seems that the new generation of craftsmen may have to display further inventiveness in the use of available materials.

Although most European baskets had important functional applications, in agrarian society they were invested with meaning as a result of the time and skill that were spent on them. Production was part of a pattern of seasonal activities which were associated with a wide variety of symbolic and ritualized practices possessing vital cultural importance at the levels of individual, family and community. In many other cultures, baskets and related woven objects are overlaid with other significances. They may have strong spiritual meaning, or involve the use of significant patterns, important to the maker as well as to the user and the observer.

In Puget Sound, on the north-west coast of British Columbia, Canada, in the myth period before the arrival of the Native Americans, animals were attributed with many human qualities. Crow was the basketmaker.[4] At the moment when the Transformer changed the pattern of life into what it is today, the baskets were changed into clam shells, the patterns now found on those shells being the remains of those on the baskets. Crow became a supernatural spirit who aided the basketmaking. Although many baskets was purely functional, for hunting, fishing, gathering and storage, others were made purely as beautiful objects for gift-giving on ceremonial occasions. These were carefully preserved and highly valued. Size and technical construction depended on use: clam-washing baskets needed open spaces; those for boiling food needed to be tightly woven in order to hold water. Those for ceremonial use varied with the makers, these being women who learnt from their mothers in early childhood and sought Crow's help with their work. The many groups who lived in this region had frequent contact by canoe and shared a wide range of coiling, twining and plaiting techniques. The learning process ended with the girls' first menstruation, which was passed in seclusion and spent weaving baskets, during which time each would complete her own basket. A girl's character was believed to be formed during this period of seclusion, the starting and finishing of projects, individual accomplishment, concentration and hard work, and a serious attitude to the task all being important virtues. If she had an idle hour the walls of the basket would have bulges; if she chatted the stitches would be uneven. Although most women could make functional baskets, there were experts among them who were involved with the aesthetics of their baskets and were excused some routine duties to concentrate on their work. This gave them a spiritual power.

# The Origins of Contemporary Basketmaking

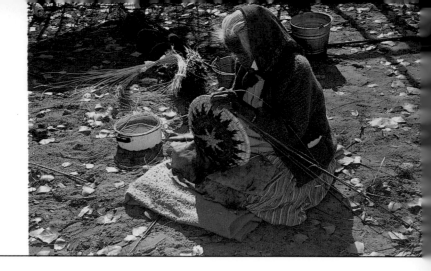

**Marie Lehi,**
Southern Paiute, making
a Navajo wedding
basket of sumac,
commercial black dye,
mountain mahogony root,
red dye, near Tuba City,
Arizona
1991

The 'potlatch', a ceremonial and social meeting of often one thousand people from many tribes and lasting several days, involved the giving and exchange of these fine baskets, each gift having to be outdone in artistic and technical mastery by the basket given in return, and all conferring a valued spiritual status on the recipient. Today, a few women still continue to practise their craft and endeavour to imbue it with appropriate reverence. The Hopi, too, use baskets as an important part of their social and ritual life.[5] A basketry roundel is presented to the man at his wedding and is kept for carrying him later to the after-life. The women carry baskets throughout the wedding ceremony and throw them to the assembled guests at the end. Linda Mowat and Abigail Kaursgowra, a basketmaker, attended a Hopi Basket Dance in 1991, in Hoterilla, Arizona. Women of all ages, from young girls to the elderly, took part, wearing their traditional dress and holding a new, highly coloured basketry plaque. They danced with a shuffling step in a broken circle, singing quietly as they went and moving the baskets to the rhythm. This dancing celebrates fertility and the end of harvest, and traditionally ends with the women throwing their baskets at their male relatives, but now, fearing they would reach spectators, they are kept for presentation directly, cheaper objects being thrown in their place. A video entitled *And Women Wove it in a Basket* shows the persistence of these traditional central roles for baskets in Native American culture. Native American makers working at the Pitt Rivers Museum in Oxford in 1992 and at the British Museum (Ethnography Department) in London were eager to show that they continued to maintain their skills and were actively passing them on to the next generation.

In Maori culture, basketmaking and fibre work has a strong cultural significance, the New Zealand flax (*Phormium tenax*) being used for cloak-making.[6] Made by women and worn by men, the cloaks confer rank and are accounted the greatest treasures, today as in past times. Traditional clothing consisted of waist-mats and cloaks, ranging from simple rainwear to these prestigious cloaks, worn by both men and women. Some have decorative twined borders in two colours, but the finer ones had coloured borders woven in a more complex technique known as *taniko*. In the early nineteenth century these were plain, apart from the borders, but later the body of the cloak was decorated with hanging black cords, sometimes with red pom-poms. There was much experimentation with colour and design on the *taniko* borders, leading to the development of feather cloaks, which appeared towards the end of the nineteenth century. These cloaks would have taken one or two years to make. They all have *Phormium* fibres as their basis, and its use is integral to the revival of Maori skills, which began in the 1960s. The fibres are extracted by taking the edges and midrib from the leaf, splitting it into long sections (1 cm wide), cutting it at two points at right angles to the length on the underside and pulling the leaf blade (cut side down) across the edge of a mussel shell, and thus separating the fibres from the rest of the leaf blade. Groups of these fibres are then twisted in two groups by

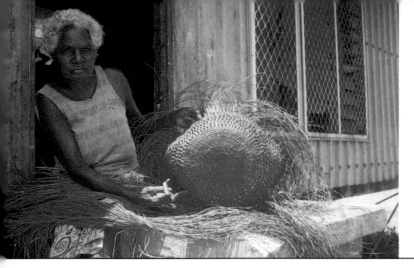

**Shirley Minyingarla**
of the Burrava language
group, Maningrida,
making a twined dilly
bag
*Pandanus* palm dyed
with *Pogonolobus
reticulatus* root
1995

Notes
5  L. Mowat and L. Hill (edd.) 1993.
6  D.C. Starzecka (ed.) 1996, p. 119.
7  Australian Exhibiting Touring
   Agency 1995.
8  M. Jordan 1998.

rolling them down across the thigh and then rolling them up to ply them into a strong, fine thread. This is used for the twined cloak edges.

Much care is taken in gathering the flax by the present weavers. Recently, Kahu te Kanawa, on being offered supplies of flax by Cambridge University Botanic Garden while working at the British Museum, told me never to pick it from flowering plants and to respect the latter by taking only a few leaves from each. *Phormium* strips are also used for plaiting baskets and mats, a technique brought to New Zealand from Polynesia. Many of these objects are functional, used for gathering and storing, each basket being used for only one sort of food. Now such baskets are used by women as personal accessories, and are treated with special respect, thereby reflecting the skill that goes into making them and the woman's relationship with the individual maker. They also display a sense of pride in Maori culture.

In Arnhem Land, Northern Territories, Australia, weaving with fibre has also enjoyed a resurgence, and here objects made for religious and functional use have a strong significance for their makers.[7] Although the objects produced are functional, in Aboriginal culture everything, including both inanimate and functional objects, is given a gender, and their existence "is never attributed to human creativity but to the actions of certain Ancestral Beings, who initially forged the connections between the spiritual and the more mundane spheres of life". Our Western ideas of what is art and what is craft are meaningless here. The weavers pay homage to the Beings who gave them the skills and continue weaving because of this inheritance: "I do the same thing my Ancestors have given me. I've got that from my Ancestors and still remember. I remember when I make weaving – it's in my heart. That's my feeling." The dilly bags from east and central Arnhem Land are symbols of fertility, representing the womb and therefore creativity. Weavings can also be Creator Beings, many features of the clan lands being attributed to them. Ancestral *Pandanus* dilly bags were said to have travelled from the east, creating waterholes as they went. Many men's items, woven mats and dilly bags have equal significance, and even now, when many objects are woven for an external market and for exhibition, their cultural importance remains. The weavers value the way in which outside influences enable them to continue to make such culturally important items while also earning a living from them.

The Luvale people of Angola and north-west Zambia, along the Angola border, have a basket which may be used for food, but which has another function as a divination basket, being transformed from the first, *mbango*, into the second, *ngomba*, as the result of a ceremony which involves the diviner stealing the basket, and the basketmaker chasing and cursing him for the theft.[8] Only menopausal women are allowed to weave this coiled

# The Origins of Contemporary Basketmaking

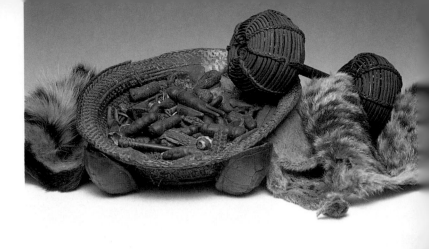

Divination basket and
rattle, Chokwe,
Angola/Zambia,19th
or early 20th century
Fibre, tortoise shells,
animal skins, and other
materials
31 cm diameter

**Notes**
 9 *Making Weaves* 1998.
10 *Making Weaves* 1998.
11 *Making Weaves* 1998.

basket. It has two possible fundamental meanings: "as a woven container that extends and assists the human body; and as a powerful entity with human-like qualities". Once transformed, it retains its character as an object for divination. The basket is filled with "natural objects, tiny sculptures expressing a variety of human conditions and relationships, and relics of human experience". The basket is shaken, resulting in different arrangements of the objects, which must be interpreted by the diviner. Interpretation is followed by a discussion between the diviner and the client, who provides personal details to support the interpretation, which leads to a problem-solving plan that the client can implement.

Most Westerners, perhaps, regard baskets as purely functional items. Many contemporary basketmakers in the West, however, attribute meaning to the making process, even of a spiritual nature. Lizzey Farey has remarked, "For me, willow has become a medium for an interaction with nature which is deeply personal".[9] Anna King says, "I see my baskets as containers for ideas – and secrets". For Marion Hildebrandt, "My basketmaking has a symbiotic relationship to my interest in California native plants – specifically those growing in Napa Valley. It is still possible to find plants there that were used by basketmakers four thousand years ago."[10] Characteristic of a kind of affective individualism is Sarah Pank's poem:

Absorbing the landscape.
Embracing the elements.
Earth. Rock. Water. Wind.
Walking into woodland. Welcoming winter.
Weaving willow. Wandering the hedgerows.
Reclaiming the heart.
Feeling the textures. The sound.
Watching the woods in dormancy.
Awaiting early buds. The awakening.
Receiving the wildness.
Gathering winter's branches.
Larch's colour in clear light.
Collecting hues and stacking bundles.
I weave: to hold, to remember.
For the rhythm, patterns.
For containing. For pleasure. For sharing. To give.
For love.[11]

Basket of reycled
Woodbine tobacco
packets
Probably 1940s
10 x 25 x 18 cm

More restrained, but no less passionately spiritual, was the advice of Alwyne Hawkins, a Cambridge-educated farmer turned basketmaker, who taught me technique, instilled in me a sense of respect and love for willow, and fostered a thoughtfulness towards the making process: "Listen to the willow talking. Treat the rods as you would people."

## New directions in contemporary basketmaking

In the second half of the twentieth century, a contemporary basketmaking has emerged which reflects new conditions of production and artistic development, intent on a sculptural expression rather than a domestic, agrarian or industrial functionality, but often also concerned with environmental issues. Makers have emerged from art schools and from among those concerned with traditional practice. Everywhere the need to find new markets has provided a stimulus, and financial pressures have made responses essentially eclectic in their relationships with other twentieth-century developments in the arts. The nature of the materials has inevitably brought makers to confront issues concerning traditional cultures and ecology.

An increasing environmental awareness in Western society has forced craftmakers in all disciplines to re-examine their materials and experiment with new ones, a luxury not often accorded the indigenous maker, who is usually forced to respond to direct need. Found material, waste from our consumer society, may be used as they are but in new contexts, or transformed as in John Garrett's Multi-technique Tower or Lois Walpole's baskets of newspaper spills, or of coiled flex and telephone wire with the surprise of a film-mount border, or of flattened apple cartons. This is not only about thrift, as in the case of the Woodbine basket, or about lack of choice. It is often a liberation for the basketmaker, setting the imagination free to produce new forms, explore juxtapositions of materials, and produce vivid and unexpected colour. It encourages vigour and exuberance and has nothing of the driven necessity that forces other cultures to turn to the use of rice sacks or bell wire, although here, too, vibrancy may be an end product. It also creates space for the non-functional basket, of which the purpose is often solely to explore materials. There is opportunity to investigate new materials in depth, to discover their characteristics (pliability, tension, angularity), and to use these discoveries as an integral part of the development of the work. Every time Dail Behennah uses telephone wire in one of her grid baskets she learns more about the systems and the interplay of the wood and wire she uses; and for Maggie Henton the same is true of the forms which may be made with birch ply and wire. One of the ironic consequences of budget cuts in craft courses in art schools and universities during the 1980s was the creative stimulus of being forced to re-use waste materials.

# The Origins of Contemporary Basketmaking

**Judy and David Drew**
Live willow sculpture at
Chaumont, France
1995

**Notes**

1 Information Susi Dunsmore
  1997.
2 Information Susi Dunsmore
  1997.
3 Information L. Mowat and
  L. Hill (edd.) 1993.

"Craft knowledge is not old knowledge, for it is constantly evolving and adapting to new materials, new tools, new demands, new skills." Tradition is not static. Early generations of basketmakers responded to industrial needs, and their work has disappeared from the basketmakers' repertoire as the industrial infrastructure has altered. New markets develop, however, and outside influences infiltrate and create change. Examples may be found in Western and non-Western cultures. In south-east Nigeria, where the raffia palm (*Raphia vinifera*) is common, the leaves have long been used for weaving mats and baskets. In the early 1980s, a workshop was established to bring in new ideas and markets for this work, producing hats, school bags and fine woven fabric, comparable with the finest linen – and expensive. This has successfully kept the skills alive as the products competed successfully with machine-made plastic and enamel containers. Women in Sarawak make baskets for transport and to support a traditional way of life, and are still making and using baskets for ritual purposes, but even here, where villages cannot be reached by road, there is development.[1] Leper patients, settled permanently in hospitals in Kuching, are using traditional designs in the basketwork they sell to tourists. In Nepal, too, the traditional shapes of baskets are still used widely but some have become modified under the pressure of modern demands.[2] A basket once used for offerings has been adapted as a bread-roll basket for use in hotels. In Botswana, baskets have been used in all parts of the food production cycle, for planting, gathering, storage, processing such as winnowing, and for brewing and drinking.[3] The baskets seldom last more than a few years and, since the 1960s, many designs have been lost – although the forms of the baskets have survived because the women started to make them for sale in the 1970s. Many thousands of pounds worth of baskets are distributed annually, and for many families this is their only source of cash income. The original basket designs were altered to more modern versions, although the original ones are kept alongside as a source of possible future developments.

Many willow basketmakers in Britain have earned an additional income through the 1990s producing drawers for designer kitchens and one-off baskets for conjurers and theatres, in addition to the usual shoppers, log baskets, cradles and other domestic items. Graduates from the French basketmaking school are now unusual in often maintaining quite rigidly the traditional patterns they have been taught, so that professional basketmakers all over France still have largely the same repertoire. The large upsurge of interest in basketmaking in Britain and even more in Denmark is a response to the use of natural materials and environmentally friendly renewable resources – rush, willow, straw and many other colourful hedgerow woods – and to the new forms being created by the basketmakers.

Much of this work is large-scale, outdoor and sculptural, a response to increased awareness and concern for environmental issues. A new generation of Northern European

artists has gained prominence by reflecting their experience of the natural world in their art. They have a fascination with materials and make sculpture by constructing single works from particular substances or from found objects, selecting, ordering and reassembling them, creating new juxtapositions, exploring shape, colour and textural changes in this way. Alongside this has been a strong movement using weaving techniques on a large scale in the landscape. In Britain, this work was begun by David Drew, who in the early 1980s constructed a fence of living willow wands as an experiment in his garden at Hare Farm. The diagonal arrangement of wands, the exploitation of the natural tension of the rods and the pressure they exert on each other at the cross-over points enable the hedge to become grafted, a solid, living piece of wood. The experiment was highly successful, and Drew has developed the idea, carrying it to his present home at Villaines-les-Rochers in France, and to Denmark, where, in 1992, he constructed a zig-zag structure, mixing living and white peeled willow with a zig-zag of black and white flints. One of his most recent, large-scale fencing works was constructed at the château of Chaumont, on the Loire, in France. His work always involves the use of strong, evenly matched willow rods and accurate spacing, features that raise his work above the functional.

Projects Environment, an association with strong environmental interests, which aims to bring art to a wider public, organized a large event in 1991 at Ness Gardens, the botanic gardens of the University of Liverpool. Called *New Forms in Willow*, it brought together major artists and basketmakers from several countries – John McQueen and Patrick Dougherty from the USA, Valerie Pragnell from Scotland, David Drew from England, Annette Holdensen from Denmark, and Britt Smelvar from Norway, among others – to create large-scale works in parts of the garden, using any plant materials available, including willow from the National Willow Collection held in the gardens. A wide variety of different pieces resulted, each reflecting the artist's nature and concerns. The student workshops with these artists that followed were a great inspiration to many of today's contemporary basketmakers.

The maintenance of a strong connection between art and its natural surroundings counters, in some measure, the environmental pessimism that is prevalent in the West. The pieces created often evolve alongside natural processes, changing with the seasons or as living structures which grow and become an essential part of their environment. The creation of such works, particularly those built of willow or hazel by community groups, brings the creative use of our surroundings directly to people of all ages, creates a new knowledge and respect for the landscape, and returns areas of our towns and cities to their natural state.

# The Origins of Contemporary Basketmaking

**Serena de la Haye**
*One metaphors*
1993
Willow

A paramount example of this is the project carried out with the schoolchildren of Rossendale by Ian Hunter and Celia Larner of Projects Environment. On Hunter's own admission he had little knowledge to build on but, over several years, the primary school children successfully cleared land, planted willow cuttings, looked after them, manured them, measured growth rates, examined leaf and stem structures, and cut and wove some into baskets. Large living willow wands were made into an outdoor classroom, which extended over several years into a tunnel complex shaped like a tree. New growth was interwoven to thicken up the structure. A kiln for firing pots of the local clay, and a charcoal-burning oven, were all built and used by successive year-groups for whom the appreciation of art and environment was an enriching experience.

The use of living willow for sculpture and garden structures is currently fashionable in Europe. Willow and hazel are renewable resources and environmentally friendly, although they have extensive root systems which have to be kept away from buildings. These works, linking craft, sculpture and garden design, use a range of willows with different coloured barks, and may involve an exacting and highly skilled placing and arrangement of willows. Others, such as those by Serena de la Haye, involve curving and interlacing dead willow stems to provide a strong sense of movement in her figurative works, creating body form, musculature and a sense of power. Her work is normally a response to a particular site. The growing arbours and seats of Clare Wilks, however, may be constructed and woven in a wide variety of environments.

In the last few decades, perceptions of the utilitarian basket and of objects made with basket materials have begun to change rapidly. Informed by a new popular aesthetic, the easy availability of small goods (such as brushes and spoons) from non-European cultures, employing basket techniques has made possible the development of new meanings for such mundane items as decorative objects in Western homes. They have become dislocated from their place and mode of production and from their primary functionality. In the same ways, the significance of traditional Western basketware has been transformed from its place in historic peasant and industrial society. Value begins to be invested from the world of artistic commodities, increasingly demanding high quality, excellent technique, masterful choice of materials and an individuality of expression. At one extreme in these developments, such objects acquire a new market value and become exhibitable artistic objects, attracting attention in ways similar to ceramics and no longer simply as ethnographic objects of another or byegone culture.

Yet it is important to see basketry and basketmaking as simultaneously inhabiting a number of separate but interrelated domains. The functional, everyday basket in domestic,

**Ian Hunter and children from Rossendale School, East Lancashire**
(Willow Tree Sculpture Project)
Tree-shape willow maze, an outdoor environments classroom in living willow
1989–99

agricultural and industrial life is still with us, even if there have been changes in the centres of demand and production. Baskets and basketmakers are being more widely recognized within their cultures as possessing a historical and ethnographic importance, one that reaches beyond mere function and is seen also to serve social and spiritual purposes. Furthermore, this craft and its practitioners may be regarded, perhaps as never before, as multicultural, the product of ancient exchanges of knowledge between the local, regional and national, and still vitally involved in such exchanges. Finally, the aesthetic changes of the late twentieth century have seen basketry enter the world of artistic commodities. The origins of contemporary basketmaking are to be found in the discovery of complex relationships between all these domains, and in the recognition of intimate connections between basketmaking and other craft and artistic forms. Moreover, the global political concerns that exist at the end of the second millennium have been influential, as indeed they are in most cultural activities. Basketry has always been an essential craft rooted in social practice and adaptable to changing needs, individually and collectively expressive of technical and artistic virtuosity. Contemporary basketmaking, as Rossbach suggests in the epigraph to this chapter, has inherited all these features and is vigorously developing its inheritance.

# Stories from a New World  Laurel Reuter

The history of contemporary basketmaking in the West emerges from stories. True stories? Yes, at least in the larger way that cultural history is accumulated. The following story, well known, often told, still underpins the work of artists making baskets the world over.

Basketmaking as art in North America begins with a war story, for it was Pearl Harbor that rescued Ed Rossbach from an unruly classroom of seventh-graders in the small town of Puyallup, Washington, and landed him three years later in the Aleutian Islands off the coast of Alaska. As a member of the Alaska Communications System, he had learnt the rudiments of security work, including the Morse Code. His job confined him to a desk in the Signal Corp office, but when he was not working he was free to wander the windswept Adak Island beaches, engulfed in that timeless landscape.

One day, Rossbach stumbled across an exquisite little basket. Much later he would learn that the Aleutians, unlike other Inuit cultures, had a class system and slaves.[1] This encouraged a tradition of making flexible baskets that are among the finest in the world. With grasses alone, these people made the most delicate twined baskets of the entire New World – as fine in texture and as dense in thread-count as European linen. The culture was almost eradicated in the mid eighteenth century by Russian fur traders, who employed the Aleuts on their ships. Gradually, the old ways were lost, the people converted to the Russian Orthodox Church and found new ways of living off the Bering Sea. Change came again in 1867, when America purchased Alaska from the Russians.

Rossbach stared at the little basket cupped in the palm of his hand. "How did they make this?" he wondered. There was no-one to ask. The native residents of one island had been taken to a Japanese prisoner-of-war camp. The remaining Aleuts had been removed to US internment camps. So he wrote to his sister at home: "Please send that old Boy Scout manual on basketry". But the booklet was long lost and Rossbach was left to figure it out on his own.

"I set about gathering individual grasses and stalks which seemed promising, although I had little idea what constituted quality in basketry materials. No information was available, for the Aleuts had been removed from their islands and, strangely, nothing of their culture was to be seen anywhere. It was as though hostile elements had furiously erased every mark of human existence and returned the land to something primeval, alien, and – despite the army which had alighted – uninhabited … I found myself indulging in a solitary ritual of observation. The islands became for me, at least in retrospect, a land of dreams – various, beautiful, and new. I achieved no baskets, only a box of selected grasses and a brittle start of interweaving."[2]

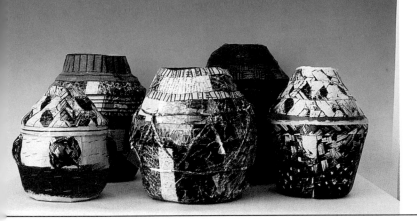

**Ed Rossbach**
Paper baskets
1987
Xerox, lacquer, yarn
and found materials

It would be years before Rossbach could turn his attention back to baskets. First he studied ceramics and weaving at Michigan's Cranbrook Academy of Art on the GI Bill. Through this remarkable piece of national legislation, many a returning soldier, or GI, was able to re-enter civilian life via the university. Across America, a formidable future generation of artist-educators, made up of returning veterans, was back in school. For example, Peter Voulkos entered the University of Montana in 1946 on the GI Bill and went on to become the driving force in abstract expressionist ceramics and the father of the contemporary ceramics movement. Focussed and mature, such men as Rossbach and Voulkos were to lead the craft revolution that was in full swing by the 1960s.

In 1950 Rossbach joined the staff of the University of California at Berkeley, where he would spend the rest of his academic life. From there he would found whole artistic movements and influence more artists than anyone in the history of American craft. Rossbach also set out to do what pleased him; to observe historic textiles; to study traditional techniques; to wander the world in the company of his wife and fellow textile artist, Katherine Westphal; to look and learn and make something completely new of it all. But the basketry traditions of the ancient Americas always remained closest to his heart.

It seemed that basketry flourished where ceramics did not. For example, the Pueblo tribes of the Southwest created masterfully in clay but made simple, undecorated baskets. The Hopi, who live in three extensions of the Black Mesa, evolved specialities in separate villages. Only on the Second Mesa did women develop coiled baskets of yucca leaves wrapped around a grass core, and on the Third Mesa fine wicker baskets made on frameworks of sumac. The Pima and the Papago developed no arts at all, with the exception of basketry. However, their masterful coiled baskets were the direct descendants of the ancient Anasazi basketmaking tradition, as were those of the Western Apache. A nomadic people who produced no textiles, no sand paintings, no silver work the Western Apache excelled in basketry. On the plateau of what is now Washington, Idaho and Oregon, basketry developed to a fine art, as it did among the Paiute of Nevada. Up and down the whole of the West, baskets found places to flourish.

Not surprisingly, some of the most beautiful coiled baskets in the world were created by California Indians. With plenty to eat and living in a temperate climate, they were able to turn their attention to pursuing an art form. The Pomo in particular produced highly coveted jewel or gift baskets, covered with brightly coloured natural feathers or shell pendants, which ranged in size from that of a pea to a metre in diameter. Or they made splendid, coiled basketry plaques as memorials to the dead – and intended to follow them into their graves. The designs were worked entirely in tufts of coloured feathers inserted under each stitch as the basket was constructed.

Rossbach began to arrive at a clear, personal philosophy grounded in observation: first and foremost, basket traditions evolve around local needs and readily available materials. He began to make baskets out of his own time and place; his students followed. In 1973 Rossbach published his book *Baskets as Textile Art*. Despite the quiet, elegant presence of the writer throughout, the book dropped a bombshell on Californian artists. Baskets as art! Baskets made out of junk materials such as plastic! It was a revolutionary idea at the time, especially his championing the materials of middle-class America: twine, vinyl tape, local palm-leaves, plastic, newspaper, travel brochures.

Ed Rossbach thus started the contemporary basket movement in California, and subsequently across the United States, Japan and Europe, throwing his ideas into the centre of an already vibrant fibre movement, the participants of which were itching for a way to take their art off the loom and into three-dimensional space. Whereas Rossbach was drawn to baskets through the ancient traditions of western North America, and later the world, basketmaking as a contemporary art form grew out of artists' need to create a particular kind of art at that moment. Rossbach showed them how.

Another story: John McQueen was the son of a mechanic. Fresh out of college, where he had studied sculpture, he moved to Albuquerque, New Mexico, and supported himself as a mechanic. To understand something thoroughly, McQueen needed to know how it was made. Ed Rossbach tells a charming story about McQueen, which says much about this new and ingenious mind that was about to become a major force in American basketry: "1973 – He worked as an auto mechanic and would go to a nearby park on his lunch hour. The park had a locomotive on exhibit that intrigued him. He proceeded to sketch the mechanism in a remarkable way: he mentally divided the steam engine into a number of squares, like the squares of a grid. Each day he would concentrate on one square section, memorizing all the structural details while he ate his lunch. He preserved his image in his head until returning home after work when he would transcribe the mental image on to paper. John could simply have taken a sketchbook to the locomotive or he could have taken a photograph. But what he did became a different experience – an investigation of time and memory contrasted with the intricacies of mechanical detail."[3] McQueen discovered something else while living in New Mexico in the early 1970s: baskets. They were everywhere, the makers anonymous, but, both singly and in mass, they evoked communal life. Masterfully constructed, beautifully formed, the baskets seeped into his being. He had come to the land of traders, and great baskets flowed in and out of New Mexico. The museums were full of them; one could buy more along the roadsides. He did not learn to make baskets from these Indian basketmakers. Instead, they taught him how an object that goes back thousands of years carries that collective memory forward. He applied to the textile department at Tyler School of Art in Philadelphia

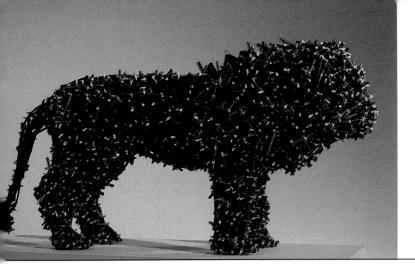

**John McQueen**
*Lion*
1998
Sticks and rundle ties

**John McQueen**
*My Father turning into
a luscomb*, detail
1998
Sticks and string

because he wanted to learn to make baskets. Even there, he was to teach himself, with Ed Rossbach's book *Baskets as Textile Art* as his only text.

McQueen was to become the perfect foil for Rossbach's teaching. Nothing he ever made resembled a Rossbach; however, he took Rossbach's proffered freedom, his suggestion that a basket needed to reflect the time and place of the maker, and he began to make formal, highly inventive container forms from plant life.

In the next few years McQueen was to build a home on eight acres outside Alfred Station, New York. From his own land he harvested his materials: cockleburs, linen and wool; morning glory vines, leaves and milkweed; bark and basswood and pine; raspberry canes and red osier; ash splints and red string; day lily stalks and willow bark. Each unexpected combination grew into a formal object, a rigorously defined container of space, a technical wonder and a thing of great beauty. Most importantly, his great technical inventiveness was always subservient to the intellectual rigour he brought to each basket. His reputation quickly rocketed to critical attention. Five years out of graduate school and major museums were collecting his work.

Ed Rossbach never claimed that his baskets were sculpture, just as McQueen insisted that he made baskets, not sculpture. Both found a freedom to pursue their own path in a way sculptors tied to centuries of the Western tradition never could.

Later, McQueen allowed his baskets to break out of the container form, to speak through written language. Poetic, witty, humorous, they continued to be endlessly inventive. In the late 1980s he was invited to make a basket for the exhibition *Frontiers in Fiber: The Americans*, which was to travel throughout Asia. Amused with the difficulty Asian museums have with audiences examining artworks with their hands, he twined the words "Please Touch" into the surface of his three-dimensional Latin cross made from willow.

McQueen brought the contemporary American basket movement to the attention of the East Coast art establishment, and then to the rest of the art world. Rossbach invented it; McQueen validated it. And his work just keeps changing. It is as though each piece comes from a different artist within one community. You know it is a McQueen, but each is different. He never repeats the same visual thoughts; each basket informs the next. There simply is no-one like him. The 'village' of McQueen is a rich one indeed. Like the Pomo and the Aleuts, like the Western Apache and the Papago, McQueen will be remembered for his contribution to the history of human creation.

Patrick Dougherty blew the field wide open by reaching back into the wellsprings of

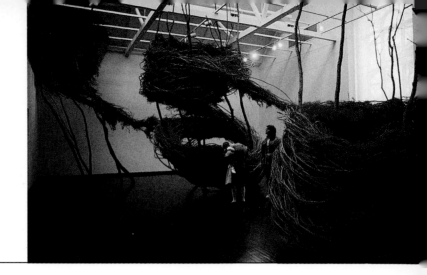

**Patrick Dougherty**
*Shelterbelt*
1990
Swamp willow

ancient building techniques to create monumental shelters and abstract presences that activate space. They remind one of animal nests, hives, cocoons or lairs. They evoke ancient builders of huts and baskets – especially the basket architecture of early American Indians. The Mandans of North Dakota built winter earth-lodges on a post-and-beam framework that was interwoven with grass and then covered with mud. Wichita grass houses, in what is now Kansas, were 7 m tall and as wide as 20 m at the base. In 1540 Coronado admired how their thatch was sewn "in and out in such an ingenious manner that each bunch of grass overlaps the bunch below". Across the land, woven and sewn mats covered frame structures, each tailored to local materials and climate. They might expand to 40m long and house several family groups. Woven granaries on stilts appear throughout the West and Southwest. Among the most exquisite are the Pomo acorn granaries, open-work storage baskets, 2 m tall and 2 m in diameter, placed on their own platforms and stilts.[4] A Pomo fishing shelter is the antecedent of a Patrick Dougherty hut.

Born in 1945 in Oklahoma, Dougherty grew up in the North Carolina woodlands. At college he studied literature and went on to receive a master's degree in hospital administration. But by choice he was a stay-at-home father, building the family house, caring for his children while his wife nursed. Visitors to his North Carolina home would inevitably exclaim, "But you are an artist". One day he simply decided that he was an artist. So, at the age of thirty-six he returned to college for two years to take courses in studio art and art history. From 1984, when he made his first piece, to 1988, when his career took off, he subsidized his art with carpentry.

One day he went to hear a lecture by visiting artist Martie Zelt. She was known for her mixed-media works incorporating fabric with printmaking techniques. However, she began her working life as a trained seamstress who continued to sew her artwork together. Dougherty asked himself, "What do I already know that I could turn into art?" He answered, "I know how to build with wood".

Today, Dougherty builds site-specific installations from the natural materials he finds near by. For example, in the summer of 1990 he created an installation at the North Dakota Museum of Art. He spent the first few days gathering truckloads of newly cut swamp willow from neighbouring wetlands. Consciously inspired by the nest building of birds, he wove the supple saplings into a large-scale, site-specific sculpture comprising four shelters, or baskets of gigantic proportions, two earth bound, the next 3m into the air, and the third 8m into the upper reaches of the soaring gallery space. They flowed, one into the next, like a grand series of connected tree-houses. Like nests, the sculptures are supported solely by the tension produced from the interweaving of branches. The invasive aroma of freshly cut trees permeated the museum. Dougherty's work becomes known

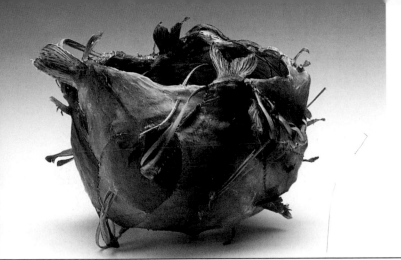

**Fran Reed**
*Wild pinks*
1996
Pink salmon skin, gut,
seaweed, cane

**Notes**
1 Norman Feder, *American Indian Art*,
  New York (Harry N. Abrams)
  1969.
2 Ed Rossbach (ed.), *Baskets as Textile
  Art*, New York (Van Norstrand
  Reinhold) 1973, p. 8.
3 Vicki Halper and Ed Rossbach
  (edd.), *John McQueen: The Language of
  Containment* (Washington DC,
  Renwick Gallery of the National
  Museum of American Art,
  Smithsonian Institution/
  University of Washington Press)
  1991, pp. 16–17.
4 Peter Nabokov and Robert
  Easton, *Native American Architecture*,
  New York and Oxford (Oxford
  University Press) 1989.

through the senses long before the mind translates it into an intellectual experience – but then, isn't that true of most basketry?

This creator of architecture never studied architecture. Instead, he seems to have an innate sense of engineering, to have been given the knowledge that goes into making these pieces stand upright. Maple, which snags with everything, is his preferred building material. "I love maple saplings", he once wrote. "They have rambunctious ways … and if attacked by a maintenance crew, they fight back with flexibility and resistance and resist further – by tangling with everything in any attempt to drag them from their site." North Dakota is too cold for maple to thrive, so Dougherty switched to interweaving willow. In Japan, he used bamboo to build an installation around a 400-year-old sacred temple tree, inspired by the ancient custom of tying rice ropes around such trees. As always, he gathers his materials from areas that are to be mowed, developed or cleared. Dougherty freed basketmakers to imagine on a grand scale. He led the way in creating site-specific baskets, and baskets that successfully interact with architecture. He also was among the first to view baskets as temporal. His works either come down when the exhibitions end or they are left to decompose in the landscape.

Did three men make a movement? Of course not. Indeed, few people even think of Dougherty as a basketmaker. They simply represent three powerful forces in one of the most vital movements to emerge in the United States in the middle of the twentieth century. Very early on they were joined by the likes of Ferne Jacobs, who taught herself coiling techniques and for decades single-mindedly pursued her tightly woven linen-thread structures. Others joined her. Dorothy Gill Barnes began making refined wooden-stick structures that only sometimes refer to baskets. Kay Sekimachi, with her elegant, hand-made-paper bowls, and Jane Sauer, with her tightly knotted, waxed-linen, increasingly simplified sculptural forms, opened up new vistas for basketmakers who followed.

Lillian Elliott created abstract expressionist surfaces and loose, asymmetrical forms. In collaboration with Pat Hickman, she supplied the form and Hickman applied the surface skin; both led with their art as well as their teaching. Karyl Sisson brought rare humour to the basket world with her wired, clothes-pin creations. Lisa Hunter developed a decorative style reminiscent of old Pomo baskets with their highly embellished surfaces on traditional basket forms. Joanne Segal Brandford, with her softly formed, netted images of baskets, and John Garrett, with his contrasting angular baskets from garish, synthetic materials or metals such as copper, aluminium and galvanized steel, took newer paths. Together, and in the company of many others, they forged this vibrant movement.

# Artists' Voices

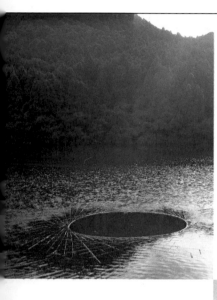

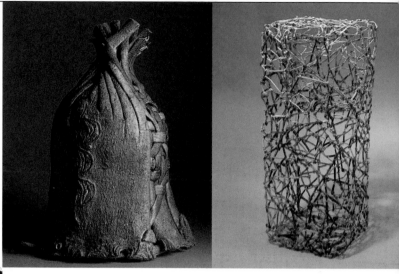

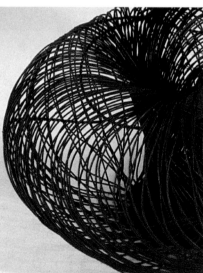

From left to right

**Ueno Masao**
*Circle in the water*
1996

**Shuna Rendel**
Twined basket

**Dorothy Gill Barnes**
*Seven moons*
1996

**Hisako Sekijima**
*Untitled*
1994

**Lois Walpole**
Apple basket
1995

**Ueno Masao**
*Fort*
1992

**Norie Hatakyeama**
*Endless line, series II*
*"six holes. 9110"*
1991

**Dail Behennah**
*Willow grid*
1998

What follows is based on the responses of an invited group of
basketmakers to a series of questions about the nature of their
work. Their views may invoke the glad recognition of a shared
response or, perhaps, strong disagreement. What they all provide,
however, is some insight into the world of the basketmaker, albeit
with a refreshing diversity of outlooks. The questions serve as the
warp threads around which the responses are woven; and the
editorial comment seeks to give temporary unity to the many weft
voices.

# Artists' Voices

**Baskets seem to provide a freedom for these artists to explore both self-expression and the idea of the container. There are no expectations from the public, but rich traditions to draw on. However, in most societies, especially those of Western Europe, the traditional maker has seldom, if ever, been completely free to make artistic explorations.**

# What is a basket?

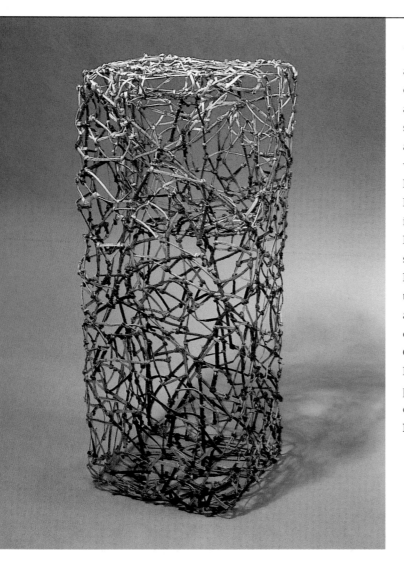

**Hisako Sekijima**
*Untitled*
1994
Kudzuvine
44 x 17 x 17 cm

"An object of vessel form in a textile structure where dynamics of components are all visible. That which implies some relation to any one of the aspects of basketry. My related vocabulary: Lines bent. Resilience. Flexibility. Rigidity. Planes folded. Drawing lines in the space. Filling space. Eliminating materials to keep space. The shadow and the real. Repetition; rhythm; texture; twining; joining; dividing; accumulating; interior and outside; hiding; opening. Curiosity. Sphere; bundle. Handle. Hanging; stuffed; pressed; weighing; balancing; distortion; transformed …."
**Hisako Sekijima**

"Burn the basket! Or at least light the fire with the paper the word is written on. The problem, of course, is that the most familiar and everyday basket is almost indestructible; you need an angle grinder to cut it up and a foundry to melt it down. The supermarket shopping basket is an unnoticed and unpraised design classic. As soon as we try to define the nature and essence of baskets we unwittingly begin to exclude. Terminology becomes redundant. The deep sighs and 'tut tuts' of tradition serve little to preserve forms and techniques, but rather push on another generation to find their own creative path."
**Tim Johnson**

"Baskets bring together my interests in textile structure and in three-dimensional form. Containers offer endless fascinations, with their ability both to occupy and contain space, and for the interplay between inner and outer surfaces, and so on."
**Maggie Henton**

44

**John McQueen**
*Manitou*
1992
Spruce bark, red osier sticks
16 x 105 x 46 cm

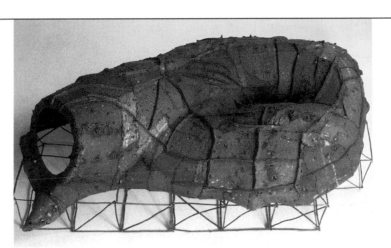

"Traditionally, baskets are made in response to a need, to separate or contain, to protect and transport. My work is in response to my own need, to make and create through a process of exploration and to communicate my interest, fascination and pleasure in rhythm, repetition, reflection and light. 'If we could forget the familiar definitions … basketmaking might then seem more akin to music than to the visual arts'
[Ed Rossbach, *The New Basketry*]."
**Alex Bury**

"When I make a basket it is an object with an interior space related to carrying or holding something. I enjoy the connection with traditional basketry. I am amazed at the complex weaves and problem-solving to build containers needed over the centuries."
**Dorothy Gill Barnes**

"Baskets are the sculptural realm of textiles. They are the architecture. Their forms employ semi-rigid materials with curves held under tension, with flexed energy built into the structure. It is possible that the arch, that strongest of elements in architecture, came to us from a bent stick. Some refer to baskets as containers for the human soul. This lyric connection could have arisen because baskets have been indispensable companions to our daily existence for millennia."
**Gyöngy Laky**

"A basket is a container. Therefore, all containers can be looked at for basket aspects. The human body is a container. So is the earth: we are contained within its atmosphere. But best are mental constructs. The sentence I just finished has a beginning and an end. It contains a thought. This paragraph contains ideas."
**John McQueen**

"I think that seeking categorizations is neither useful nor relevant; much more important is one's reaction to the piece itself. Basketry has inherent associations which can restrict not only what is made but also how it is viewed."
**Shuna Rendel**

"A functional container, made from materials that are woven, plaited or coiled or twined."
**Jenny Crisp**

"Each artist has his/her own style and must use the method and materials freely. She [Hisako Sekijima] realizes that you must adopt an open-minded approach to the basket. What I'm really interested in is her way of thinking. I still remember, clearly at the time surprise and bewilderment, even joy. Substance in nature has all the attributions and basis for being there already. Connect to 'form' by directly understanding the work of attribution, changing the substance into materials. I felt it by intuition. [The] basket emerges as a cubic construction making use of the power balance between materials for nothing in space."
**Norie Hatakeyama**

# Do you refer to yourself as a basketmaker?

"Basketmaker? I call myself a basketmaker because the things I make have developed as a result of my training in basketry. Although I have a thorough grounding in basketry techniques, many of my techniques are really stitching, drilling and threading. When I discovered basketry it immediately appealed to me as it literally added another dimension. My baskets are decorative objects: the implied function is more important than their actual use. Many other containers are now widely available, as well as very cheap and often beautiful baskets from the Far East, so I do not feel the necessity to make purely functional baskets. Throughout the world there is a long tradition of baskets being made for their own sake: their design and construction show that their makers regarded their baskets as a means of self-expression, as I do."

**Dail Behennah**

"I do not call myself a basketmaker, though previously I have called myself, or have been called by others, a painter, sculptor, environmental artist, etc. These are essentially labels used by other people; I apply the appropriate label as required. It is not really a question of personal identity (I am me), but a marketing term."

**Tim Johnson**

"Trained in sculpture and basketmaking, I have become a designer [with] a delight in the manipulation of materials and form. I no longer feel I have to restrict myself (initially it was useful because it provided a readily understood context for my work). I have never been particularly interested in baskets. I am not someone who spends my holidays looking for unusual baskets (I would rather go skiing). I don't collect baskets; my own fill the house."

**Lois Walpole**

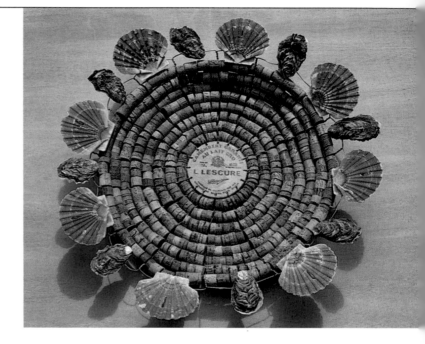

"I don't think of myself as a basketmaker but as an artist. It is just that what I feel with my hands is as important as what I see with my eyes … On the whole I prefer to work three-dimensionally."

**Alex Bury**

"I do not call myself a basketmaker. This would be to set false boundaries around my work and limit ways of seeing and interpreting it. Concept comes first; form follows the idea."

**Maggie Henton**

**Lois Walpole**
1992
Corks, shells, cheese box
60 x 13 cm

**It is interesting to see how people mould themselves according to their own ideas and those of the outside world. The term 'basketmaker' has meaning for the public. Why am I concerned with designations? What about the confidence to be myself? Labels are for outsiders. But we do need a term, and I prefer to use the age-old one. The basket is a vessel/container. If I make those, I am a basketmaker. I would like to persuade others that the word has a wider significance.**

**Norie Hatakeyama**
*Endless line, series II*
*"six holes. 9205"*
1992
Paper fibre strips
36 x 36 x 36 cm

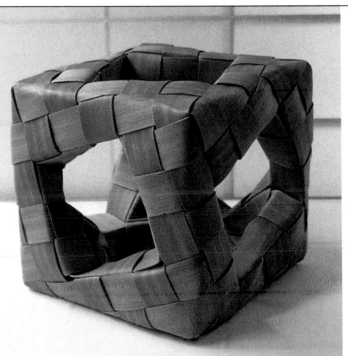

"No, I can't be classified as a basketmaker (though others call me one), as I am lacking in the traditional craftsman's apprenticeship and skill. But my work borrows from basketmaking and the understanding of the materials and techniques. My knowledge is wider but less particular. But this is also about declassifying. It's not about producing a set of rules any more."
**Shuna Rendel**

"No. In addition to basketry I create installations, free-standing sculptures and works for the wall. All of it is related to basketry. I sometimes use the references, 'textile sculpture' or 'constructed textiles'."
**Gyöngy Laky**

"I call myself a basketmaker because the world (however small that world is) calls me one. It's the role they assign to me. Within my head I do not call myself anything. I do not need to. I am myself."
**John McQueen**

"Basketry; the expanse is infinite. I think making baskets is not just denying the crooked world, one's own inconsistency; it may just reaffirm those kinds of things. There is no point in asking whether my work is mathematical, art or science, because I would say that the basketry formula is the very formula itself for nature. I'd like to continue working on basketry with a consistent and flexible spirit, keeping my balance."
**Norie Hatakeyama**

"Statement: Form, Space and Spirit. I am a maker of objects. I have chosen basketry because it allows me the greatest freedom to work with colour and pattern in a rigid form. Baskets are my way to make a personal difference in a vast, often impersonal, computerized world."
**Kari Lønning**

"Yes, I call myself a basketmaker, because I am concerned with ideas that I gain by processing the nature and history of basketry, and also because, in order to realize the ideas, I choose to use materials and structural methods which typically have been used for basketmaking for a long time. I enjoy [the fact] that the ideas go beyond the boundary of what I thought [of] as a domain of basketry, and thus I can reconstruct my relationship [with] ordinary matters."
**Hisako Sekijima**

# How important is chance in your work?

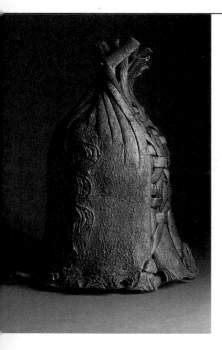

**Dorothy Gill Barnes**
*Seven moons*
1996
Dendroglyph
41 x 28 cm

"I prepare branch bark, limbs, roots etc. I lay out my harvest and study it. I mark trees with tape to plan for years ahead. Making can be minutes or years … Chance is very important in my work. Experimentation after strange, unexpected shrinkage will hold a stone just right. These things cannot be planned."
**Dorothy Gill Barnes**

"I make all my pieces after cardboard forms; therefore, I first build the piece out of cardboard."
**John McQueen**

"There is always an element of chance, but it is slight. The interplay of natural materials varies between pieces. The [completed] piece may contain some surprises, but no shock."
**Jiro Yonezawa**

"Chance scares me to death."
**Jenny Crisp**

"The form, built by manipulation of a simple method, emerged as a geometrical structure that a living thing has, and then, in a complex plaiting series, the form is getting closer to a living thing."
**Norie Hatakeyama**

"The shadows cast by these baskets are as significant as the containers themselves and I am particularly interested in the way that the stack of grids moves from two to three dimensions as the viewer moves around the basket. These are carefully worked out on graph paper and they are very time-consuming."
**Dail Behennah**

"Chance may not be the right word, but I do know that I follow where the work leads me. If it ends up as it starts out, the making is a very boring, uninteresting activity."
**John McQueen**

"Usually I plan baskets and sculpture in my head, but sometimes I draw out what I am after. I am not sure I would use the word 'chance'. Allowing for the unexpected is more what occurs to me as important to my work. I have extensive skills in planning and organizing, but for creative work these are not the best tools for developing an idea. I like to work with the immediacy of sketching, which allows ideas to flow from the visualizing rather than the rational part of the brain."
**Gyöngy Laky**

"I don't think we can compare the thinking with the actual making."
**Norie Hatakeyama**

There is an element of the unknown in almost all baskets, as materials are so variable. The initial concept gives us the confidence to start, but the making is a separate process, in which planning is followed by serendipity, and organizational skills are combined with intuitive action. This intuition needs to be developed.

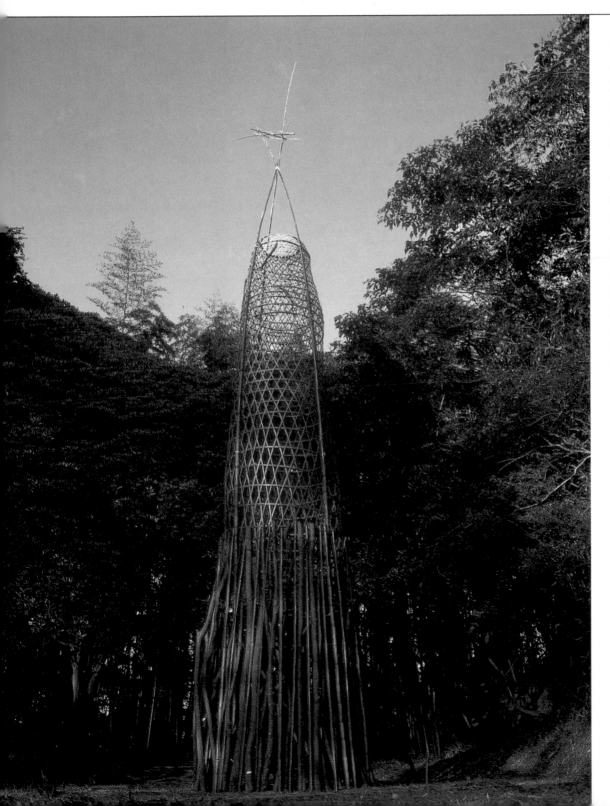

"In order to have the confidence to start, I have to have a concept of what I want to achieve, but the reality very quickly diverges."
**Shuna Rendel**

"I use mathematical software to stimulate my works. To make a [hexagonal] woven pattern, I only input the width of the bamboo strips. I draw with charcoal on watson paper before I begin to work in the landscape. To make a form exactly the same as the drawing is not important for me."
**Ueno Masao**

**Ueno Masao**
*Fort*
1992
Bamboo
1220 x 305 x 305 cm

# Comment on the importance of the creative process

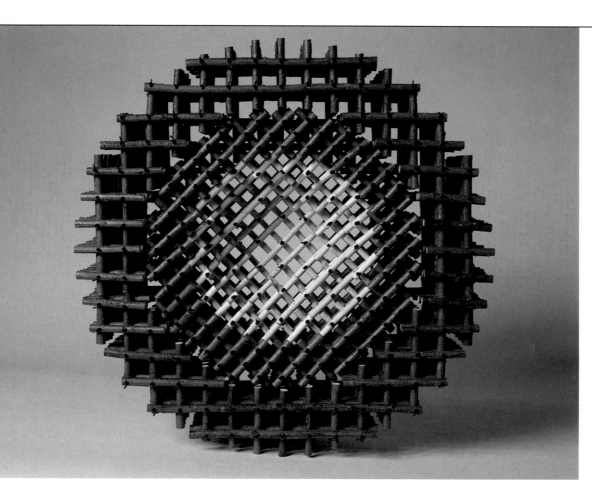

**Dail Behennah**
Brown willow grid with
peeled hollow
1998
Brown willow and bell
wire, peeled, drilled
and threaded
13 x 41 x 41 cm

"When I was at school I used to draw sheets of knotted and tangled rope. It's how I feel inside, but my work appears very calm. My baskets are an attempt to bring order and form to the knotted and tangled rope. I don't analyse – it's all instinct."
**Dail Behennah**

"I hope to keep the creative process as open as possible for as long as possible, reinventing the initial idea as the work progresses. I draw before, during and after much of my work."
**Tim Johnson**

"As my work stems from the exploration of ideas, thinking time and the development of ideas are the starting place. The work process involves a dialogue between the material substance of the object and the idea. The making, the manipulation of material and colour, should not be underplayed."
**Maggie Henton**

"I like seeing chaos in material and putting order into it. I like the process to show. I don't usually like fly-away, distracting embellishments."
**Dorothy Gill Barnes**

"There have been certain key moments in the development of my work. These moments come when I am pushing the limits of my control over the techniques and materials. A positive by-product of the slowness of this approach is the opportunity to reassess the piece in progress – the exploration occurs through the making itself."
**Shuna Rendel**

**No one produces finished pieces exactly as planned: doing generates more ideas and extends practice. The creative process is often sparked off by play. Interestingly, no one mentions the way that work is sparked off by another process, that of being commissioned.**

"I used deliberately to create pattern in my work for visual impact. Now I tend to allow the process and materials to make their own patterns. I cannot work randomly. No matter how much I might like the idea, there is usually a symmetry to the forms that I create which I cannot resist."
**Lois Walpole**

"I like working on a series of pieces. As I work with the material, lots of ideas come to me, but because the process takes so long, I can't afford to risk ruining what I've already done by trying out something new, so I do it in the next piece."
**Dail Behennah**

"One of my works that I think [was] the turning point in my making baskets was the coiled basket. There is a story about it. One day, I made a coiled structure with thick rattan sticks and raffia fibre. As the sticks were so stiff, I could not make them curved. When I finished it, I took one of the sticks out of the structure just for fun and found what happened. There was a hole and without the stick the coiled structure existed. I was very interested in that happening."
**Noriko Takamiya**

"Previously unused materials may be gathered and brought to the studio to lie around for months, sometimes years, before the second step is taken; this may be as simple as forming an association, in my mind, with the material that lies next to it on the floor. And then the fun begins!"
**Tim Johnson**

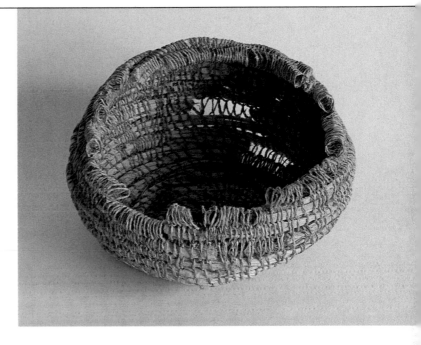

**Noriko Takamiya**
*Untitled*
1986
Wisteria fibre and
wood, coiled
19 x 19 x 12 cm

# What is your interest in form?

**Norie Hatakeyama**
*Endless line, series II*
*"six holes. 9110"*
*1991*
Paper fibre strips
21 x 21 x 21 cm

"From a mathematical point of view, my works turn out to show baskets with polyhedra abstracted in pure geometry. However, that doesn't mean I created the form using geometrical structure. It means the form has appeared on the real scene, through redefinition. Geometry might be incorporated into the method. It would seem that the form came out from another world."
**Norie Hatakeyama**

"In basketry I tend to love the quintessential open bowl. It suggests timelessness, elegance and balance. What I find curious about this is that I would describe my interests in very different terms. I like things which are slightly irritating or uncomfortable or off balance or grotesque."
**Gyöngy Laky**

"I am also working on a series of organic forms. They resemble leaves, seed pods and vessels. The placing of each coil can change the form of the basket and I am constantly making decisions."
**Dail Behennah**

"When I began exploring non-loomed constructions I discovered hardware cloth, a wire mesh composed of small squares. I developed systems of interlacing strips on or through the mesh. The addition of more materials may obscure the geometry of the construction so it appears organic. When the surface treatment is dense and complicated I use simple symmetrical forms. Most baskets begin with a square and some have other various constructed parts added."
**John Garrett**

For some, form arises from the materials used and the limitations of technique. For others, form arises from making order out of chaos, drawing without paper. There is no fixed vocabulary: this adds to the excitement.

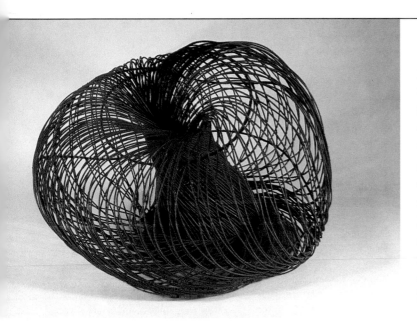

"If I had to prioritize my concerns for a piece I would have to put form first. I don't hold with the notion that form necessarily follows function: I think function can be fulfilled by many different forms, and the form that an object takes within a particular space can be one element of its function."
**Lois Walpole**

"I use simpler forms for my recent works: circle, disc, sphere, hemisphere and polyhedra. When I make a small work, relation between material and concept is very important. When I site my work in a landscape, relation between site and concept is more important. The work in the landscape should be site specific."
**Ueno Masao**

"My work has always been primarily concerned with rhythm and form and the interaction between layers of structure, defining spaces. Over the years, work has shifted from the exploration of ordered grids and symmetrical forms: the rhythm has become less regular, the edges and shapes less formal. There is an interplay between order and disorder."
**Maggie Henton**

"I see my baskets as sculptural forms rather than utilitarian pieces, hopefully with different views from different angles."
**Shuna Rendel**

"Depending on the materials used, I consider the balance of shape, texture, colour and surface finish."
**Jiro Yonezawa**

"The forms of these pieces are derived from the limitations of the technique I am using (complex linking at present). The forms that preoccupy me are those which have a feel of continuous movement within the overall structure as well as in the detail."
**Shuna Rendel**

**Shuna Rendel**
Twined basket
Dyed cane and cotton
1992
56 x 82 cm

# Comment on your preoccupation with space

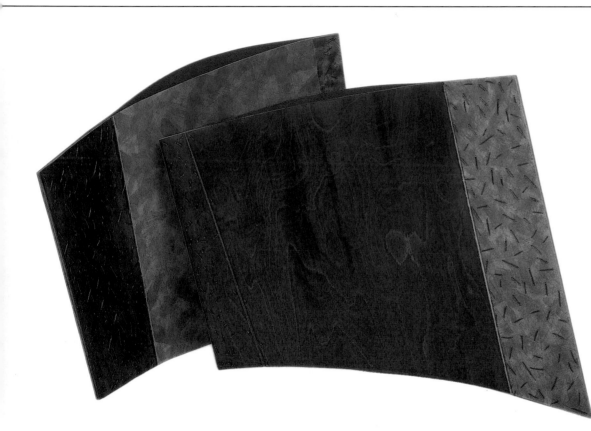

"I am a keen gardener and interested in the articulation and manipulation of space as expressed within gardens. My work with architects on public art commissions for interior spaces has largely been concerned with the issue of movement through buildings, with walls and doorways. The articulation of space is the unifying theme. Forms define and interact with space occupied, space contained."
**Maggie Henton**

"Inner space interests me. An example would be as follows: I sit 'in' this chair, 'in' this room, 'in' this house, 'in' this neighbourhood, 'in' this section of town, 'in' this town, 'in' this county, 'in' this state, 'in' this country, 'in' this hemisphere *etc*, *etc*. How about galaxy?"
**John McQueen**

**Maggie Henton**
Pair of curved forms
1996
Painted birch plywood
and copper wire,
stitched
45 x 65 x 12 cm

For some, the inside space is the vital part of the form. The 'real' is the form; the 'unreal' is the inner space. An object becomes a basket if it has an inner space, even if it is impossible to put things into it.

"I think a form reveals richer aspects when it is viewed not only in terms of the real materials such as sticks or bark, but also in terms of space or holes which lack in real materials."
**Hisako Sekijima**

"My works have a hollow space even if you cannot put something into it, so I can say I am making baskets. I made some works using a sphere shape of Styrofoam and the works I made had to have an opening in the sphere to take pieces out. The shape of the inside space could not be intricate. I came across an idea to make a framework using thin metal sticks. I made a geometric shape; I wrapped ramie fibre over it. After I finished working, I could take the metal sticks out. Thanks to the strength of the fibre, I could make some works with hollow space whose shape was intricate."
**Noriko Takamiya**

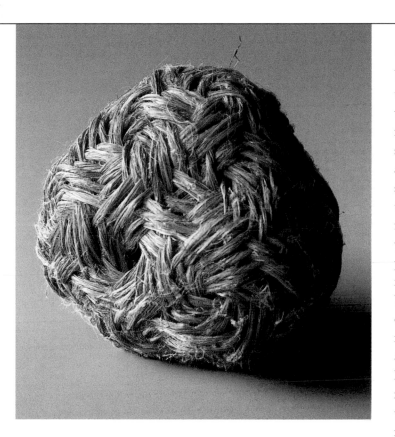

**Noriko Takamiya**
*Untitled*
1997
Ramie, knotted
17 x 17 x 12 cm

"The actual forms have their beginnings in baskets, which to me embody so much of what we are: soft, flexible, impermanent, fibrous structures. A balance of tension and compression; felt to exist since the beginning of time, terribly common, universally familiar, encountered in mass yet a uniquely individual presence, power, and mystery; made of disparate elements brought together into a complete often compelling magical form; hollow yet with a memory for what they have held, the thin outer skin both revealing and concealing an unknown interior. These represent the balance of complements that I feel are so strongly a part of us all.
**Linda Kelly**

# Do you explore traditional techniques or use a wide variety of methods?

"In recent work I have been particularly concerned with setting up relationships between two objects. These paired objects engage in a dialogue, a dialogue created and manipulated by the objects' imperfect similarity and their placement or closeness - almost comforting and caring for each other.

… The twisting, tying and handling of the material itself, the physical manipulation, is a slow and consuming business. Absolute concentration, total and exhausting focus on the stuff in hand."

**Tim Johnson**

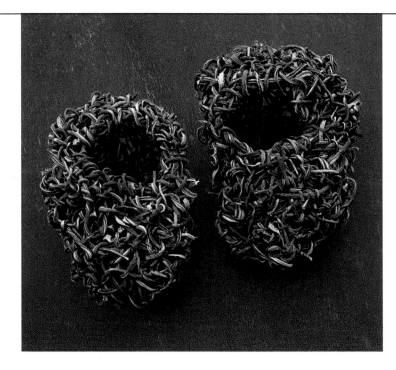

**Tim Johnson**
*Cradletide*
1998
Kelp
left: 17 x 22 x 34 cm
right: 20 x 27 x 36 cm

"I use a weaving technique where five strands of rattan are woven sequentially to create the 'fabric' of the walls and a form of tapestry to weave in the specific designs. To suggest further a sense of weight, I developed the double walled construction. I enjoy this because, in making vessels, I can draw on my training as a potter."

**Kari Lønning**

"I have begun using some traditional furniture joinery techniques in my work. I am proficient in practically every technique of textile construction, even such esoteric methods as boondoggling or split-ply twining, but I am most intrigued when I can innovate with standard approaches. I have recently been using the furniture technique of dowelling. What has been fascinating to me is that it feels much like pinning fabric together in dressmaking! I am particularly fond of this association because of my profound love of textile techniques and deep respect for them as building blocks of our lives. Without spinning we would have no Golden Gate Bridge."

**Gyöngy Laky**

"I have not yet exhausted the possibilities of creating form with complex linking. I love the flexible, manipulative possibilities of push, pull, stretch and squash which it encourages."

**Shuna Rendel**

**It is possible to work with formal techniques, or with any technique that suggests itself, through the endless exploration of one technique, by embracing a profusion of techniques, or by avoiding technique altogether. So what is the role of teaching? Does it disrupt the creative process or enhance it?**

**John McQueen**
*Heart in hand*
1992
Bark, twisted stick
120 x 118 x 94 cm

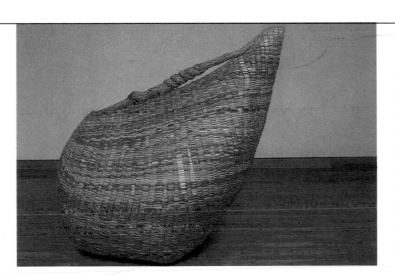

"I use many kinds of construction methods, both existing ones and my own techniques. I work with traditional methods such as plaiting, when I am interested in re-examining or conceptualizing one of its natures, by using either its specific combination with a material, or under some unusual conditions. I am interested in developing my own techniques. I want to test imaginative methods because they might have preceded refined formulae of what we call basketry techniques. My own methods are less regular and less economical compared with the formulated ones, but they look very attractive and expressive. I like their ambiguity."
**Hisako Sekijima**

"I create small sculptures using a simple overhand knot around a core of waxed linen threads. It is very labour intensive. The simplicity of the basic knot, combined with the repetitive nature of x knotting, is meditative and allows me to immerse myself in the work."
**Norman Sherfield**

"If you know only a few words you have limited conversations; likewise, if you know only a few techniques, your options for expression are restricted. I also aim to use those techniques as skilfully as I can, because they are part of the visual whole, and, if clumsily executed, attract attention."
**Lois Walpole**

"What are traditional techniques? I don't quite get the meaning of this. I find the original structure within the basket, observe and analyse it. In short, the most important thing is how we get the meaning of the technique. Furthermore, thought and actual action is the link to creation."
**Norie Hatakeyama**

"I have deliberately avoided things that I do not like, notably wet materials and weaving. In order to avoid these, I have had to find new solutions to problems in constructing vessels, and this in turn has meant that my baskets are easily identifiable as my work."
**Dail Behennah**

"I think I use many ways of working, but really, if it comes right down to it, only, or mostly, just a couple. I tie sticks together and sew bark together. I used to plait a lot but seem to have stopped. I'm not sure why."
**John McQueen**

# Describe your materials, their importance to you and your reasons for selecting them

"The list of plants I have ever used would include more than forty names. I live in the city where people need to trim tree branches to control them. This is one of my material sources. I work with natural plant materials for many reasons. For one, I value the fact that the plants live for their own reasons, but not for the human. This means that I should respond to them objectively and modestly or with respect."
**Hisako Sekijima**

"The materials are the reason I make baskets! It is a joy to harvest in nature. I choose the material for its strength, color, flexibility and availability. It's seasonal, very time-consuming, often hard, dirty work to prepare, but I love it! Some pieces take many years because the design is growing on a designated live tree. I plant trees as well as harvest."
**Dorothy Gill Barnes**

"In a country where willow is the traditional basketry material it is a challenge to use it to make a different kind of basket."
**Dail Behennah**

"The willows I have are top quality and a pleasure to use. The character and dimension of the willows are the main criteria that create the form of the basket."
**Jenny Crisp**

"I use two materials. The first is bark, mostly tulip poplar because it is what grows near. Also, I like its tradition. Houses were roofed with it in the southern US in the last century. It also works well and easily and is strong (meaning not brittle). The other is willow. Willow, because it works well and is the most traditional for my ethnic group (Anglo-Saxon)."
**John McQueen**

"When the material changes, the form changes, too. It doesn't matter whether it's natural or artificial – except that it's not materials in recent virtual realism: it should actually exist, because the things we can touch actually are completely different from things retained in our memory and things we can put into words."
**Norie Hatakeyama**

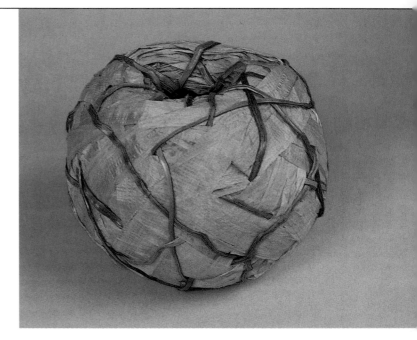

**Hisako Sekijima**
*Untitled*
1991
Cedar scrape and root
22 x 25 cm

"Contrast and role reversal stimulate me. Using a stiff material for a traditionally flexible technique allows me to create and manipulate semi-rigid forms. And I find the challenge exciting. It is essential to understand the qualities and characteristics of the materials. For example, the use of complex linking with chair cane highlights the difference between each side of the material, alternating ridges and valleys with contrasting surfaces as the technique reverses the exposed face."
**Shuna Rendel**

58

The artists' comments show love and respect for the materials. There is often a process of intuitive collection, storage and contemplation over time, before their use suggests itself. The choice of materials can be influenced by tradition and the environment, or be made independently for reasons specific to the work. Which comes first?

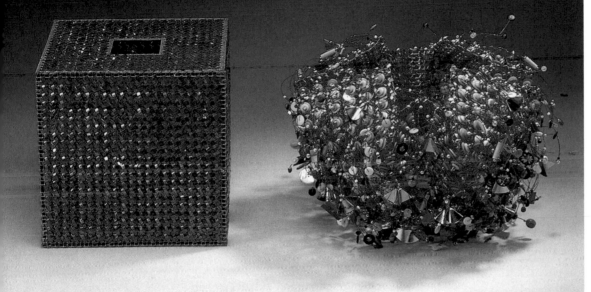

"Much of the plastic and card that I was using was taken from the streets of East London, where I live. I try to listen to my materials and not force them into ugly and uncompromising positions; that only results in tortured-looking work. I dislike overworked materials and there are enough battles to be fought in life without taking up a struggle with one's materials as well."
**Lois Walpole**

"I am fascinated by man-made fabrics and materials. I love translucency, transparency and sparkle. This all goes back to a childhood fascination with sweet-wrappers. They were my real treasure. I always want to handle materials, discover their ability or inability to fold, curve, crease, spring and surprise."
**Alex Bury**

**John Garrett**
*Forty years on*
1997
Copper, hardware cloth, wire, beads and various materials
left: 26 x 36 x 36 cm
right: 28 x 28 x 28 cm

"When I began my art career I was living in Los Angeles and chose to work with highly coloured plastics and vinyls, which for me reflected the urban landscape. In a large urban centre there is an abundance of manufacturing waste and discarded materials from many sources. I have always gravitated to used materials because they are cheap or free and because they already have a history. I became involved with metal when the renovators of an apartment building discarded a substantial quantity of window blinds, which I could not resist."
**John Garrett**

"The actual making process can be an improvized response to the materials, in an effort to work with them in a 'collaborative' way rather than imposing on them."
**Tim Johnson**

# Comment on the importance of colour in your work

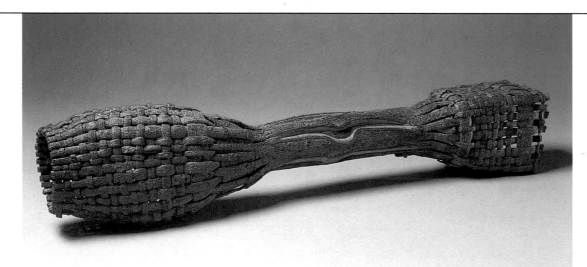

**Dorothy Gill Barnes**
*Marked by hand*
1995
Young white pine
21 x 16 x 11 cm

"I look for colour in nature. I have a series [made] of dyed wood and a piece with blue wire, but I don't really feel right about those pieces yet."
**Dorothy Gill Barnes**

"Colour is something I avoid – I'm rather scared of it. I like the subtle variations in colour of the natural materials I use. When I incorporate found objects they add tiny bits of colour, and I do use coloured wire to highlight these at times. Texture and shadows are more important to me."
**Dail Behennah**

"I am interested in making the most of the natural colour of the plants. I employ difference in natural colours or apply paint or dye only when I want to mark some specific concern. Colours are functional but not simply decorative. For example, in one basket, a brown cross in the centre is placed to enhance the lowering in the centre of the square."
**Hisako Sekijima**

"The only colour in my work comes from the colour the material has naturally. The only exception is the colour of the waxed string I tie with."
**John McQueen**

"I think it's one of the structural elements. We may use them, if there's reason to do so in our work. But thus far, I haven't had the preference to use colour in my work. I would rather use the colour of the material itself."
**Norie Hatakeyama**

**There seems to be a strong feeling for exploiting the natural colours of the chosen materials. Small exceptions to this can make a huge difference to the piece. This feeling was perhaps not so strong a few years ago.**

"The use of intense colour in India was spectacular. This experience had a great impact on my work. Once during my days as a student I decided to do a weaving using every yarn that I did not like. The result was amazingly beautiful so I learned something about colour and prejudice."
**Gyöngy Laky**

"Colour is certainly a concern in the selection of materials for my work; however, as a decision it seems to be quite subconscious and intuitive compared with other concerns. For example, during the process of deciding to use a new material, the specific physical qualities, cultural and geographical associations and abundance/availability will have a definite and conscious influence."
**Tim Johnson**

"Colour and light are the determining factors of the feeling and stability of a piece. They establish the balance, heaviness and depth."
**Jiro Yonezawa**

"Colour is an important and integral part of my visual language, suggesting mood and emotional response."
**Maggie Henton**

"I no longer use colour for its own sake, but as a means to expose the inherent qualities of the materials used and highlight the form and structure of the piece. Previously, colour acted as a concealment of these qualities. With chair cane, for example, each side of the material absorbs dye at a different rate. The dye highlights the material's double-sided nature. Traces of dye seep into minute cracks and natural aberrations on the protective outer surface, compared to the unimpeded absorption of the inner fibres."
**Shuna Rendel**

"At first I was concerned that if I was no longer dyeing materials I would not be able to get as much colour into my work. But this has not been a problem as much of the packaging that I use is highly coloured. Now quotidian waste materials such as juice cartons, corks, plastic bags and bottles, cans, telephone wire, newspaper, cardboard, bottle tops and anything feasible are the challenge and the inspiration for the work."
**Lois Walpole**

"In keeping with my Norwegian heritage, I work in a subdued palette of rose, peach, lavender, blues and blue-greens, and shades of grey and taupe."
**Kari Lønning**

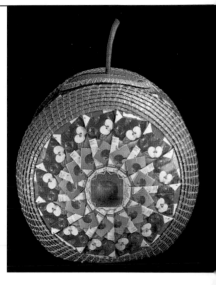

**Lois Walpole**
Apple basket
1995
Juice cartons and
cardboard
85 x 65 x 52 cm

# Are you influenced by ecological or political concerns?

As a former ecologist, I share the concern for the use of renewable resources or those already destined for destruction. The return to the hand-made, whether in natural or recycled materials, may be all that can be contributed to large-scale global problems by the present generation of artists.

"Most of my work over the past several years has been composed out of orchard debris. I am interested in making a small dent in changing attitudes about what is waste to be discarded and what is material for useful purposes. It seems that garbage, as beauty, is in the eye of the beholder. In my early work I experimented with using what was generally considered trash – I called it my industrial harvest. One motivation was clearly economic – the stuff was free – but another was the emerging environmental consciousness of the 1960s and 1970s and the concern about recycling that came with it."
**Gyöngy Laky**

"In these [Asian] countries, most of the villagers grew up as part-time bamboo craftsmen or craftswomen. They knew the ecological balance of their bamboo forest. Their approach to the material was entirely different from our modernized society. I was deeply impressed with the attitude of basketmakers living in these countries."
**Ueno Masao**

"The rattan was being cut from virgin tropical forest, fumigated, milled and shipped from South East Asia to Europe, where it was being distributed by road to suppliers and then posted to me. I was then putting poisonous dyes on it and pouring the dye residue down the drain. At first I was concerned that if I was no longer dyeing materials I would not be able to get as much colour into my work. But this has not been a problem as much of the [recycled] packaging that I use is highly coloured."
**Lois Walpole**

**Ueno Masao**
*Cut the woven circle*
1996
Bamboo
92 x 36 x 101 cm

**Gyöngy Laky**
*Affirmative no. 2*
1996
Finished pine and orchard prunings, dowelled
36 x 36 x 36 cm

# Do you need the stimulus of deadlines or the prospect of an audience in order to produce work?

**Jiro Yonezawa**
*Cascade*
1997
Bamboo
22 x 63 x 35 cm

"My working style is that of proceeding to the next step based on what I had done up until then. So I don't need outside pressures in my work."
**Norie Hatakeyama**

"I try to make regularly one basket in one month, unless I need to travel or write articles."
**Hisako Sekijima**

"The need to produce finished pieces (for exhibitions, commissions *etc*) is in a way a hindrance to the longer-term development of my work. Its development is not necessarily one of refining but of continually questioning, pushing the boundaries of what I know, and of what I am able to do. The pressures, deadline imposed, cap this continuous exploration and its process of discovery, but in turn force out resolved moments which act as markers of development."
**Shuna Rendel**

"My desire to handle materials, solve problems and construct something interesting are the driving forces behind my work. Not physically making work is frustrating. Deadlines merely concentrate the mind."
**Alex Bury**

"Without a venue in which to exhibit my work and feedback from an audience it would be difficult to push myself. The challenge of a solo show and the feeling that I need to continue to create new and different work are motivations for me."
**Jiro Yonezawa**

"I have noticed over the years that my most innovative works and new directions in thinking come from time which is uncommissioned, unburdened and free of expectations."
**Gyöngy Laky**

**Deadlines, the client, the exhibition, the need for bread and butter spur on the completion of pieces, but unfettered time for serious thought and playing allows for changes in the nature of the work.**

**Tim Johnson**
*Kelp*
1997
Kelp
left: 23 x 28 x 170 cm
right: 22 x 30 x 185 cm

"Deadlines are stressful but help me to focus on finishing pieces. Of course, it's a pleasure to see work installed well and appreciated by others."
**Dorothy Gill Barnes**

"I buy my groceries and pay my rent by making baskets and selling them. That is all the pressure I need."
**John McQueen**

"Ideally, I would like to develop new work without the pressure of deadlines, but there never seems to be time to do this. I have a lot of unexplored ideas, but as my baskets take so long to make I can't afford to take risks if a deadline is looming."
**Dail Behennah**

"During 1998 I returned to a very different creative environment, studying for a sculpture MA. Working outside the deadlines of exhibitions and residencies, which have become very familiar over recent years, has provided me with a very different work experience. The pressure has changed from the public to the institutional, acclimatization is difficult and raises awkward questions: Who is the work for? Why do I make it? Is it better to make it more or less?"
**Tim Johnson**

# How important is isolation to the development and completion of your work?

"I made a woven circle in the lake. Two students and the American sculptor Roy F. Staab helped me. In October 1996 I made the same woven circle. Six assistants from the museum helped me. At the same exhibition I made another woven circle. Students from the graduate school of Shibaura Institute of Technology helped me this time. I depend on the global heritage of mankind and reflect present society. I like to make my work with the help of people in the community."

**Ueno Masao**

**Ueno Masao**
*Circle in the water*
1996
Bamboo
100 m diameter

Many of today's makers influence each other. Most of the artists were influenced by small, personal events: this is perhaps in keeping with the apparent 'domesticity' of much basketmaking. The discovery of techniques has often been the pointer towards artistic development; the major issues of our time perhaps less so. But a number of our artists appear to have been touched by the historical, whatever their relationship with tradition.

"The creative process is, on the whole, a very private one; the concentration required excludes the external. But I value the dialogue with my peers, the stimulus of audience, and intelligent criticism."
**Maggie Henton**

"I work by myself. Isolation is necessary to think in depth and concentrate to find out what I become conscious of in what moment. I don't want to miss any subtle moment of revelation, because I know this might be the time I get into a new way of looking at things."
**Hisako Sekijima**

"I like to work alone. The big work usually is done outdoors or in my garage/studio. I do like to have certain people see the work near the completion. Because the pieces are so different from each other I must risk … some pieces are not good!"
**Dorothy Gill Barnes**

"I work alone out of choice, for maximum concentration. Working in isolation as I do, I am constantly questioning, doubting, as well as enjoying, my work."
**Alex Bury**

"I work every day in my studio. I teach workshops only from time to time. Is this isolation? It is lonely in the studio but that is how I believe it should be. It has to do with concentration. I feel lucky to be able to do this."
**John McQueen**

"Assessing one's own work is one of the hardest things, and someone else's response can often open up different understandings."
**Shuna Rendel**

"I usually work alone and this is essential for the one-off pieces. I am happy being alone and this is one of the reasons that I am suited to being a craftsperson."
**Dail Behennah**

"I dare not be isolated."
**Norie Hatakeyama**

**Gyöngy Laky**
in her studio

"When I am doing individual pieces in my studio I work alone (though sometimes I work with one or two studio assistants as well). On the other hand, once every year or two I like to have a major project, often outdoors, which is possible to achieve only by working with several other people. I enjoy both immensely and seem to desire both circumstances."
**Gyöngy Laky**

# Techniques

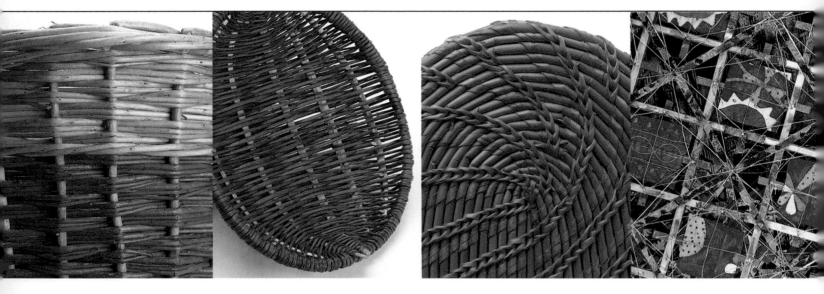

From left to right:

**Stake and strand**

**Frame baskets**

**Coil**

**Interlace**

**Assembly**

**Plait**

**Twine**

**Knotting, netting, linking and looping**

# Techniques: Stake and strand

**Marianne Seidenfaden**
*Bull*
1995
Willow
140 x 80 x 336 cm

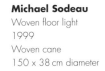

**Michael Sodeau**
Woven floor light
1999
Woven cane
150 x 38 cm diameter

**Roland Seguret**
Société Coopérative
Agricole de la Vannerie,
Villaines
*Egrappoir*
1998
Willow (*triandra* and
*viminalis*) and cane

**Jenny Crisp**
Set of trays
1999
Willow, hazel, oak,
damson, ash, beech
78 x 130 cm

**Owen Jones**
Oak swill basket
1998
Steam-bent hazel rim,
oak boiled and riven
30 x 70 x 90 cm

# Techniques: Stake and strand

**Peter Rogers**
*Teddy bear bridge*
(1:50 scale model of
steel bridge)
1997
Brass strip and copper
rivets
33 x 80 x 80 cm

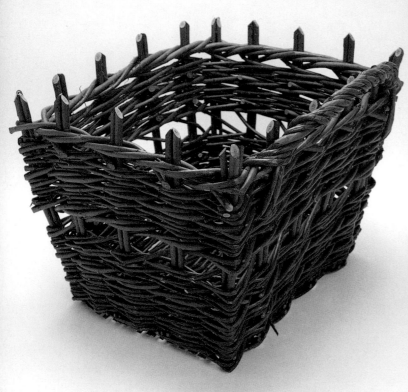

**Joe Hogan**
Donkey creel
1998
Brown willow
61 x 46 x 46 cm

**Anna-Maria Väätäinen**
*Through that time*
1998
Unstripped willow, wild
and cultivated
145 x 32 cm

**Keiko Takeda**
*Urban air*
1998
Reeds, cane, copper and
electric wire
35 x 20 x 18 cm
58 x 18 x 15 cm
22 x 30 x 15 cm

**Michael Davis**
*Flower series – yellow
dahlia in blossom*
1997
Reed, acrylic and
enamel paint, quilting
pins, tin
48.2 x 72 x 72 cm

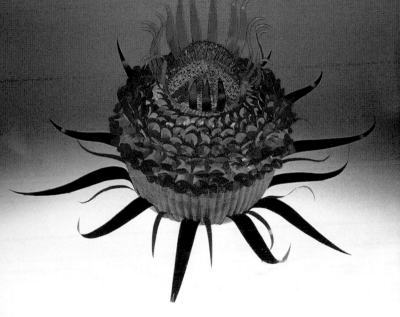

**Jackie Binns**
*Pink thistle basket*
1997
Buff willow and re-used
plastic
180 x 100 x 100 cm

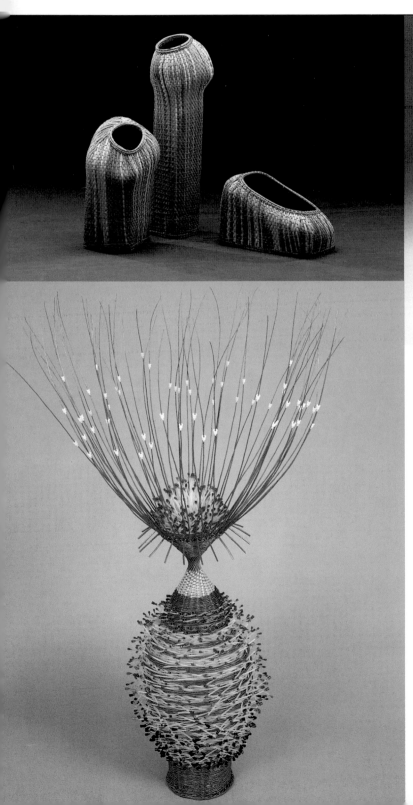

75

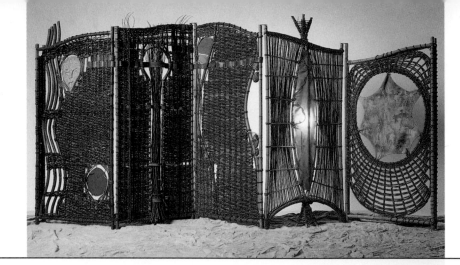

**Johann Bachinger**
*Paravent*
1997
Willow, glass, leather,
stone, electric lighting
180 x 500 x 15 cm

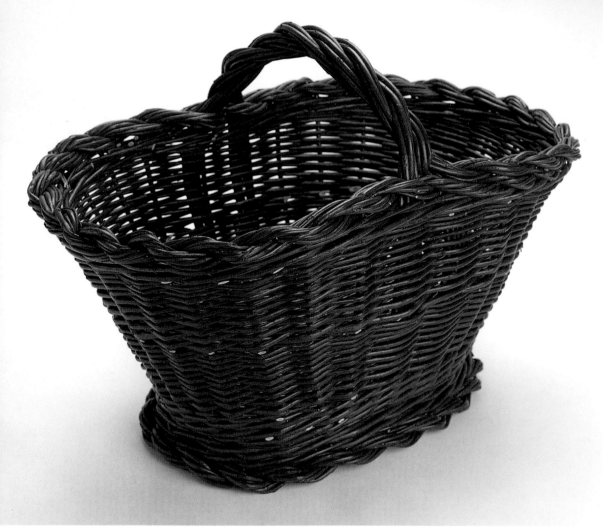

**Mike Smith**
Roped border arm basket
1998
Willow
14 x 20 x 13 cm

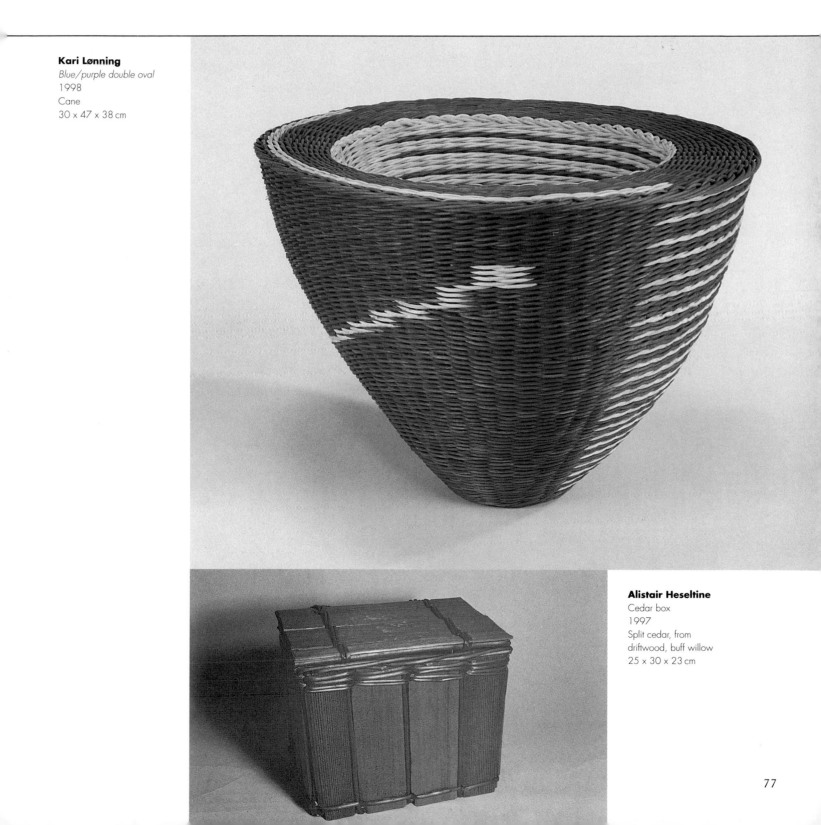

**Kari Lønning**
*Blue/purple double oval*
1998
Cane
30 x 47 x 38 cm

**Alistair Heseltine**
Cedar box
1997
Split cedar, from
driftwood, buff willow
25 x 30 x 23 cm

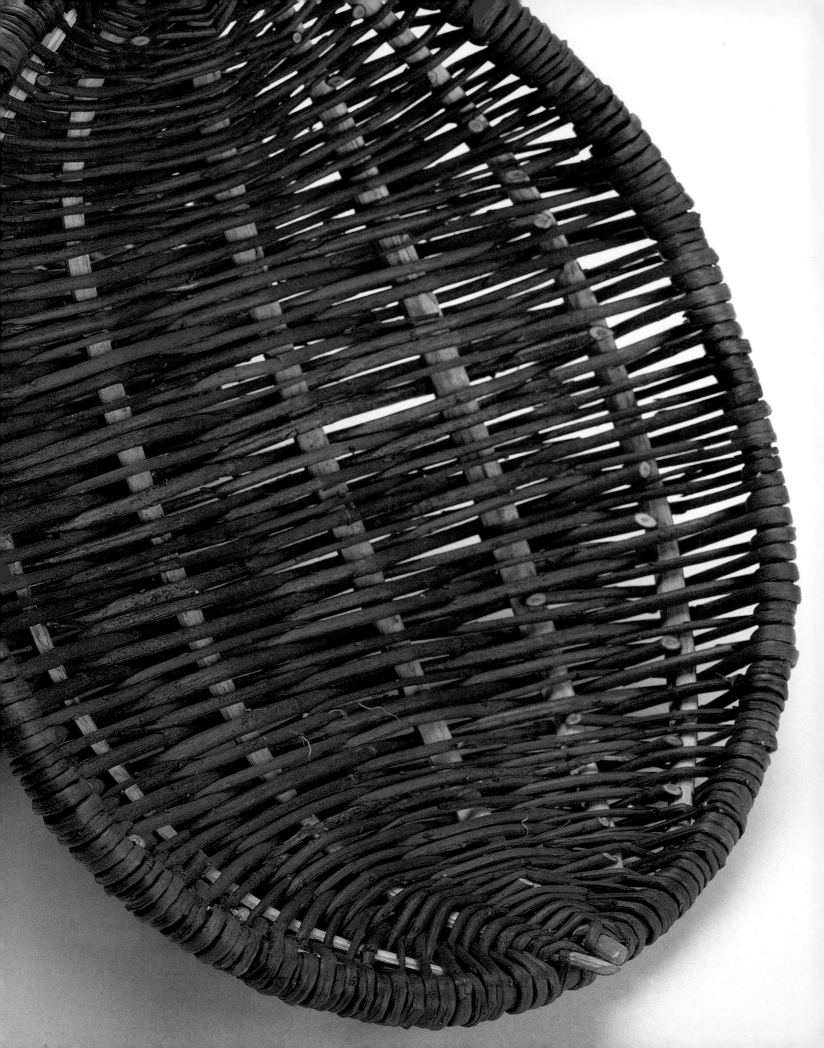

**Alison Fitzgerald**
Small sciathóg, detail
1998
Mixed willows
30 x 7cm

# Frame baskets

In the context of the exhibition these have been included in the 'Stake and strand' section, since they have in common active elements passing over and under passive ones. In a frame basket an additional feature is a hoop or hoops which determine the basket's form. The most common arrangement involves a top hoop or two hoops at right angles to each other, one forming the handle and centre point on the base of the basket, the other the top rim. Weaving begins at the junction of the two hoops, where passive elements, or ribs, are inserted and then used as a skeleton for the weaving. There are many arrangements of ribs, the lengths of these being the key factor in determining the profile of the basket and therefore its volume. The split spruce root basket shown here, with a central rib and an oval top hoop, is a form found across Europe, the pine root example being a less common rib arrangement seen in frame baskets from the Cevennes to the north-west coast of France and elsewhere. The traditional Irish sciathógs by Alison Fitzgerald have an even number of ribs, but with a different arrangement, one being the traditional form from Roscommon, the other from Longford, a good example of the regionality of much work. Broad principles may be the same, but each village or district had its own characteristic weave pattern. In the majority of frame baskets the weavers and ribs are of unequal weights, the passive elements being either wider (for flat material) or thicker (for round material). The oak swill from Cumbria, a traditional basket that is now the speciality of Owen Jones, has weavers and ribs similar in width and apparently similar in weight, but in practice, the curved form is achieved as a result of the ribs being heavier. In Europe, frame baskets were made outside the mainstream industry by farmers and villagers for their own use, a fact reflected in their individuality.

**Jonas Hasselrot**
Frame basket
1998
Spruce root
12 x 31 x 20 cm

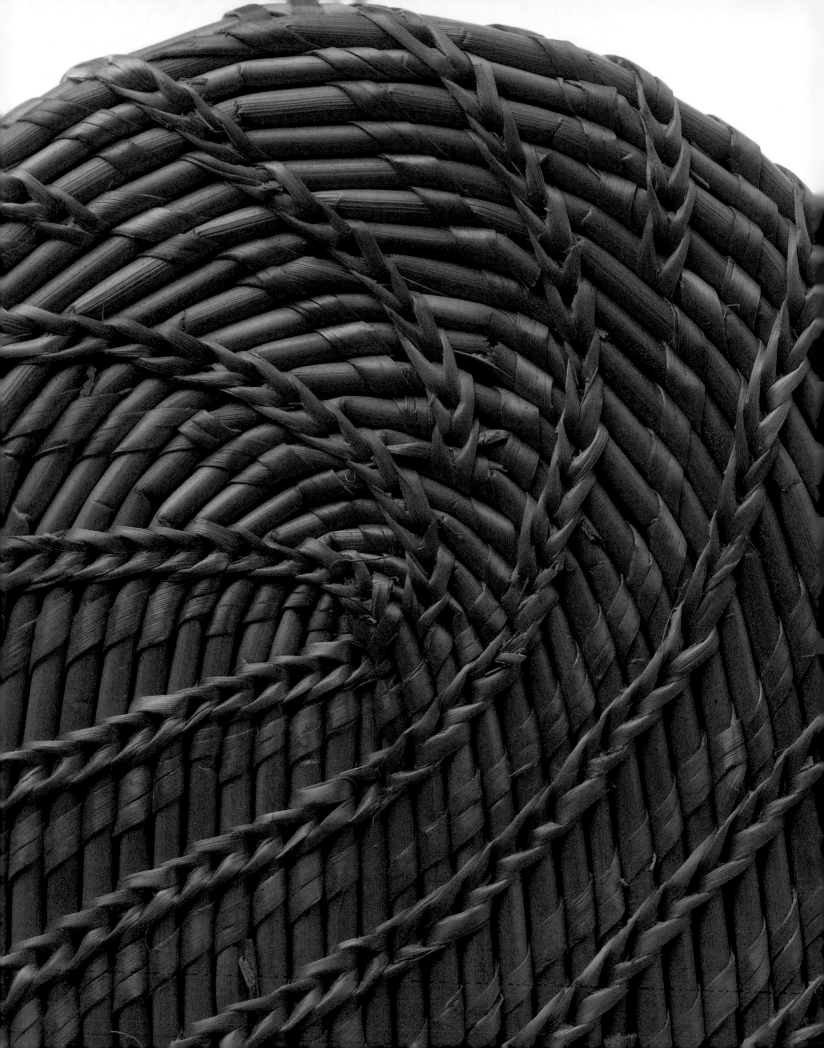

Lid of grass basket,
detail
Orissa, India
1998
5 x 15 x 10 cm

**Contemporary International Basketmaking**

# Coil

Coiled baskets are made by using a single passive element (or group of elements), which is coiled and held securely by an active element (or group of elements). The passive elements are called the core or foundation and the active is the sewing thread, winder or stitching material. A wide number of variations are possible. The core may be of one or more strands, may be hard or soft, and may be spaced out so that one coil is at a distance from its neighbours. There are also a number of sewing stitches that allow for different densities of stitching and simple or complex pattern formation and a variety of surface textures.

The materials used can range from roots of spruce, larch, pine in the Northern Hemisphere (from the USA and Canada, across Scandinavia and into the Baltic states), to leaves such as yucca, split palm leaves, pine needles, grasses, raffia, rattans, split willow, hazel and many others. All these materials must be prepared before use, by being soaked, peeled, split, sorted or dyed, according to the needs of the weaver. Coiling techniques are extremely slow, particularly if decoration is applied to the outside surface, as in the imbricated baskets of the north-west USA, but such baskets do not need the work space of other techniques and may be picked up and put down as time allows. Completion of traditional pieces may take months or years.

The baskets and contemporary structures made of coiling may be rigid and impermeable, or quite flexible and open. The Latvian lidded baskets in the exhibition use finely split willow called skein, and are rigid structures, using a single core of whole willow and each using a different stitch. Edite Laivina's is one traditional to Latvia, while Dzidra Birkenfelde's is her own innovatory method. The coiled stitching on Dail Behennah's basket has been arranged so that the placing of every stitch, as well as being decorative, is essential to the arrangement of the poleuti cane (a rattan) foundation, whereas Sally McIntosh's coiling involves less formal stitching around the core built-up of many raffia threads. The Hungarian rush basket with ceramic form is traditional, for the storing of dried plums, and uses a stitch that creates a smooth appearance. The tools used for coiling are very few: a knife for cutting material, and an awl or needle (often of bone) for sewing. The cleave, shave and upright are used across Europe for splitting willow and other hard material. Where softer materials are involved, knives, fingers and even teeth are used for splitting.

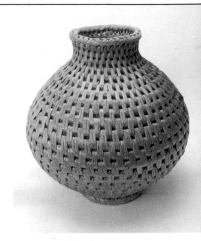

**Hanis Janos**
Hungarian storage basket
for dried plums
1995
Rush coiling
38 x 37 cm

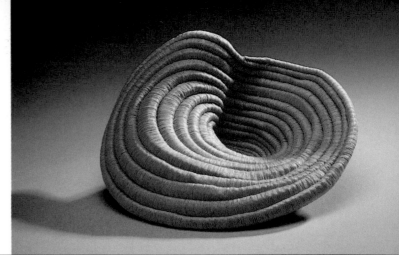

**Joleen Gordon**
*New piece 1998–2*
1998
Waxed and polished
linen threads
10 x 19 x 17 cm

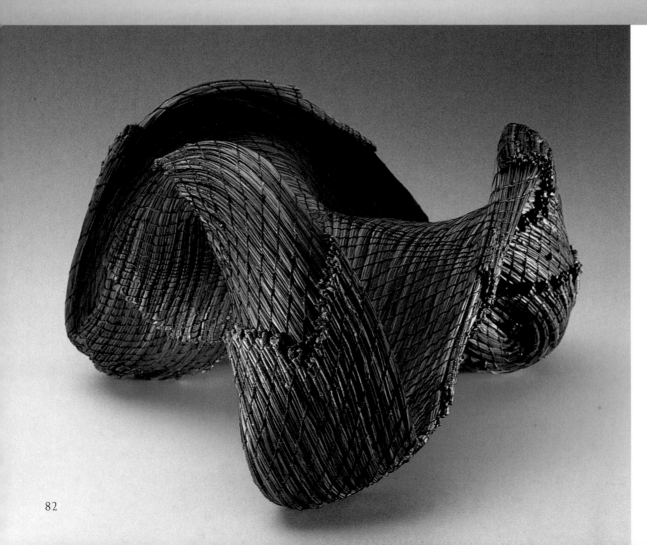

**Dail Behennah**
Long coiled dish
1998
Poleuti cane, copper
wire, crimps
6 x 99 x 18 cm

**Clay Burnette**
*Tri's wide open*
1998
Dyed and painted long-
leaf pine needles,
waxed linen, antique
glass seed beads
25 x 39 x 39 cm

**Dzidra Birkenfelde**
Latvian lidded basket
1995
Whole and skeined
willow
9 x 12cm

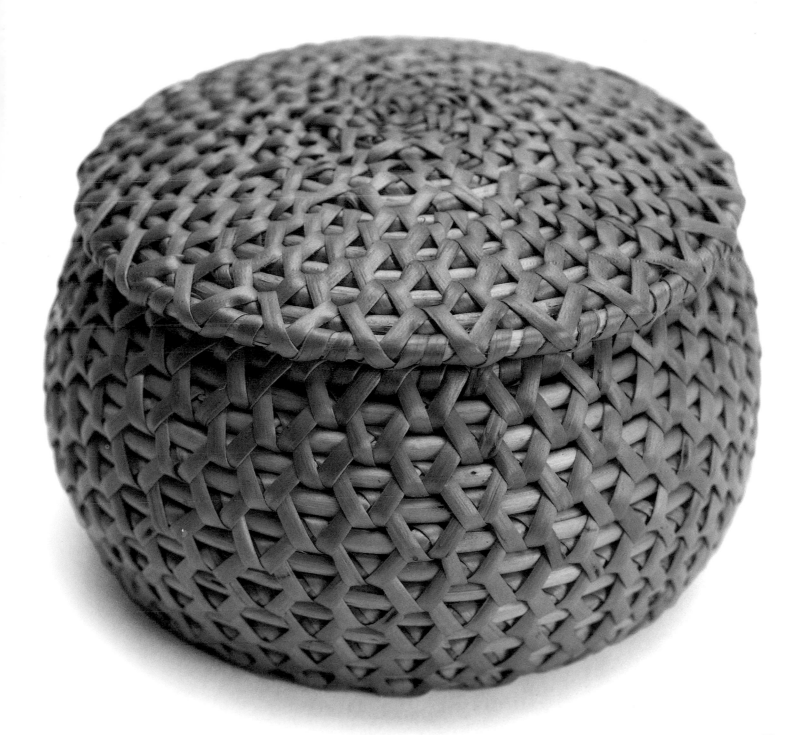

# Techniques: Coil

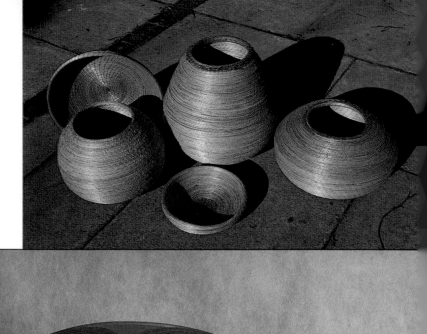

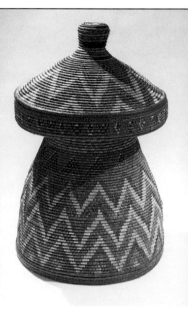

**Shoa District Weavers**
Messob or Ethiopian
marriage table
1998
Dyed and natural grasses
Coiled
85 x 57 cm

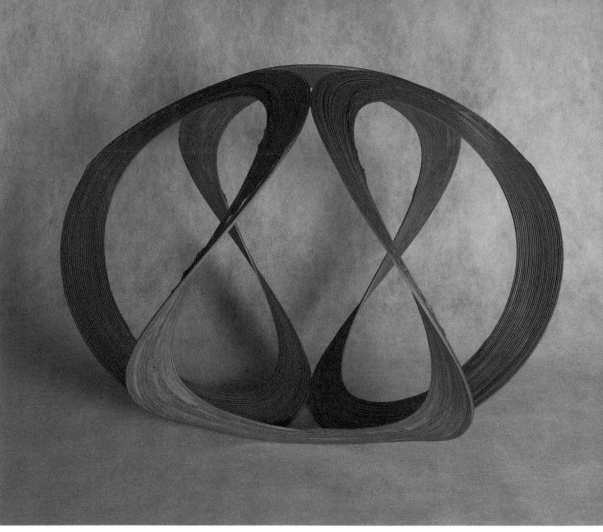

**Ueno Masao**
*Minimal surface 3*
1998
Bamboo
31 x 51 x 51 cm

**Molly Rathbone**
Star grass pots
1996
Marram grass and pine
needles

**Mary Giles**
*Dusk/dawn*
1998–99
Waxed linen, copper, iron
91 x 9 x 51cm
Base: 89 x 16 cm

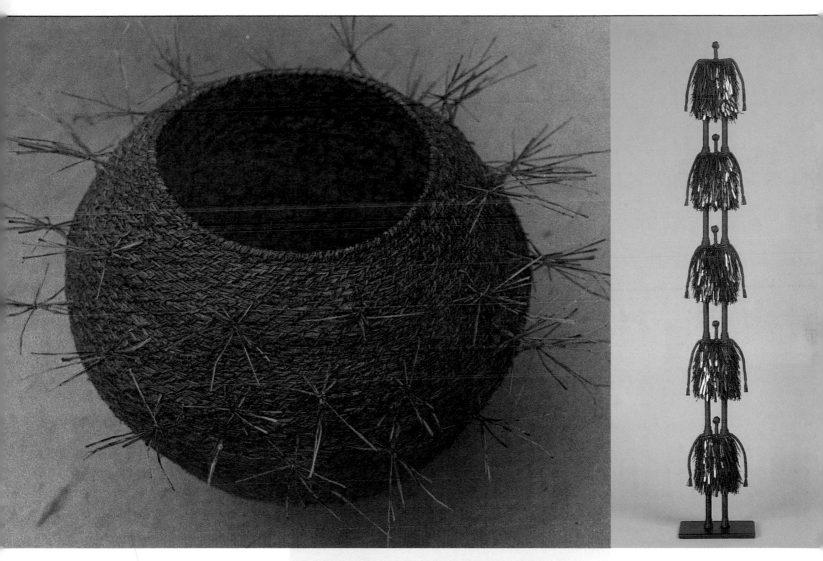

**Sally McIntosh**
Spikey raffia basket
1998
Raffia
26 x 31 cm

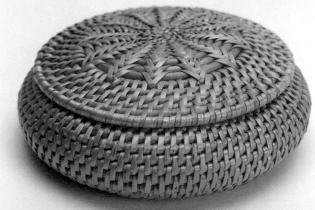

**Edite Laivina**
Lidded basket
1993
Whole and skeined
willow
7 x 17 cm

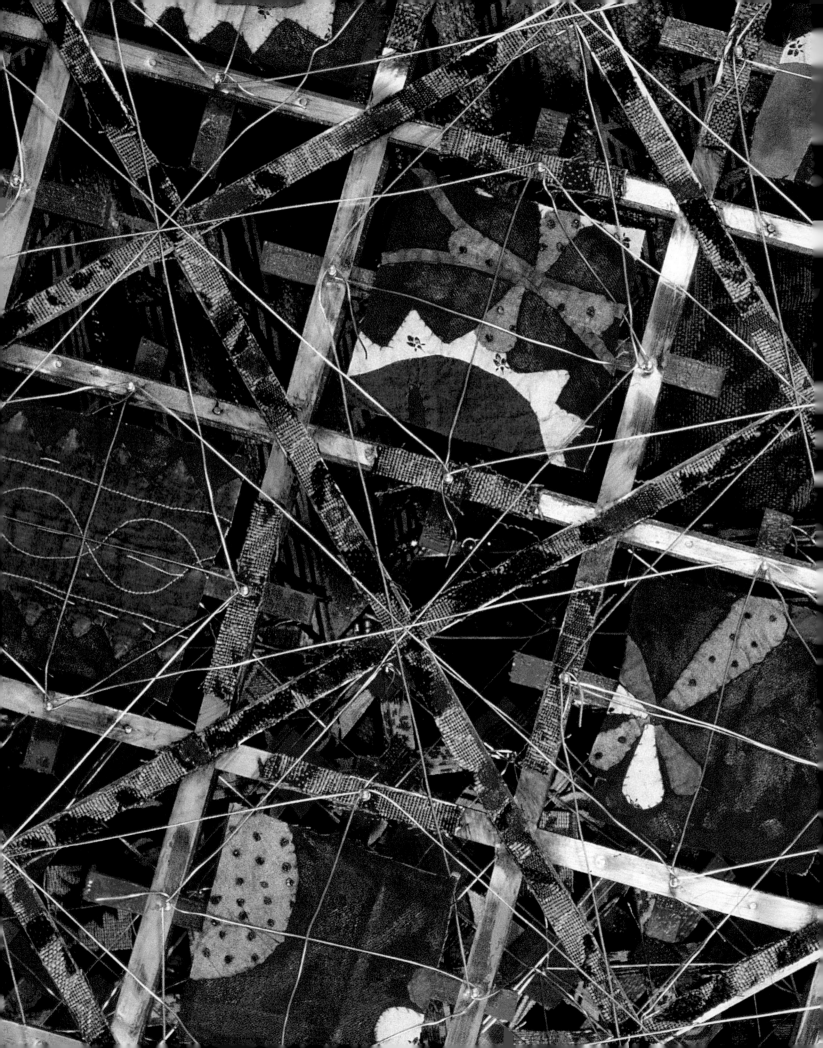

**Michael Brennand-Wood**
*Slow turning*, detail
1989
Fabric, thread, wire, metal,
acrylic, oil and wood
200 x 200 x 12 cm

# Interlace

Most basket structures are 'bound intricately together' or 'cross each other intricately'
as defined in the Pocket Oxford English Dictionary. In the context of this exhibition,
however, interlacing has been used to describe structures formed of a series of long
pieces of materials that are bound round each other in apparently random distribution
to form a hollow structure with an external and internal mesh, without a formal
arrangement of loops and knots. Structures such as Lizzie Farey's willow balls may be
built on a foundation of three rings of approximately similar circumference, tied top and
bottom and arranged at 60° with further willow rods curved in and out of this central
core, which disappears as the woven density increases and the string is removed. Many
such randomly woven structures are built on base rings. Michael Brennand-Wood has,
in much of his previous work, interlaced short lengths, creating a rigid grid into which
more flexible units are wound to form a secondary, less formal, overlay, but here the
interlacing is minimal, and the elements appear to stay together by effort of will only.
Christine Joy bundles her willows and then spirals them to tie informal knots. It is
tempting to think that traditional carriers would have been built in this way, short-lived
containers for light objects easily made of any liana-like material, although in many
cultures these would have become formalized as open hexagonal plaiting.

**Lizzie Farey**
Willow and birch ball
1999
Willow, birch
220 x 170 x 170 cm

Japanese basket
Early 20th century
Split bamboo
23 x 12 cm

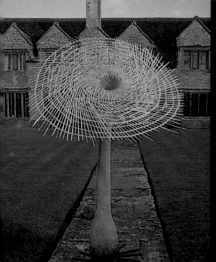

**Hisako Sekijima**
*Resilience V*
1997
Willow (grown by
David Drew)
10 x 54 x 54 cm

**Chris Dunseath**
*The Einstein–Rosen Bridge*
1988
Limewood and ash
veneer
220 x 125 x 110cm

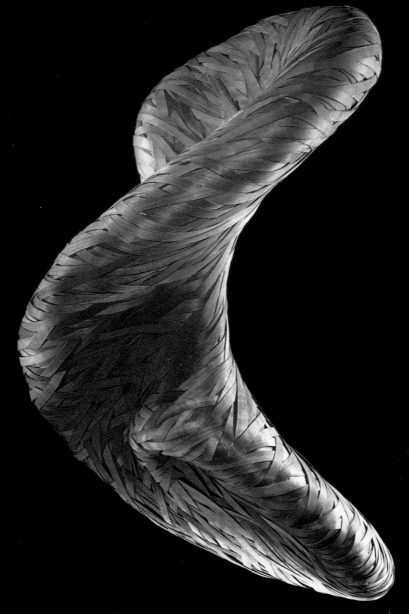

**Barbara Cooper**
*Sonus*
1995
Wood
94 x 147 x 71cm

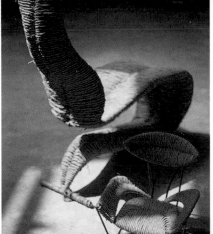

**Tom Dixon**
*'S' chair*
1988
Bent steel frame with
woven cane seating
100 x 50 x 60 cm

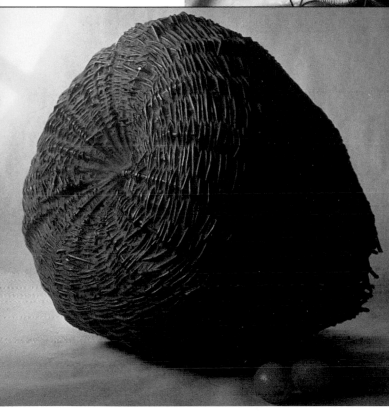

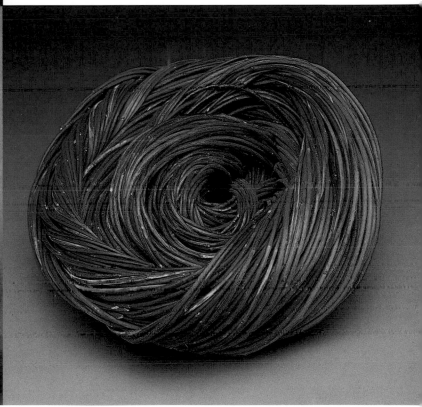

**Valerie Pragnell**
*Red earth pod II*
1998
Willow, flax, straw,
papier mâché, red
earth
84 x 69 x 3 cm

**Christine Joy**
*Fruit*
1996
Willow and red
dogwood
18 x 38 x 36 cm

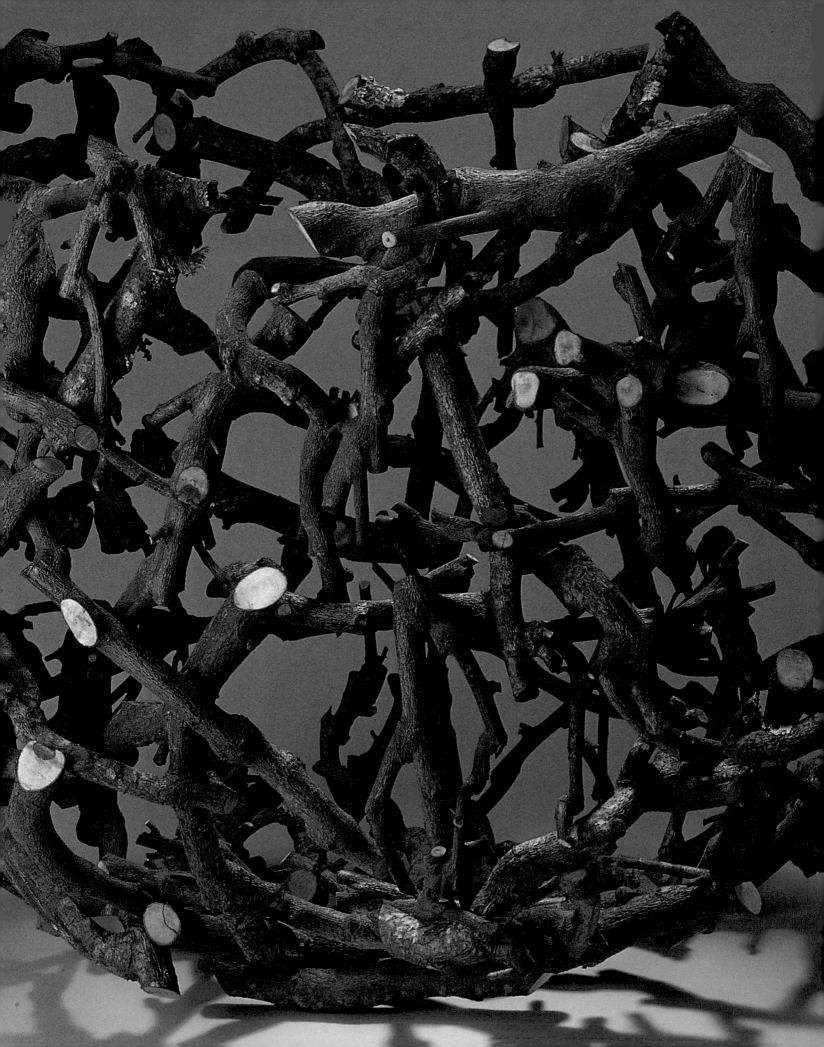

**Gyöngy Laky**
*Valley house,* detail
1998
Plum prunings with
sheet rock bullets
Openwork distorted
grid structure
48 x 61 x 41 cm

# Assembly

In Europe there is a tradition of making a small number of baskets by attaching pre-formed pieces, usually by nailing or lashing, into a basket form. In England the trug is a basket formed of split willow slats on a hazel rim and with a hazel or chestnut handle, and in France they have a basket of willow slats especially for Jerusalem artichokes, the topinambour. These are both also frame baskets and nails are used for attachment. Contemporary makers may use nails in a different way, as prominent elements making a political statement, as in Gyöngy Laky's pieces, which use prunings. Dail Behennah constructs her grid systems with careful time-consuming ties of bell wire, which is thicker than the telephone wire of her coiled forms.

Some of these, such as Dail Behennah's, have a formality in their construction, with careful control of depth and positioning of colours, while James Marston's ash bases are pieces cut, dressmaker style, from boards planed on one side only, to avoid 'knots, shortgrain, ripple, stains and splits' (Marston 1998), which might provide irregularity. Laky's, although apparently random, have all the prunings carefully positioned, drawing on forms of construction: "That part of human endeavour which is folded, whittled, tethered, twisted, wrapped, wrinkled, braided, bound and bandaged for millennia" (Laky 1998). The two assembled structures of Behennah and Laky create exciting shadows, with shading and depth, a feature of importance to both artists, as are the spaces left between pieces.

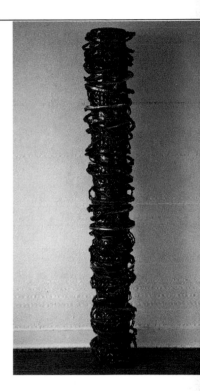

**John Garrett**
*Memorial*
1997
Copper, steel, brass,
wire, beads

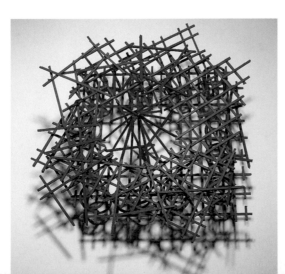

**Michael Brennand-Wood**
*Cloud collar*
1998
Wood, string,
acrylic, light
100 x 100 x 50 cm

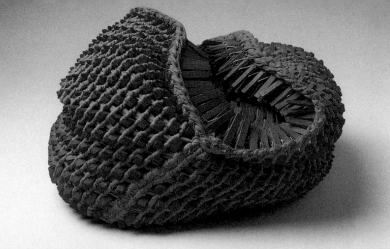

**Karyl Sisson**
*Vessel XXI*
1994
Cotton twill tape,
thread, miniature wood
spring clothes-pins
18 x 41 x 36 cm

**James Marston**
Ash basket
1999
Ash, copper, steel
40 x 36 x 36 cm

Thomas Smith's trug workshop,
Herstmonceaux, East Sussex
1996
Cricket-bat willow and
chestnut

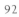

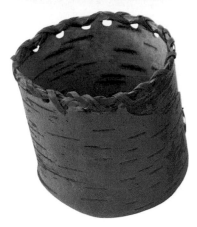

**Màza Geipele**
Birch bark pot
1995
Birch bark; stitched with
birch bark
10 x 8.5 cm

**Alex Bury**
*Flip-side*
1998
Matt laminate, silk
paper, linen thread
16 x 48 x 45 cm

**Markku Kosonen**
*Spiral*
1996
Willow
39 x 43 x 43 cm

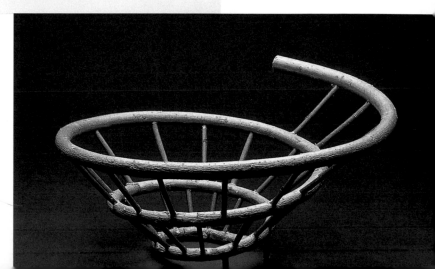

**Alex Bury**
Plaited bag, detail
1993
Acetate, film and
monofilament, film gel,
staples
4 cm wide strips

# Plait

This is a form of basketry in which all the elements are active. Strips of flexible material pass over and under each other at definite angles and are not held together in any other way. Usually all the elements have the same flexibility. Simple plaiting involves a weave of over one, under one (1/1) although each set may have more than one element, the elements in a set being worked together. This form of plait is also known as check weave and plain weave. In more complex twill plaiting, one set of elements passes over and under two or more in the other set (generally 2/2, 3/3 or 4/4), this also being known as twilling, diagonal or bias plaiting, and herringbone weave. Plaits may be flat or round strips and involve any number of elements from two upwards.

Plaited artefacts are found all over the world. In England, rush mats have for centuries consisted of strips of plaiting 9 cm or so wide, using eight or nine elements, stitched side by side. In Papua, New Guinea, complex bias or twill plaited structures act as spirit traps, and Joanna Gilmour's paper plaited vessels explore Pacific palm-leaf hats and baskets. Open, hexagonal plaiting is much used in Bali and other parts of South-East Asia, India and China for carrying pigs, hens, for trapping rats and for many domestic purposes. The colourful Mexican finger traps found in many of our shops have versions to be found, until recently, in the catalogues of Hungarian medical suppliers for the realignment of dislocated fingers. Diagonal plaiting provides opportunity for turning corners and so allows for highly complex, unexpected structures.

The plants used for plaiting must be suitable for preparing as strips, either splitting into fine, semi-rigid elements such as bamboo and rattan, or into flexible strips, such as *Phormium tenax*, the New Zealand flax used by Maoris for their traditional plaited kete bag, or the *Pandanus* species used in Hawaii and elsewhere in the Pacific. In Europe and elsewhere, *Schoenoplectus* (*Scirpus*) species are used for strips of flat plait. Again, basketmakers make use of any suitable local material, Susan Garrett Wright's flavour trap of polypropylene tape and sweet-wrappers and Susan Jamart's grosgain ribbon both fitting this pattern.

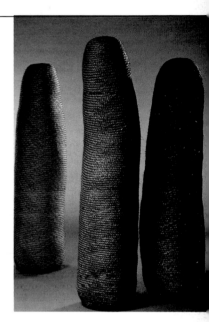

**Linda Kelly**
*Form 9.1.3*
1998
Flat reed splint
166 x 41 x 44 cm

# Techniques: Plait

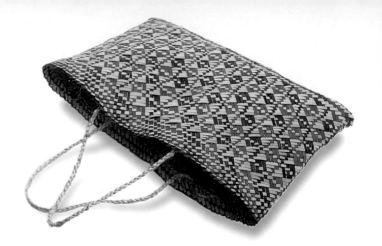

**Kahu Te Kanawa**
*Kete*
1998
New Zealand flax,
*Phormium tenax*
32 x 22 cm

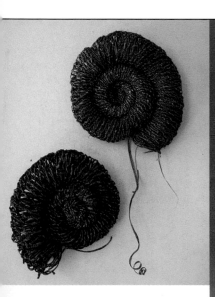

**Molly Rathbone**
*Bark ammonite*
1998
Willow bark
56 x 56 cm

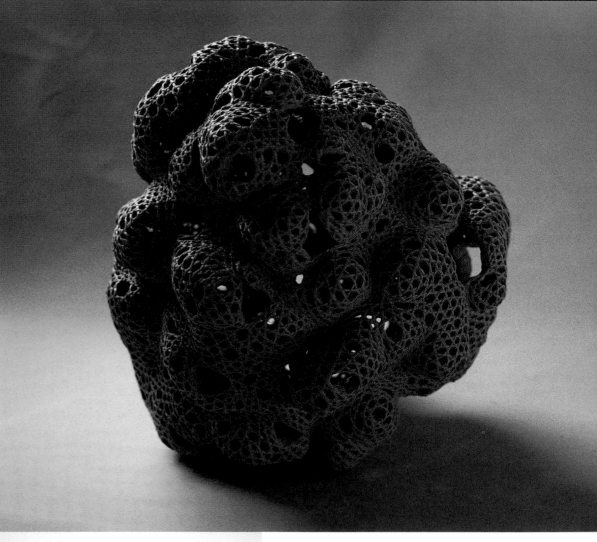

**Akru Savino**
*Angami Naga
ceremonial basket*
1998
Khophi cane
52 x 59 cm

**Norie Hatakeyama**
*Complex plaiting series –
connection 1 – 9609*
1996
Paper fibre strips 0.55 cm diameter

**Peiling Lee**
*Spiral armpieces*
1997
Polypropylene strapping
56 x 11 x 3 cm

**Norbert Fauré**
Société Coopérative Agricole
de la Vannerie, Villaines
*Panier périgourdin*
1998
Willow
28 x 43 x 34 cm

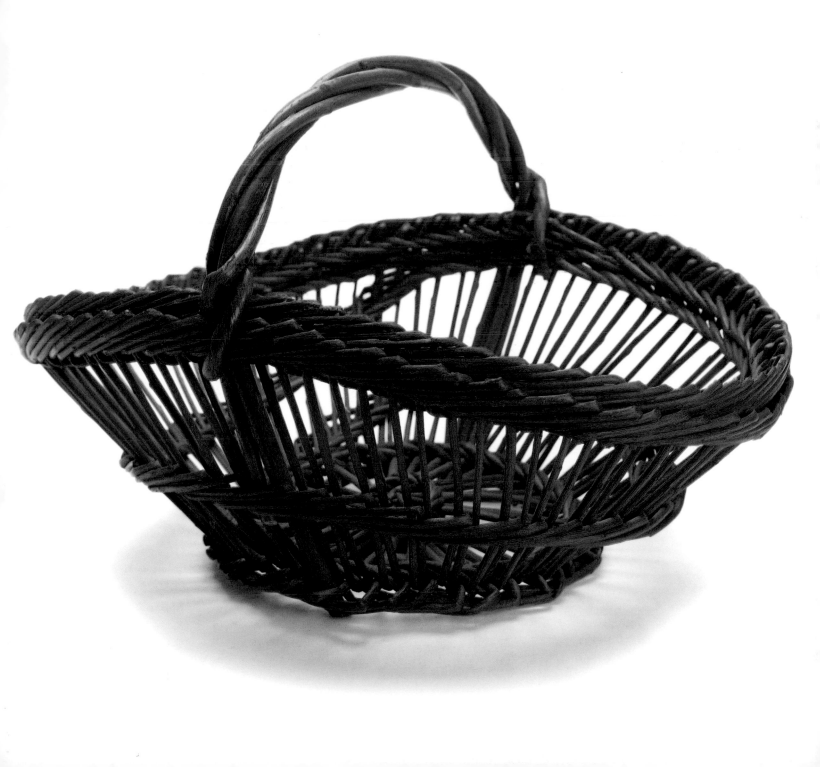

# Techniques: Plait

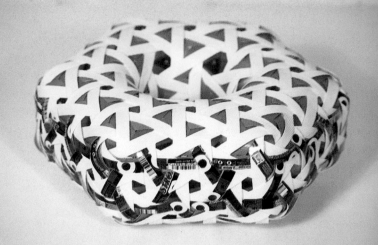

**Susan Garrett Wright**
*Flavour trap*
1997
Polypropylene tape and
laminated recycled sweet-
wrappings
12 x 27 x 28 cm

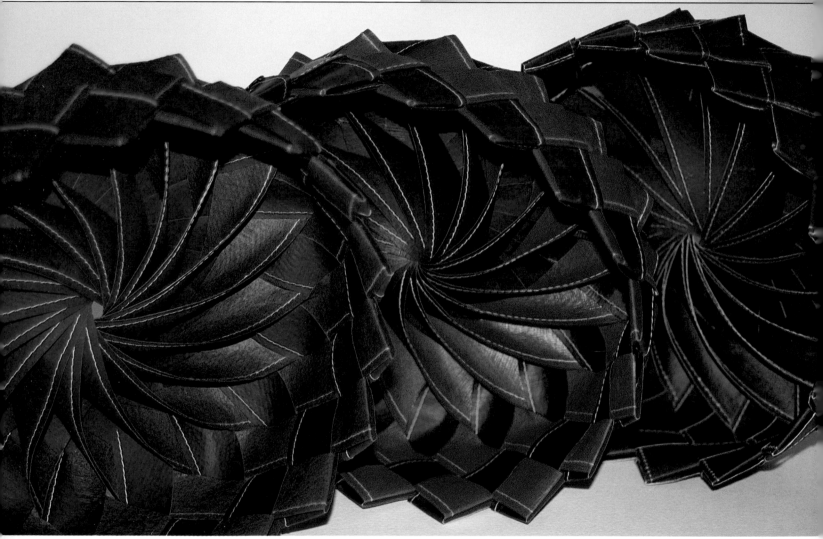

**Joanna Gilmour**
*Pinwheel baskets*
1999
Decorated Indian
paper and thread
8 x 25 cm each

**Teresa Pla Belío**
*Small cubes*
1996
Cotton
90 x 90 x 10 cm
(27 cubes of 9 x 9 x 9 cm)

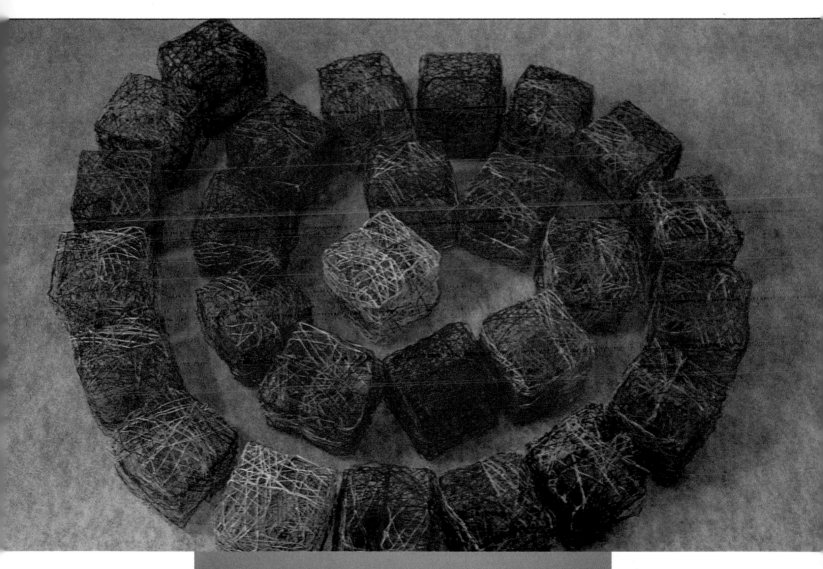

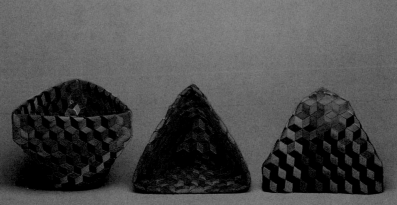

**Susan Jamart**
*When is a basket not
a basket?*
1997
Grosgrain ribbon
14 x 16 x 18 cm each

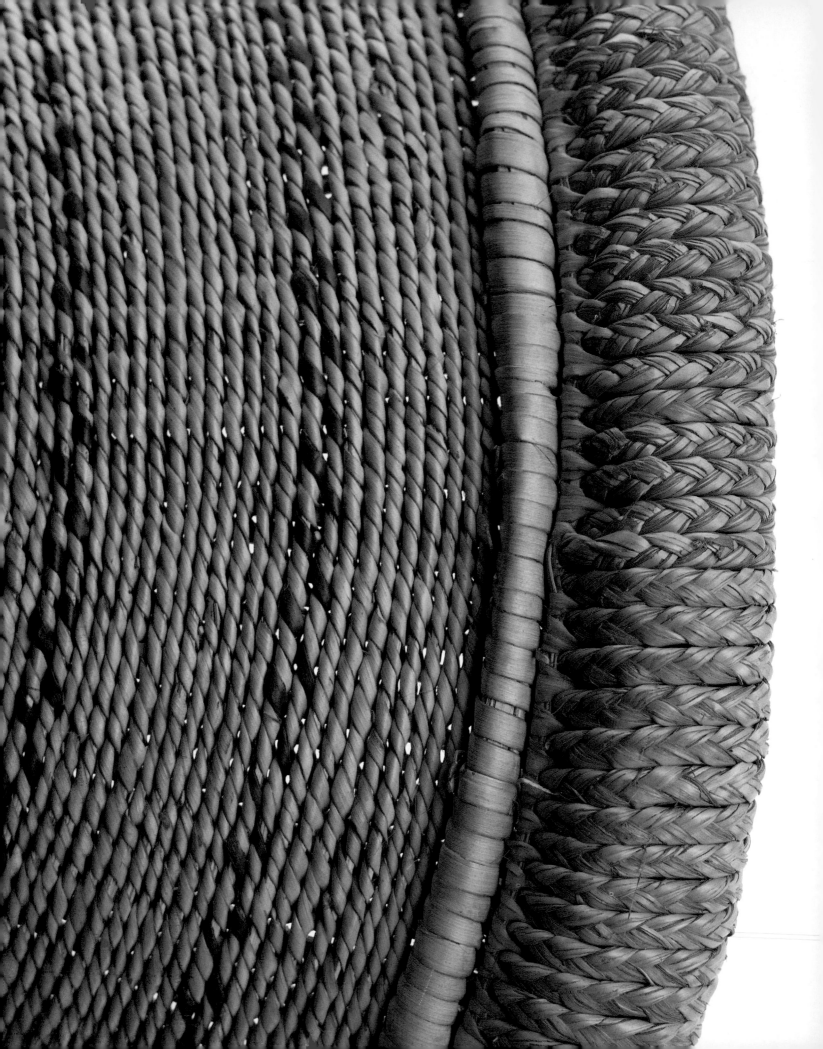

# Twine

**Laurence Copland**
*Shetland kishie*
1998
Straw
40 x 35 cm

**Myra Salayumptewa**
Hopi third mesa wicker
plaque
1991
Warp, sumac; weft, rabbit
brush; edge, yucca leaf
29 x 2 cm

In this technique, the wefts or weavers are actively moved around vertical warps, and consist of at least two separate elements. The wefts consist of groups of threads moving as one unit at right angles to the warps in such a way that they engage with one warp and the next, in sequence, which provides a way of distinguishing the weave from coiling. The weft rows may be spaced in a number of ways, may travel round one, two or more warps at one time and may slant with an S-twist or a Z-twist. The warps may be packed tightly or spaced out, and all may be rigid or flexible. Twining is another variation of the stake-and-strand technique, and a simple form of it is known in Britain as pairing. Many plant materials may be used for twining. In Australia the Aborigines use *Pandanus spiralis* and other native plants, which they split and form into threads. The Maori do the same with *Phormium tenax*, from which they extract the fibres by removing the sides of the blade to form strips of equal width, cutting across each blade at right angles to its length and then using the edge of a mussel shell to pull firmly along the underside of the leaf blade. This separates the blade from the fibres (Te Kanawa 1992: 9). Native American and other peoples also use their native plants. The Alaskan Tlingit is split into fine strands with a mussel shell or knife to make the first cut, followed by the use of the fingers and teeth to continue the split evenly along the length. In Hawaii, *Freycinetia arborea* roots have been used to twine fish traps and baskets, whole material being used for warps, or split for weft.

In contemporary basketmaking, any thread-like material may be used for twining: telephone wire and plastic string, strips of colourful polythene bag, with rigid warps of willow and wire, or soft fabric warps to produce soft structures with changeable form. It is a versatile technique with many possible surface textures, but extremely time-consuming to execute. The dilly bag, made by Elizabeth Mipilangurr in Arnhem Land, Northern Territories, Australia, took four days to weave after collection and preparation of the materials, splitting and dying with natural dyes. The South African grain basket, a detail of which is illustrated here, took even longer as the weave is so closely packed. The surface decoration of coloured bark strips is also painstaking. Much Native American work is densely woven, there being often more than seven or eight strokes of the weft threads per 2.5 cm. The baskets may also be overlaid with false embroidery or other fine decoration. Even with modern materials twining is a slow technique but worthy of further exploration as fine patterning is possible.

# Techniques: Twine

Twined aboriginal dilly
bag, detail
Maningrida, Arnhem
Land, Australia
1997
*Pandanus*
33 x 19 cm

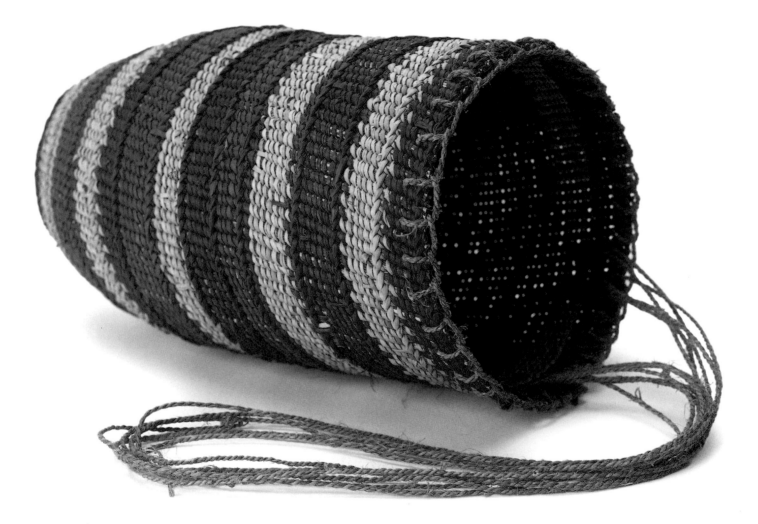

**Elizabeth Mipilangurr**
Aboriginal dilly bag
1998
*Pandanus*
33 x 18 cm

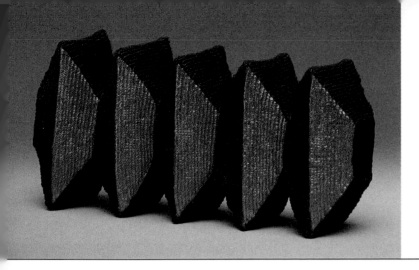

**Jan Buckman**
*Untitled # 6–5*
1995
Waxed linen and
gold leaf
9 x 18 x 5 cm

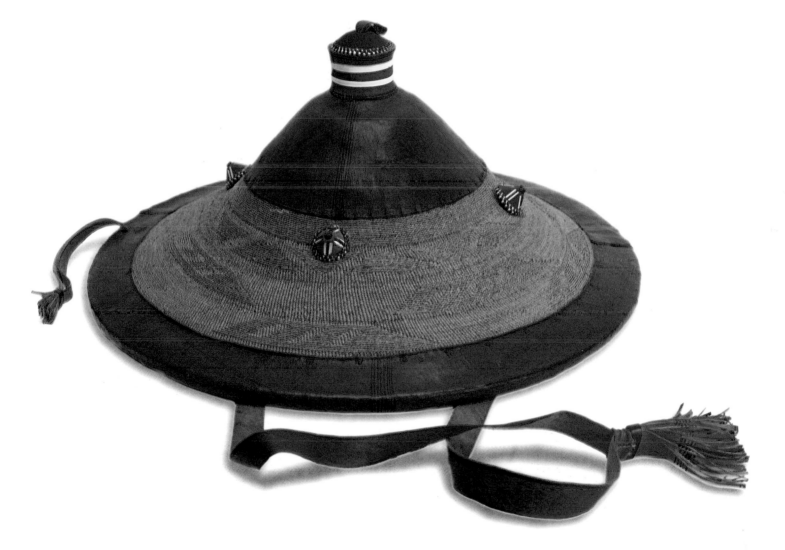

Fulani hat
1998
Grasses, leather
27 x 50 cm

**Alice
Gundaburrburr**
String bag, detail
1998
*Brachichiton
diversifolius* fibres
Looped
67 x 40 cm

# Knotting, netting, linking and looping

## Knotting

Knotted baskets and other structures are made by pulling loops tightly so that the mesh is secured. Because the knots cannot be moved within the mesh the structure has no elasticity. The final structure depends on the knot-form, the relationship to the next row, the relationships between the adjacent knots on one row, and the tension of the knot itself. Many different knots are used, including simple knots, overhand knots, hitches, square knots and many more. Jane Sauer's pieces are composed of close knots, with little space between them or the rows, to create a dense, light surface texture.

## Netting

A net consists of a fabric of loops of twine secured by knots at the intersections. The process involves a netting needle and a mesh gauge, although finger-width is often used instead, with the string wound on to the needle. The mesh gauge controls the size of the loops and therefore spacing of the knots. The mesh may be diamond-shaped or square and built into square or circular structures. Netting technique is used widely around the world for openwork structures, some flat, some shaped in complex ways for catching fish, butterflies, or as bags. Nets may be made with a wide range of plant material, including hemp, sisal, other types of Agave fibre, cotton or nettle fibre, or flax.

## Knotless netting or linking

This technique uses looping without knots. The thread is loosely wrapped around itself in such a fashion that regularly spaced meshes of simple shape are formed. The structure is very elastic.

## Looping

In this technique, loops are formed with the material, often using the fingers as a gauge, or using an eyed needle for fine fabrics. If the loops are small, the structure is dense and firm, elasticity being obtained only from larger loops. Many looped structures have complex lateral links as well as links between the meshes. However, the *shigra*, from Ecuador, is composed of simple looping, worked in a spiral from the base, the quality of pattern being determined by the number of loops per centimetre.

*Shigra*, Ecuador
1994
Agave fibre and
chemical dyes
Looped

**Norman Sherfield**
*Lucky tree*
1996
Waxed linen, stone,
bingo balls
Knotting
4 x 2 x 9 cm

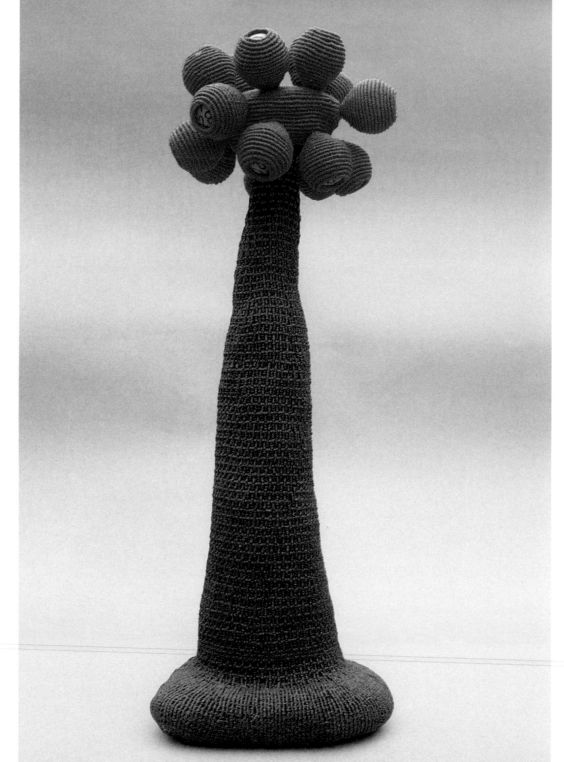

**Shuna Rendel**
Complex linking, detail
1998
Flat band cane, dyed

Knotted Aboriginal
bag, detail
Maningrida, Arnhem
Land, Australia
1998

# Techniques: Knotting, netting, linking and looping

**Jane Sauer**
*New road*
1998
Waxed linen thread
and acrylic paint
Knotting and netting
72 x 41 x 18 cm

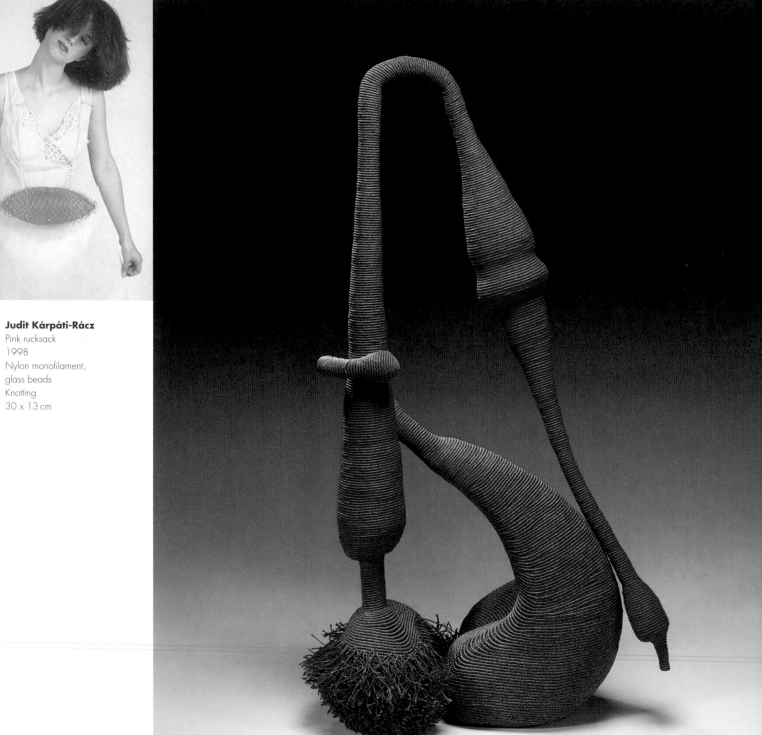

**Judit Kárpáti-Rácz**
Pink rucksack
1998
Nylon monofilament,
glass beads
Knotting
30 x 13 cm

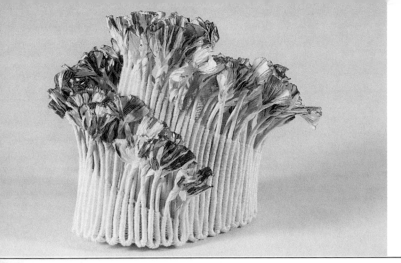

**Penny Burnfield**
*Ziggurat*
Paper string and cotton
yarn, paint and varnish
Knotting
20 x 20 cm diameter

**Alice Gandaburrburr**
Maningrida string bag
1998
*Brachichiton diversifolius*
plant fibres
Looped
67 x 40 cm

# Exhibits List

All measurements in cm,
height x width x depth.
Details correct at time of going to press.

**Johann Bachinger and Wth Regensburger, Germany**
*Paravent*
1997
Willow, glass, leather, stone, electric lighting
Stake and strand
180 x 500 x 15

**Dorothy Gill Barnes, USA**
*Marked by hand*
1997–98
Willow, wood, bark
Assembly
44 x 12 x 11
Thanks to Mr and Mrs Worley for their tree from the old basket willow grove

**Dorothy Gill Barnes, USA**
*Marked by vine*
1998
Mulberry wood, bark, Dendroglyph
Assembly
30 x 9 x 8

**Dail Behennah, UK**
*Long coiled dish*
1998
Poleuti cane, copper wire, crimps
Coiled
6 x 99 x 18

**Dail Behennah, UK**
*White willow grid bowl*
1998
White willow, telephone wire
Assembly
18 x 45 x 45

**Jackie Binns, UK**
*Pink thistle basket*
1997
Buff willow and re-used plastic
Stake and strand
180 x 100 x 100

**Dzidra Birkenfelde, Latvia**
*Lidded basket*
1995
Whole and skeined willow
Coiled
9 x 12
Thanks to Andris Lapins
Mary Butcher collection

**Michael Brennand-Wood, UK**
*Cloud collar*
1998
Wood, string, acrylic, light
Interlaced
100 x 100 x 50

**Jan Buckman, USA**
*Untitled # 6–5*
1995
Waxed linen and gold leaf
Twining
9 x 18 x 5

**Fiona Bullock, UK**
*Fine wire cage*
1999
Steel hoop and steel wire
Twining
100 x 50

**Clay Burnette, USA**
*Tri's wide open*
1998
Dyed and painted long-leaf pine needles, waxed linen, antique glass seed beads
Coiling
25 x 39 x 39

**Penny Burnfield, UK**
*Triad (3 parts)*
1998
Paper string, cotton yarn, dye, paint
Knotting and netting
18 x 7, 14 x 9, 11 x 10

**Alex Bury, UK**
*Flip-side*
1998
Matt laminate, silk paper, linen thread
Assembly
16 x 48 x 45

**Cardiff Institute for the Blind, UK**
*Bumper pad*
Bonded chipfoam encased in polypropylene fabric with an outer casing of hitched coir yarn
Knotting and netting
66 x 51 x 26

**Cardiff Institute for the Blind, UK**
*Diamond signal*
Hand-woven rattan cane
Stake and strand
120 x 6

**Mangcobo Ngidi, South Africa**
Ukhamba Zulu beer pot
1998
42 x 39
Tessa Katzenellenbogen collection

**Barbara Cooper, USA**
*Sonus*
1995
Wood
Interlaced
94 x 147 x 71

**Jenny Crisp, UK**
*Set of trays*
1999
Willow, hazel, oak, damson, ash, beech
Stake and strand
78 x 130

**Michael Davis, USA**
*Flower series – Yellow dahlia in blossom*
1997
Reed, acrylic and enamel paint, quilting pins, tin
Stake and strand
49 x 72 x 72
Dodie and Corbin Day collection

**Tom Dixon, UK**
*'S' chair*
1988
Bent-steel frame with woven cane seating
Interlaced
100 x 50 x 60

**Chris Dunseath, UK**
*The Einstein–Rosen Bridge*
1988
Limewood and ash veneer
Interlaced
220 x 125 x 110

**Lizzie Farey, UK**
Willow and birch ball
1999
Willow, birch
Interlaced
220 x 170 x 170

**Norbert Fauré, France**
Société Coopérative Agricole de la Vannerie, Villaires
*Panier périgourdin*
1998
Willow
Plaiting
28 x 43 x 34

**Alison Fitzgerald, UK**
Sciathóg (Roscommon style)
1998
Willow
Stake and strand
37 x 8
*Used for draining boiled potatoes.

**Alison Fitzgerald, UK**
Small sciathóg (Roscommon style)
1998
Mixed willows
Stake and strand
30 x 7
*Used for draining boiled potatoes.

**Fulani Tribe, Mali, Africa**
Hat
1998
Grasses, leather
Twining
27 x 50
Thanks to Caroline Hart, Joliba
Mary Butcher collection

**Alice Gandaburrburr, Australia**
String bag
1998
*Branchichiton diversifolius* fibres
Looping
67 x 40
Thanks to Debbie Booth
Mary Butcher collection

**John Garrett, USA**
*Elegy II*
1998
Steel grid; copper, brass and steel wires and slats; glass beads
Assembly
185 x 25 x 25

**Susan Garrett Wright, UK**
*Flavour trap*
1997
Polypropylene tape and laminated recycled sweet-wrappers
Plaiting
12 x 27 x 28

**Mary Giles, USA**
*Dusk/dawn*
1998–99
Waxed linen, copper, iron
Coiled
91 x 9 x 51; base 89 x 16

**Joanna Gilmour, UK**
*Pinwheel basket*
1999
Decorated Indian paper and thread
Plaiting
51 x 12

**Joleen Gordon, Canada**
*1998 – 2*
1998
Waxed and polished linen threads
Coiling
10 x 19 x 17

**Norie Hatakeyama, Japan**
*Complex plaiting series –*
*Connection 1 – 9609*
1996
Paper fibre strips 0.55 diameter
Plaiting

**Maggie Henton, UK**
*Against a straight line*
1999
Sycamore, linen, acrylic paint, stain
Assembly
28 x 28 x 5 (approx.)

**Alastair Heseltine, Canada**
Cedar box
1997
Split cedar, from driftwood, buff willow
Stake and strand
25 x 30 x 23

**Joe Hogan, Eire**
Donkey creel
1998
Willow
Stake and strand
61 x 46 x 46

**Emily Jackson, UK**
*Nest*
1997
Glass canes with real twigs
Interlace
20 x 30 x 30

**Paul Jackson, UK**
*Untitled*
1997
Paper, dry pastel, glue, starch
Origami
15 x 15 x 62

**Paul Jackson, UK**
*Untitled*
1998
Paper, dry pastel, glue, starch
Origami
24 x 24 x 30

**Susan Jamart, USA**
*When is a basket not a basket? (3 pieces)*
1997
Grosgrain ribbon
Plaiting
14 x 16 x 18 each

**Hanis Janos, Hungary**
Basket for dried plums
1995
Rush
Coiling
38 x 37
Mary Butcher collection

**Tim Johnson, UK**
*Kelp*
1997
Kelp
Interlace
23 x 28 x 170, 22 x 30 x 185

**Tim Johnson, UK**
*Cradletide*
1998
Kelp
Interlace
17 x 22 x 34, 20 x 27 x 36

**Owen Jones, UK**
Oak swill basket
1998
Steam-bent hazel rim, oak boiled and riven
Stake and strand
30 x 70 x 90

**Christine Joy, USA**
*Fruit*
1996
Willow and red dogwood
Interlace
18 x 38 x 36

**Kahu Te Kanawa, New Zealand**
*Kete*
1998
New Zealand flax, *Phormium tenax*
Plaited
32 x 22
Mary Butcher collection

**Judit Kárpáti-Rácz, Hungary**
Black rucksack
1996
Nylon monofilament, glass beads
Knotting
52 x 9

**Judit Kárpáti-Rácz, Hungary**
Pink rucksack
1998
Nylon monofilament, glass beads
Knotting
30 x 13

**Linda Kelly, USA**
*Form 9.1.1*
1998
Flat reed splint
Plaited
204 x 51 x 51

**Linda Kelly, USA**
*Form 9.1.2*
1998
Flat reed splint
Plaited
178 x 51 x 61

**Linda Kelly, USA**
*Form 9.1.3*
1998
Flat reed splint
Plaited
166 x 41 x 44

**Markku Kosonen, Finland**
*Spiral*
1996
Willow
Assembly
39 x 43 x 43

**Markku Kosonen, Finland**
Basket
1998
Birch bark
Assembly
27 x 40 x 40

**Edite Laivina, Latvia**
Lidded basket
1993
Whole and skeined willow
Coiled
7 x 17
Thanks to Andris Lapins
Mary Butcher collection

**Gyöngy Laky, USA**
*Valley house*
1998
Plum prunings with sheet rock bullets
Assembly
48 x 61 x 41
Jonathan Cohen collection

**Peiling Lee, UK**
*Spiral armpiece*
1997
Polypropylene strapping
Plaited
56 x 3 x 3
Materials supplied by Plastic Extruders Ltd
and P.P. Payne Ltd

**Peiling Lee, UK**
*Spiral armpiece*
1997
Polypropylene strapping
Plaited
56 x 11 x 3
Materials supplied by Plastic Extruders Ltd
and P.P. Payne Ltd

**Peiling Lee, UK**
*Spiral armpiece*
1997
Polypropylene strapping
Plaited
56 x 11 x 3
Materials supplied by Plastic Extruders Ltd
and P.P. Payne Ltd

**Kari Lønning, USA**
*Blue/purple double oval*
1998
Cane
Stake and strand
30 x 47 x 38
Private UK collection

**Bangisiwe Majozi, South Africa**
*Imbenge*
1998
Illala palm
Coiled
8 x 23
Tessa Katzenellenbogen collection

**Colin Manthorpe, UK**
Herring cran
1994
Willow, hazel, wood, kubu cane
Stake and strand, fitched
38 x 55
Mary Butcher collection

**James Marston, UK**
Ash basket
1999
Ash, copper, steel
Assembly
40 x 36 x 36

**Ueno Masao, Japan**
*Minimal surface 3*
1998
Bamboo
Plaiting
31 x 51 x 51

**Sally McIntosh, UK**
Spikey raffia basket
1998
Raffia
Coil
26 x 31 approx.

**Elizabeth Mipilangurr, Australia**
Dilly bag
1998
Pandanus
Twining
33 x 18
Thanks to Debbie Booth
Mary Butcher collection

111

# Exhibits List

**Setlankane Mofephi, South Africa**
*Imbenge*
1998
Telephone wire
Interlacing
8 x 23
Tessa Katzenellenbogen collection

**Leon Niehues, USA**
*Fontane*
1998
White oak splint, coral berry, waxed linen
thread, dyed splint
Stake and strand
76 x 35 x 35

**Frank Philpott, UK**
Herring swill
1999
Willow, hazel
Stake and strand, a frame basket
46 x 82 x 54
Mary Butcher collection

**Teresa Pla Belío, Spain**
Small cubes
1996
Cotton
Plaited
90 x 90 x 10 (27 cubes of 9 x 9 x 9)

**Valerie Pragnell, UK**
*Blackthorn basket*
1998
Blackthorn, jute, Japanese hand-made
paper
Interlaced
46 x 59 x 2

**Valerie Pragnell, UK**
*Red earth pod*
1998
Willow flax straw, papier mâché, red
earth
Interlaced
84 x 69 x 3

**Molly Rathbone, UK**
Star grass pot
1996
Marram grass and pine needles
Coiled
43 x 43

**Molly Rathbone, UK**
*Bark ammonite*
1998
Willow bark
Plaited
56 x 56

**Shuna Rendel, UK**
*Second reading*
1998
Dyed chair cane and cotton
Netting
90 x 40 x 35

**Shuna Rendel, UK**
*Swerve*
1998–99
Dyed cane and cotton
Netting
40 x 110 x 65

**Pete Rogers, UK**
*Teddy bear bridge*
(1:50 scale model of steel bridge)
1997
Brass strip and copper rivets
Stake and strand
33 x 80 x 80

**Myra Salayumptewa, USA**
Hopi third mesa wicker plaque
1991
Warp, sumac;
weft, rabbit brush;
edge, yucca leaf
Stake and strand
29 x 2
Linda Mowat collection

**Jane Sauer, USA**
*Engagement*
1997
Waxed linen thread and acrylic paint
Knotting and netting
76 x 30 x 20
Barbara Samuel Wells collection

**Akru Savino, India**
*Angami Naga* ceremonial basket
1998
Khophi cane
Plaited
52 x 59

**Roland Séguret, France**
Société Coopérative Agricole de la
Vannerie, Villaires
*Egrappoir*
1998
Willow and cane (*triandra* and *viminalis*)
Stake and strand
30 x 90

**Marianne Seidenfaden, Denmark**
*Bull*
1995
Willow
Stake and strand
140 x 80 x 336

**Marianne Seidenfaden, Denmark**
Carver chair
1997–98
Ash frame, willow seat
Stake and strand
98 x 57 x 44

**Hisako Sekijima, Japan**
*Resilience V*
1997
Willow
Interlaced
10 x 54 x 54
Willow grown by David Drew

**Hisako Sekijima, Japan**
*Lost two corners*
1998
Maple splint
Knotting and netting
28 x 42 x 11

**Norman D. Sherfield, USA**
*Lucky tree*
1996
Waxed linen, stone, bingo balls
Knotting and netting
4 x 2 x 9

**Shoa District Weavers, Ethiopia**
Messob or marriage table
1998
Dyed and natural grasses
Coiled
85 x 57
Thanks to Betsegash Shifferaw,
The Abyssinia, Cricklewood
Mary Butcher collection

**Karyl Sisson, USA**
*Vessel XXI*
1994
Cotton twill tape, thread, miniature wood
spring clothes-pins
Assembly
18 x 41 x 36
Thanks to Brown/Grotta gallery

**Mike Smith, UK**
Roped border arm basket
1998
Willow
Stake and strand
36 x 51 x 33

**Michael Sodeau, UK**
Woven tall floor light
1998
Woven cane
Stake and strand
150 x 38

Supermarket basket, UK
1999
Wire
22 x 35 x 49
With thanks to Sainsbury's

**Keiko Takeda, Japan**
*Urban air '98*
1999
Reeds, cane, copper wire, copper and
electric wire
Stake and strand
35 x 20 x 18
58 x 18 x 15
22 x 30 x 15

**Anna-Maria Väätäinen, Finland**
*Through that time*
1998
Unstripped willow, wild and cultivated
Stake and strand
145 x 32

**Celestino Valenti, UK**
*Zig zag*
1998
Galvanized wire
Assembly
40 x 60

**Birgitta Wendel, Sweden**
*Little newspaper shoes*
1998
Newspaper
Plaiting
6 x 10 x 22

**Jiro Yonezawa, Japan**
*Cascade*
1977
Bamboo, cane, cedar root, wood, urish,
lacquer
Plaiting
22 x 63 x 35

**Z. Wcislo, Poland**
Miniature chair
1992
Whole and skeined willow
Assembly
20 x 24 x 19
Thanks to Polish School of Basketmaking,
Kwidzyn
Mary Butcher collection

# International Resources List

## ORGANIZATIONS AND SOCIETIES
### Europe

Association of Basketmakers, Lichtenfels Region Craft Association, Germany: Innungsverband der Korbmacher, Kreishhandwerkerschaft Lichtenfels, An der Mainau, D-8620 Lichtenfels am Main, Germany.

The Basketmakers' Association: Membership Secretary, 37 Mendip Road, Cheltenham, Gloucestershire GL52 5EB. Quarterly newsletter includes extensive listing of all UK courses.

The Coppice Association: Penrhiw House, Llanddeusant, Llangadog, Dyfed SA19 9YW, Wales. Newsletter: *Small Poles*.

Dutch Basketmakers: Klipper 19, 1186, VK Amstelveen, Ihe Netherlands. Newsletter: *Wilg and Mand*.

The European Textile Network: The Secretariat, PO Box 5944, D-30059 Hannover, Germany. Telephone: 0511 817006. Magazine and newsletter (each available in German and English editions): *Textile Forum*. Website (three languages): http://www.etn-net.org

The Irish Basketmakers' Association: The Secretary, 137 Templeogue Road, Dublin 6W, Ireland. Newsletter.

Landscape and Art Network: The Treasurer, 21 Gloucester Road, Kew, Richmond, Surrey TW9 3BS. Telephone: 0181 940 1845.

The Greenwood Trust: Station Road, Coalbrookdale, Telford, Shropshire TF8 7DR. Telephone: 01952 432769. Campaigns for the use of woodland products. Newsletter: *Loose Leaves*.

Pilforeneningen, the Danish Basketmakers' Association: Drammelstrupvej 20, Balle, 8300 Odder, Denmark. Newsletter: *Pilebrevet*. Annual festival, mid August.

The Scottish Basketmakers' Circle: The Secretary, Drumnahoy Mill House, Sauchen, Invernurie, Scotland AB51 7JQ. Newsletter.

The Swiss Basketmakers' Association: IGK Schweiz, Interessengemeinschaft Korbflechterei Schweiz, Bernsstrasse 9, CH-3117 Kiesen, Switzerland.

Syndicat Professionel des Vanniers de France: Ecole Nationale d'Osierculture et de Vannerie, Fayl-Billot F-52500, Haute-Marne, France.

The Worshipful Company of Basketmakers: The Clerk, 48 Seymour Walk, London SW10 9NF. Telephone: 0171 351 2918. City of London livery company which retains an active interest in its former trade.

### North America

American Willow Growers' Network: 412 Country Road 31, Norwich, New York 13815, USA. Newsletter.

Association of Michigan Basketmakers: 48201 Virginia, Macomb, Michigan 48044, USA.

The Basketry Network: 16 Moore Avenue, Toronto MR4 1V3, Canada.

High Country Basketry Guild: PO Box 1143, Fairfax, Virginia 22030-1143, USA.

North Carolina Basketmakers' Association: PO Box 181, Waynesville, North Carolina 28786, USA.

Northeast Basketmakers' Guild: The Secretary, PO Box 445, Amherst, Massachusetts 01004, USA. Newsletter.

### Elsewhere

Basketmakers of Victoria: The Secretary, 27 Bracken Grove, Altona, Victoria 3018, Australia.

Fibre Basket Weavers of South Australia: PO Box 646, North Adelaide, South Australia 5006, Australia.

## NEWSLETTERS, JOURNALS AND MAGAZINES
(See also **Organizations and Societies**)
### Europe

*Artists Newsletter*: PO Box 23, Sunderland SR4 6DG.

*Crafts Magazine*: The Crafts Council, 44a Pentonville Road, London N1 9BY.

*Folk Life: The Journal of Ethnological Studies*: The Secretary, The Society for Folk Life Studies, Blaise Castle House Museum, Henbury, Bristol BS10 7QS.

### North America

*American Craft Magazine*: The American Craft Council, 72 Spring Street, New York, New York 10012-4019, USA.

*The Basketry Express*: High Valley Farm, RR1, McDonald's Corners, Ontario KOG 1MO, Canada. ISSN 08260-9799.

*Fiberarts Magazine*: 50 College Street, Asheville, North Carolina 28801-2896, USA.

### Elsewhere

*Basketry News*: 19–11 Nishirokugo, Otaku, Tokyo 144, Japan.

## COURSES
### Britain

There are no national schools, but numerous basketmaking courses of various types and levels are available in England, Scotland, Wales and Ireland, some organized by The Basketmakers' Association. Some courses lead to formal qualifications. Comprehensive and up-to-date information on all courses is available from The Basketmakers' Association (Pond Cottage, North Road, Chesham Bois, Buckinghamshire HP6 5NA.

Key courses include the City and Guild Certificate courses in London (City Literary Institute, Bolt Court Centre, 6 Bolt Court, off Fleet Street, London EC4A 3DQ. Telephone: 0171 405 2949), Devon (Holsworthy Community College/Exeter College, Victoria Hill, Holsworthy, Devon EX22 6JD. Telephone: 01409 254505) and Buckinghamshire (Missenden Abbey, Great Missenden, Buckinghamshire HP16 0BD. Telephone: 01494 890298).

Spring and Summer Schools are organized by The Basketmakers' Association; the Oxford Summer School and other short courses are organized by Richard Speed (telephone: 01367 710593).

Important teaching centres are the Women's Institute College (Denman College, Frill Ford Heath, Oxfordshire. Telephone: 01865 391991), West Dean College (West Dean College, West Dean, Chichester, West Sussex Frill PO18 0QZ. Telephone: 01243 811301) and the University Botanic Garden, Cambridge (University Botanic Garden, Cory Lodge, Bateman Street, Cambridge CB2 1JF. Telephone: 01223 331876). A growing number of university and art school textile, embroidery and 3-D design courses also include a basketry component.

**Ireland:** Irish enquirers should also contact the Irish Basketmakers' Association (see **Oranizations and Societies**). The Centre for Traditional Skills in Waterford (telephone: 058 53196) is one centre running courses in Ireland.

**Scotland:** Scottish enquirers should also contact the Scottish Basketmakers' Circle (The Secretary, Drumnahoy Mill House, Sauchen, Invernurie, Scotland AB51 7JQ), which also organizes many of the Scottish courses.

### Europe

**Denmark:** Information on Danish courses is available from the Danish Basketmakers' Association, Pilforeneningen. Drammelstrupvej 20, Balle, 8300 Odder, Denmark. Key basketry teaching centres include Vissinggaard (Nedenskovvej 4, DK 8740 Braedstrup, Denmark) and the School of Woodskills, Copenhagen (Stig Pedersen, Dyssevaenget 23A, 2700 Brønshøj, Denmark).

**Finland:** For information on Finnish basketry courses contact: Anna-Maria Väätäinen, Purola, 71775 Tuovilaniahti, Finland.

**France:** The French state basketry school (Ecole Nationale d'Osierculture et de Vannerie, Fayl-Billot F-52500, Haute-Marne France) runs courses of various lengths. Courses are also offered by the Société Coopérative Agricole de la Vannerie at Villaines-les-Rochers (1 rue de la Cheneillere-BP, Villaines-les-Rochers 37190, Azay-le-Rideau, France).

**Germany:** The state basketry school is Staatliche Berufsfachschule für Korbflechterei, Kronacher Strasse 32, 96215 Lichtenfels, Germany. Telephone: 0 95 71 2054.

**Netherlands:** Contact the Dutch Basketmakers' Association (Oosterblokker 130, 1696 BK Oosterblokker, Netherlands) for details of basketry courses in the Netherlands.

**Poland:** The school at Kwidzyn (The Polish Basketry School, Technikum Przemyslu Wikliniarsko-Trzciniarskiego, Ul. Ogrodowa 6, Kwidzyn 82-500, Poland) is the last of Poland's five fine state basketry schools. Some surviving Polish basketry factories also provide training.

**Sweden:** For information on Swedish basketry courses contact either Birgitta Wendel (Stora Sondergatan 7, S-222-23 Lund, Sweden), or Jonas Hasselrot (Tappgatan 10, S-15133 Södertaije, Sweden).

**Switzerland:** For details of courses contact the Swiss Basketmakers' Association (IGK Schweiz,

# International Resources List

Interessengemeinschaft Korbflechterei Schweiz, Bernstrasse 9, CH-3117 Kiesen, Switzerland).

## North America
**Canada:** For details of basketry courses in Canada contact The Basketry Network. In North America courses are often organized by basketry materials' suppliers (*see* **Materials' Suppliers**). One such Canadian supplier is Caner's Corner, Ontario.

**United States:** For details of basketry courses in the United States contact individual state basketmakers' associations, including the Association of Michigan Basketmakers and the Northeast Basketmakers' Guild. American suppliers offering courses include Country Workshops (North Carolina) and English Basketry Willows (New York).

## VIDEO
Video tapes have become an important resource for mastering specific basketry skills or particular patterns, especially those of the finest traditional makers, or of appreciating the work of contemporary basketry artists.

The Basketmakers' Association Sales (216 Walton Road, East Molesey, Surrey KT8 0HR. Telephone: 0181 979 3217) has a growing collection of instructional and documentary films demonstrating traditional skills and patterns. These are available in VHS format.

Irene Edwards has made a number of films profiling leading American fibre artists and their work. These are available as videos by mail order (Bury St Edmunds Art Gallery, Market Cross, Bury St Edmunds, Suffolk IP33 1BT, England). These are also available from the Brown/Grotta Gallery (39 Grumman Hill Road, Wilton, Connecticut 06897, USA).

The Basket Museum at Cadenet, Provence (Musée de la Vannerie, La Galneuse, avenue Phillippe de Girard, 84160 Cadenet, Provence, France) has a specialized video collection.

## MATERIALS' SUPPLIERS
### Europe
Margaret Abbey: South Wind, The Street, Gooderstone, King's Lynn, Norfolk PE33 9BS. Telephone: 01366 328711. Imported rush suppliers.

Aldersons (Northampton) Limited: 4 William Street, Northampton NN1 3EW. Telephone: 01604 639346. Suppliers of basket straps.

Fred Aldous Limited: PO Box 135, 37 Lever Street, Manchester M60 1UX. Telephone: 0161 2362477. Cane and chair seating cord suppliers.

I. and J.L. Brown: 58 Commercial Road, Hereford HR1 2BP. Telephone: 01432 358895. Imported rush suppliers.

Budget Paper Supplies Limited: Arborfield Mill, Helpston, Peterborough PE6 7DH. Telephone: 01733 252868. Suppliers of paper tape for plaiting.

J. Burdekin Limited: Osset, West Yorkshire WF5 9AQ. Telephone: 01924 273103. Willow suppliers, buff only.

The Cane Store: 207 Blackstock Road, Islington, London N5 2LL. Telephone: 0171 354 4210. Cane and imported willow suppliers.

The Cane Workshop: The Gospel Hall, Westport, Langport, Somerset TA10 0BH. Telephone: 01460 281636. Cane and imported rush suppliers.

Murray Carter: Ingerthorpe Hall Farm, Markington, Harrogate, North Yorkshire HG3 3PD. Telephone: 01765 677887. Suppliers of cuttings for biomass cultivation.

P.H. Coate and Son: Meare Green Court, Stoke St Gregory, nr Taunton, Somerset TA3 6HY. Telephone: 01823 490249. Willow suppliers.

Corn Craft: Monks Eleigh, Ipswich, Suffolk. Telephone: 01449 740456. Straw suppliers.

Country Chairmen: Home Farm, School Road, Ardington, Wantage, Oxfordshire OX12 8PD. Telephone: 01235 833614. English rush, chair seating cord and cane suppliers.

Derham Brothers: Fosters Farm, Knapp, North Curry, Taunton, Somerset TA3 6BB. Telephone: 01823 442325. Willow suppliers.

Hans Ender: D-8261 Hochstadt-Thelitz 12, Postfach 20, Germany 09574-1268. Suppliers of willow, cane, tools, nails, straps and many other basket supplies.

Fibrecrafts: Style Cottage, Lower Eashing, Godalming, Surrey GU7 2QD. Telephone: 01483 421853. Weaving yarn, textile fibre and dyestuff suppliers; also specialist books and magazines.

Footrope Knots: 501 Wherstead Road, Ipswich, Suffolk IP2 8LL. Telephone: 01473 690090. Suppliers of rope, cord and twine.

Former Glory: 258 Station Road, West Moors, Ferndown, Dorset BH22 0JF. Telephone: 01202 895859. Cane and chair seating cord suppliers.

The Handweavers' Studio Limited: 29 Haroldstone Road, London E17 7AN. Telephone: 0181 521 2281. Suppliers of cord and string, dyes, yarns, tools, books and magazines.

Reg Hector: 18 Windmill Hill, North Curry, nr Taunton, Somerset TA3 6NH. Telephone: 01823 490236. Willow suppliers.

A.F. Hill and Son: Dunstall Court, Feckenham, Worcestershire B96 6QH. Telephone: 01527 575751. Suppliers of willow cuttings for cultivation.

Felicity Irons: Keepers Cottage, Pound Lane, Kimbolton, Cambridgeshire PE18 0HR. Telephone: 01234 771980. English rush suppliers.

Jacobs, Young and Westbury: Bridge Road, Haywards Heath, West Sussex HR16 1TZ. Telephone: 01444 412411. Cane and imported willow suppliers, raffia, cords, rush and chair-seating materials.

H.J. Lock: Lockleaze, Thorney Road, Kings Episcopi, Martock, Somerset TA12 6BQ. Telephone: 01935 823338. Willow suppliers.

Long Ashton Research Station: University of Bristol Department of Agricultural Sciences, Long Ashton, Bristol BS18 9AF. Telephone: 01272 392181. National willow collection; suppliers of cuttings for cultivation.

S.A.R.L. Cannage et Paillage: Zone Industrielle des Torrières, Route de Frebecourt, 88300 Neufchâteau, France. Telephone: 29 06 16 46. Cane, paper cord, rush, straw and raffia suppliers.

Smit and Company Limited: Unit 1, Eastern

Road, Aldershot, Hampshire GU12 4TE. Telephone: 01252 343626. Cane, plastic cane, chair seating cord and raffia suppliers.

Somic plc: PO Box 8, Alliance Works, off New Hall Lane, Preston PR1 5PS. Telephone: 01772 79000. Paper yarn suppliers.

Stoke Willows: Dark Lane, Stoke St Gregory, nr Taunton, Somerset TA3 6EU. Telephone: 01823 490115. Willow suppliers.

Fernand de Vos: Eksaardedorp, B-9160 Eksaarde, Lokeren, Belgium. Telephone: 00329 3468040. Willow suppliers.

Edgar Watson: Coppice Green Nursery, Brightlands, Brockley Way, Claverham, Bristol BS19 4PA. Telephone: 01934 86464. Suppliers of green willow; suppliers of willow cuttings for cultivation.

The Willow Bank: Y Fron, Llanwr-y-glyn, Caeraws, Powys, Wales SY17 5RJ. Telephone: 01551 6263. Suppliers of willow cuttings for cultivation.

The Woodworkers' Superstore: Riverside Sawmills, Boroughbridge, North Yorkshire YO3 9LJ. Telephone: 01423 322370. Cane and chair seating cord suppliers.

### North America
The Basket Maker's Catalogue: G.H. Productions, PO Box 621, 521 E. Walnut Street, Scottsville, Kentucky 42164, USA. Telephone: 800 447 7008. Splint basketry supplies by mail order.

Caner's Corner: 4413 John Street, Niagara Falls, Ontario, Canada L2E 1A4. Telephone: 905 374 2632. Suppliers of cane.

The Caning Shop: 926 Gilman Street, Berkeley, California 94710, USA. Telephone: 510 527 5010. Cane suppliers.

Country Workshops: 90 Mill Creek Road, Marshall, North Carolina 28753, USA. Telephone: 704 656 2280. Suppliers of bark.

English Basketry Willows: 412 Country Road 31, Norwich, New York 13815, USA. Telephone: 607 847 8264. Willow suppliers.

W.H. Kilby and Company: 1840

Davenport Road, Toronto, Ontario
M6N 1B7, Canada.
Telephone: 416 656 1065.
Suppliers of cane, reed and seating cords.

H.H. Perkins Company: 10 South Bradley
Road, Woodbridge, Connecticut 06525,
USA. Telephone: 203 389 9501.
Cane and rush suppliers.

D.L. Reed and Company: 153 Colbeck
Street, Toronto, Ontario M6S 1V8,
Canada. Telephone: 416 763 1079.
Suppliers of reed and cane.

Royalwood: 517 Woodville Road,
Mansfield, Ohio 44907, USA. Telephone:
419 526 1630. Cane suppliers.

Sandra Whalen: 880 Mone Road, Milford,
Michigan 48042. USA. Telephone: 810
685 2459. Suppliers of willow.

**TOOL SUPPLIERS**
**Europe**
Fred Aldous Limited: PO Box 135, 37
Lever Street, Manchester M60 1UX.
Telephone: 0161 2362477. Cane
basketry and chair seating tool suppliers.

The Cane Workshop: The Gospel Hall,
Westport, Langport, Somerset TA10 0BH.
Telephone: 01460 281636.
Basketry and chair seating tool suppliers.

Footrope Knots: 501 Wherstead Road,
Ipswich, Suffolk IP2 8LL.
Telephone 01473 690090.
Needle, netting needle and fid suppliers.

Specialist Crafts Limited: PO Box 247,
Leicester LE1 9QS.
Suppliers of clamps for twining.

**North America**
The Caning Shop: 926 Gilman Street,
Berkeley, California 94710, USA.
Telephone: 510 527 5010.
Cane tools suppliers.

Bonnie Gale: 412 Country Road 31,
Norwich, New York 13815, USA.
Telephone: 607 847 8264.
Willow tools suppliers.

W.H Kilby and Company: 1840 Davenport
Road, Toronto, Ontario M6N 1B7,
Canada. Telephone: 416 656 1065.
Suppliers of cane, reed and seating tools.

Royalwood: 517 Woodville Road,
Mansfield, Ohio 44907, USA. Telephone:
419 526 1630.

**FESTIVALS AND FAIRS**
The Basketmakers' Festival, Vallabregues:
Fête de la Vannerie et de l'Artisanat d'Art à
Vallabregues, Comité Permanent des Fêtes,
30300 Vallabregues, Bouches du Rhône,
France. Annual festival at the centre of
French basketmaking, first week in August.

Lichtenfels, Germany: the annual German
basket festival, mid September. Details
available from the German state basketry
school, Staatliche Berufsfachschule für
Korbflechterei.

The Danish Annual Basketry Festival run by
the Danish Basketmakers' Association,
Pilebrevet. Two days every August.

**WHERE TO SEE BASKETS**
**Selected Museums and Special
Collections**
**Britain**
Bankfield Museum: Ackroyd Park, Booth
Town Road, Halifax HX3 6HG.
Telephone: 01422 354823.
Worldwide basketry collection from
ancient spindle baskets to a large Kowyak
Waga Hill tribe carrying basket; also
contemporary work by David Drew, Lois
Walpole, Dail Behennah and others.

Dane Valley Willow Project: Brereton
Heath Country Park, Congleton, Cheshire.
Telephone: 01477 534115.
Continual willow-sculptors- and
basketmakers-in-residence project.

Museum of East Anglian Life:
Stowmarket, Suffolk IP14 1DL. Telephone:
01449 612229. Complete basket
workshop and traditional basket collection.

Museum of English Rural Life, University of
Reading: PO Box 229, Reading, Berkshire
RG6 6AG. Telephone: 0118 9318660.
Largest holding of English country baskets.

Gloucester Folk Museum: 99–103
Westgate Street, Gloucester GL1 2PG.
Telephone: 01452 526467. River fishing
baskets; occasional demonstrations.

Great Yarmouth Museums: 4 South Quay,
Great Yarmouth, Norfolk. Telephone: 01493
855746. Basket work related to the fishing
industry, especially herring crans and swills.

Museum of Lincolnshire Life: Burton Road,
Lincoln LN1 3LY. Telephone: 01522
528448. Basketmaking display and
Whissender willow bed; collection of
willow baskets with small quantity of cane,
rush and straw work.

Luton Museum: Wardown Park, Luton,
Bedfordshire LU2 7HA.
Telephone: 01582 746728.
Good collection of straw plait work.

The Museum of Mankind, The British
Museum: Great Russell Street, Bloomsbury,
London WC1. Telephone: 0171 636
1555. Worldwide basket collection.

Norfolk Rural Life Museum: Beech House,
Gressenhall, Dereham, Norfolk, NR20
4DR. Telephone: 01362 860563.
Good collection of baskets and tools;
reconstruction of basketmakers' workshop.

Pitt Rivers Museum: South Parks Road,
Oxford OX1 3PP. Telephone: 01865
270929. Extensive collection of baskets
and basket work from around the world.
Publishes newsletter.

Rural Life Centre: Old Kiln Museum Trust,
Reeds Road, Tilford, Farnham, Surrey.
Telephone: 01252 795571.
Willow, cane and rush basket work.

Scottish Fisheries Museum: Harbourhead,
Anstruther, Fife, Scotland KY10 3AB.
Telephone: 01333 310628.
Baskets related to the fishing industry.

Somerset Rural Life Museum: Abbey Farm,
Chilkwell Street, Glastonbury BA6 8DB.
Telephone: 01458 831197.
Rural industries gallery, demonstrations
and workshops.

Stockwood Park Craft and Garden
Museum: Stockwood Park, Tarley Hill,
Luton, Bedfordshire. Telephone: 01582
746728. Willow and rush basket
collection; demonstations.

**Europe**
Ballenborg Rural Museum: Brienz,
Interlaken, Switzerland. Basket collection,
willow beds and working basketmaker.

Deutches Korb Museum: Bismarck Strasse
4, D-96247 Michelau, Bavaria, Germany.
Telephone: 095 71 83548. Extensive
display of baskets; demonstrations.

Freiamptor Stroh Museum: 5610 Wohlen,
Kirchenplatz, Switzerland. Telephone: 056
6226026. Collection of straw plaits,
ornaments and hats.

Korbmacher-museum: Dalhouse der Stadt
Bevenrungen, Lange Reihe 23, 37688
Bevenrungen, Germany. Telephone:
05645 1823. New museum with
comprehensive displays; workshop.

Negenoord Maaspark: Rechtestraat 7,
3650 Dilsen-Stokken, Belgium. Telephone:
011 75 50 16. Open-air musueum
including basket displays.

Neprajzi Muzeum: 1055 Budapest,
Kossuth Lajos Ter 12, Hungary. The
Hungarian ethnographic collection, which
includes a specalist basket holding.

Szorakakatenusz Jatekmuzum, H-6000
Kecskemet, Gaspar A U 11, Hungary.
Telephone: 76 20332. Large basketry
collection including rushwork.

Musée de la Vannerie: La Galneuse,
avenue Phillippe de Girard, 84160
Cadenet, Provence. Telephone: 90 68 22
44. Museum of basketry. Well organized
displays of baskets and tools; video
library; demonstrations.

Musée de la Vannerie: Vallabregues,
Bouches du Rhône, France.
Museum of basketry.

Wannernmachermuseum: Emsdetten,
Münster, Germany.
Telephone: 02572 3916.

Westfalische Freilichtmuseum: Detmold,
Germany. Telephone: 05231 7600.

**North America**
American Museum of Natural History:
Central Park West at 79th Street, New
York, USA.

Amerind Foundation: Dragoon, Arizona,
USA.

Arizona State Museum: Tucson, Arizona,
USA.

Bernice Pauahi Bishop Museum: 1525
Bernice Street, Honolulu, Hawaii.

Cheney Cowles Museum: West 2316 First
Avenue, Spokane, Washington 99204,
USA.

Cherokee Indian Reservation: Cherokee,
North Carolina, USA.

The Clarke Memorial Museum, Eureka:
Corner 3rd and E., Eureka, California,
USA.

Denver Art Museum: 1300 Logan Street,
Denver, Colorado, USA.

Favell Museum of Western Art and Indian
Artifacts: 125 West Main, Klamath Falls,
Oregon 97601, USA.

Field Museum: Chicago, Illinois, USA.

Grace Hudson Museum: 431 Main Street, Ukiah, California 95482, USA.

Heard Museum: Phoenix, Arizona, USA.

Indian Cultural Museum: Yosemite National Park, Yosemite, California, USA.

Maine State Museum: Augusta, Maine, USA.

Maryhill Museum of Art: 33 Maryhill Museum Drive, Maryhill, Washington, USA.

Museum of Appalachia: Norris, Tennessee, USA.

Museum of Northern Arizona: Flagstaff, Arizona, USA.

National Museum of the American Indian: One Bowling Green, New York, New York 10004, USA.

Peabody Museum of Archaeology/ Ethnology: Harvard University, Cambridge, Massachusetts, USA.

Sheldon Jackson Museum: 104 College Drive, Sitka, Alaska 99835, USA.

Sheldon Museum: PO Box 269, Haines, Alaska 99827, USA.

South West Museum: 234 Museum Drive, Los Angeles, California, USA.

University of British Columbia Museum of Anthropology: University Campus, Vancouver, British Columbia, Canada.

Wheelwright Museum of the American Indian. Santa Fe, New Mexico, USA.

**GALLERIES**
These galleries have occasional exhibitions of contemporary baskets.

**Britain**
Bluecoat Display Centre: School Lane, Liverpool.

Cirencester Workshops and Brewery Arts: Brewery Court, Cirencester.

Contemporary Applied Arts: 2 Percy Street, London W1P.

Crafts Council Gallery, 44a Pentonville Road, Islington, London N1 9BY.
Hove Museum and Art Gallery: 19 New Church Road, Hove, West Sussex, BN23 4AB.

The Oxford Gallery: 23 High Street, Oxford.

Ruthin Craft Centre: Park Road, Ruthin, Denbighshire, Wales.

**North America**
Artables Gallery: 2625 Colquitt, Houston, Texas 77098, USA.

Bellas Artes: 653 Canyon Road, Santa Fe, New Mexico 87501, USA.

Brown/Grotta Gallery: 39 Grumman Hill Road, Wilton, Connecticut 06897, USA.

Craft Alliance Gallery: St Louis, Missouri, USA.

R. Duane Reed Gallery: 1 N. Taylor, St Louis, Missouri 63108, USA.

Hibberd McGrath: 101 N. Main Street, PO Box 7638, Breckenridge, Colorado 80424, USA.

Joanne Rapp Gallery: Scotsdale, Arizona, USA.

O. Kun Gallery: 301 N. Guadalupe At Catron, Santa Fe, New Mexico 87501, USA.

The Sybaris Gallery: 202 East Third Street, Royal Oak, Michigan 48067, USA.

Adovasio, J.M., *Basketry Technology: A Guide to Identification and Analysis*, Chicago (Adkine Publishing Co.) 1977

Allen, E., *Pomo Basketry: A Supreme Art for the Weaver*, Healdsburg CA (Naturegraph) 1972

Aoki, H., *Iizuka Rokansai: Master of Modern Bamboo Crafts*, Tochigi (Tochigi Prefectural Museum of Fine Arts) 1989

Arbeit, W., *What Are Fronds For?*, Honolulu (University of Hawaii Press) 1985

*Artextiles: A Major Survey of British Art Textiles*, exhib. cat., Bury St Edmunds, Bury St Edmunds Art Gallery, 1996

Austin, R., and Koichiro Ueda, *Bamboo*, New York and Tokyo (Weatherhill) 1970

Bagshaw, T.W., *Basketmaking in Bedfordshire*, Luton (Luton Museum and Art Gallery) 1981

Bamford, J., *Open Hexagonal Plaiting*, Empingham, Rutland, 1993

Barratt, M., *Oak Swill Basket Making in the Lake District*, Kendal, Cumbria, 1993

Batchelder, A. (ed.), *Fiberarts: The Vessel*, 19, no. 1, 1992

Bates, C., and L. M., *A Basket History of the Indians of the Yosemite–Mono Lake Area*, exhib. cat., San Diego, San Diego Museum of Man, 1982

Bennett, J., *Handling White Oak*, Chelsea MI (Deer Track Crafts) 1985

Bird, A.J., Goldsberry, S., and Bird, J.P.K., *The Craft of Hawaiian Lauhala Weaving*, Honolulu (University of Hawaii Press) 1982

Bobart, H., *Basketwork through the Ages*, Oxford (Oxford University Press) 1936, reprinted London (The Basketmakers' Association) 1997

Borglund, E., and Hyllen, T., *Handbok i Korgflatnung*, Stockholm 1955

Boston, R., and Heseltine, A., *David Drew: Baskets*, London (Crafts Council) 1986

Brandford, J.S., *From the Tree where the Bark Grows*, Cambridge MA (Harvard University, New England Foundation for the Arts) 1984

Braun, B. (ed.), *Arts of the Amazon*, London (Thames and Hudson) 1995

Brotherton, G., *Rush and Leafcraft*, London (Batsford) 1977

Burns, H., *Cane, Rush and Willow: Weaving with Natural Materials*, London (Apple Press) 1998

Butcher, M., 'Animal Traps in Basketry', diss., London College of Furniture, 1984

Butcher, M., *A Polish Edition: Basketmakers' Association Newsletter*, 50,

1991

Butcher, M., 'Basketmakers in Hungary', unpublished conference paper, London, Guildhall University, 1993

Butcher, M., *Willow Work*, London (Dryad Press) 1986, reprinted Canterbury (the author) 1995

Cain, H.T., *Pima Indian Basketry*, Phoenix AZ (Heard Museum of Anthropology) 1962

Chin, L., and Mashman, V. (edd.), *Sarawak Cultural Legacy: A Living Tradition*, Kuching, Sarawak, Malaysia (Society Atelier Sarawak) 1991

Cohen, B.Z., *Botswana Baskets*, Gaborone (National Museum and Art Gallery) n.d.

Collard, B.St.G., *A Textbook of Netting*, Leicester (Dryad Press) 1948

Collingwood, P., *Textile and Weaving Structures*, London (Batsford) 1987

Cooper, E., *People's Art*, Edinburgh and London (Mainstream Publishing) 1994

Cort, L.A., and Kenji, N., *A Basketmaker in Rural Japan*, Washington DC (Smithsonian Institution) 1994

Crampton, C., *Canework*, Leicester (Dryad Press) 1924

Davies, L., and Fini, M., *Arts and Crafts of South America*, London (Thames and Hudson) 1994

Dawson, L., Fredrickson, V., and Braburn, N., *Traditions in Transition: Culture, Contact and Material Change*, Berkeley, CA (Lowie Museum of Anthropology) 1974

Dean, A. (ed.), *The Best of Basketry Express 1985 to 1990*, Oakville, Ontario, n.d.

Dean, A. (ed.), *The Best of Basketry Express 1990 to 1995*, Oakville, Ontario, n.d.

Dean, A., *The Uses of Cattails, Rushes and Grasses in the Textile Arts*, Oakville, Ontario (the author) 1991

Degener, P., 'Review: Other Baskets: An Invitational Show in St. Louis', *Fiberarts*, 10, no. 1, 1983, pp. 76–77

Derrick, F., *Country Craftsmen*, London (Chapman and Hall) 1945

Dippold, G. et al., *Deutsches Korbmuseum Michelau*, Michelau, Germany, 1984

Dormer, P. (ed.), *The Culture of Craft*, Manchester (Manchester University Press) 1997

Dougherty, R., *Splint Woven Basketry*, Loveland CO (Interweave Press) 1986

Drury, C., *Shelters and Baskets*, Derry (The Orchard Gallery) n.d.

Duchesne, R., Ferrand, H., and Thomas, J., *La Vannerie: L'Osier*, Paris (Bailliere) 1981

Eaton, A., *Handicrafts of the Southern Highlands*, New York (Dover) 1973

Edlin, H.L., *Woodland Crafts in Britain*, Newton Abbot (David & Charles) 1973

Ellmore, W.P., *The Cultivation of Osiers and Willows*, London 1919

Elton Barratt, O., *Basketmaking*, London (Letts Contemporary Crafts) 1990

Employers' Federation of Cane and Willow Workers' Associations and the Basket, Skip and Hamper Makers' Federation of Great Britain and Northern Ireland, *The National List of Basic Wage Rates in the Basket Industry*, London 1956

Farrelly, D., *The Book of Bamboo*, London (Thames and Hudson) 1996

Feder, N., *Indian Basketry: Varieties and Distribution* (leaflet), Denver (Denver Art Museum) 1933

Feder, N., *The Main Divisions of California Indian Basketry* (leaflet), Denver (Denver Art Museum) 1937

Feder, N., *Indian Basketry East of the Rockies* (leaflet), Denver (Denver Art Museum) 1939

Field, C., *The Art and the Romance of Indian Basketry*, Tulsa OK (Philbrook Art Center) 1964

Fisch, A.M., *Textile Technique in Metal*, Asheville NC (Lark Books) 1996

Fitzrandolph, H., and Hay, M.D., *Rural Industries of England and Wales, I: Timber and Underwood Industries and Some Village Workshops*, Oxford (Oxford University Press) 1926, reprinted London (E.P. Publishing) 1977

Fitzrandolph, H., and Hay, M.D., *Rural Industries of England and Wales, II: Osier-growing and Basketry and Some Rural Factories*, Oxford (Oxford University Press) 1926, reprinted London (E.P. Publishing) 1977

Florance, N., *Rushwork*, London (Bell) 1962

Gabriel, S., and Goymer, S., *The Complete Book of Basketry Techniques*, Newton Abbot (David and Charles) 1991, rev. 1999

Galtier, C., *Les Vanniers de Vallabregues*, Grenoble (Centre Alpin et Rhodanien d'ethnologie) 1980

Gardner, M.F., 'The Berberidopsis Story: An Account of the Chilean Coral Plant', *The Plantsman*, 4, no. 4, December 1997

Gettys, M., *Basketry of Southeastern Indians*, Idabel OK (Museum of the Red River) 1984

Gillooly, M., *Natural Baskets*, Pownal VT (Storey Communications Inc.) 1992

Gordon, J., *Edith Clayton's Market Basket: Heritage of Splint-wood Basketry in Nova Scotia*, Halifax (The Nova Scotia Museum) 1977

Gordon, J., *Withe Baskets, Traps and Brooms: Traditional Crafts in Nova Scotia*, Halifax (The Nova Scotia Museum) 1984

Grossert, J. W., *Zulu Crafts*, Pietermaritzburg (Shuter & Shooter) 1985

Grotta, T., *Sheila Hicks Joined by Seven Artists from Japan*, Wilton CT (Brown/Grotta Gallery) 1996

Grotta, T., and Brown, R., *The Tenth Wave, I: New Baskets and Freestanding Fiber Sculpture*, Wilton CT (Brown/Grotta Gallery) 1997

Grotta, T., and Brown, R., *The Tenth Wave, II: Textiles and Fiber Wall Sculpture*, Wilton CT (Brown/Grotta Gallery) 1997

Guss, D.M., Grotta, T., and Brown, R., *To Weave and Sing: Art, Symbol and Narrative in the South American Rain Forest*, Berkeley and Los Angeles (University of California Press) 1989

Halper, V., and Rossbach, E., *John McQueen: The Language of Containment*, Washington DC (National Museum of American Art, Smithsonian Institution) 1991

Harrod, T. (ed.), *Obscure Objects of Desire: Reviewing the Crafts in the Twentieth Century* (conference papers), London (Crafts Council) 1997

Hart, C. and D., *Natural Basketry*, New York (Watson-Guptill) 1975

Hartley, D., *Made in England*, London (Eyre Methuen) 1974

Harvey, V., *Techniques of Basketry*, London (Batsford) and Washington DC (University of Washington Press) 1975, reprinted 1986

Hasluck, P., *Basket Work of all Kinds*, London (Cassell) 1912

Hasselrot, J., *Korgar*, Stockholm (LTs forlag) 1997

Hedges, K., *Fibers and Forms: Native American Basketry of the West*, San Diego (San Diego Museum of Man) 1997

Hennell, T., *The Countryman at Work*, London (Architectural Press) 1947

Herald, J., *World Crafts*, London (Oxfam and Letts) 1992

Heseltine, A., *Baskets and Basketmaking*, Princes Risborough (Shire Books) 1982

Heseltine, A., 'Sum of Experience: Why Make Baskets in Britain in the 1980s?', *Crafts Magazine*, 63, July/August 1983

Hickman, P., *Baskets: Redefining Volume and Meaning*, Honolulu (University of Hawaii Art Gallery) 1993

Hickman, P., Rossbach, E., and Westphal, K., *Joanne Segal Brandford: A Basketmaker's Legacy*, Royal Oak MI (The Sybaris Gallery) 1995

Hickson, J. *Dat so la lee*, Popular Series No. 3, Carson City NV (Nevada State Museum) 1967

*History of Technology, 1: From Early Times to the Fall of Ancient Empires* Oxford (Clarendon Press) 1954

Hodge, A., *Nigeria's Traditional Crafts*, London (Ethnographica) 1982

Hodges, N., *Art and the Natural Environment*, London (Art and Design) 1994

Hodgson, R., *Peppimenarti Basketmakers*, Nakara, Northern Territory, Australia (the author) 1988

Hoppe, F., *Wicker Basketry*, Denver CO (Interweave Press) 1986

Hoppe, F., *Contemporary Wicker Basketry*, Asheville NC (Lark Books) 1996

Hughes, A. with Booth, D., Carew, M., Hanby, L., and West, M., *Maningrida: On the Track of the Centipede (A Celebration of Aboriginal Women's Fibrecraft from Maningrida, Central Arnhem Land)* forthcoming [1999]

Hutchinson, H.P., 'Willow Growing and Basketmaking as Rural Industries', *Journal of the Board of Agriculture*, 1916

Irwin, J.R., *Baskets and Basketmakers in Southern Appalachia*, Exton PA (Schiffer) 1982

Jaoul, M., and Goldstein, B., *La Vannerie française*, Paris (Musée National des Arts et Traditions Populaires)

Jenkins, J.G., *Traditional Country Craftsmen*, London (Routledge & Kegan Paul) 1965

Jensen, E., *Baskets from Nature's Bounty*, Loveland CO (Interweave Press) 1991

John, B.S., *Rural Crafts of Wales*, Newport, Dyfed (Greencroft Books) 1976

Johnson, K., *Canework*, London (Dryad Press) 1986

Johnson, K., *Basketmaking*, London (Batsford) 1991

Johnson, P., *Ideas in the Making: Practice in Theory*, London (Crafts Council) 1998

Jones, A.M., *The Rural Industries of England and Wales*, 4, Oxford (Oxford University Press) 1926, rev. 1927, reprinted London (E.P. Publishing) 1978

Jones, J.L., *Crafts from the Countryside*, Newton Abbot (Readers Union) 1976

Jones, J.M., *The Art and Style of Western Indian Basketry*, Surrey, British Columbia, and Blaine WA (Hancock House) 1982

Jones, M.E., *Welsh Crafts*, London (Batsford) 1978

Jones, S., *Pacific Basket Makers: A Living Tradition*, Fairbanks AK (University of Alaska Museum) 1981

Jordan, M., *Chokwe! Art and Initiation Among Chokwe and Related Peoples*, Munich, London and New York (Prestel) 1998

Joyce, R.O., *A Bearer of Tradition*, Athens GA (The University of Georgia Press) 1989

Ketchum, W.C., *American Basketry and Wooden Weave*, New York and London (Collier Macmillan) 1974

Knock, A.G., *Willow Basketry*, Leicester (Dryad Press) 1946

Kosonen, M., *Paju/Willow*, Helsinki (Kyrirri Oy) 1991

Kudo, K., *Japanese Bamboo Baskets*, Tokyo, London and New York (Kodansha International) 1980

Kunecki, N., Slockish, M., and Thomas, E., *The Heritage of Klickitat Basketry*, Portland OR (Oregon Historical Society) 1982

Kuoni, B., *Cesteria Tradicional Iberia*, Barcelona (Ediciones del Serbal) 1981

La Plantz, S., *Plaited Basketry: The Woven Form*, Bayside CA (Press de la Plantz) 1982

La Plantz, S., *The Mad Weave Book*, Bayside CA (Press de la Plantz) 1984

La Plantz, S. (ed.), *Basketry Round Up*, Bayside CA (Press de la Plantz) 1991

La Plantz, S., *Twill Basketry*, Asheville NC (Lark Books) 1993

Larsen, J.L., and Freudenheim, B., *Interlacing: The Elemental Fabric*, Tokyo (Kodansha International) 1986

Lasansky, P., *Willow, Oak and Rye*, Philadelphia (Keystone Books/Pennsylvania State University Press) 1979

Law, R.N., and Taylor, C.W., *Appalachian White Oak Basketmaking*, Knoxville TN (University of Tennessee Press) 1991

Lawrence, C. (ed.), *Fibrearts: Basketry*, Asheville NC (Nine Press) 1988

Leftwich, R.L., *Arts and Crafts of the Cherokee*, Cherokee IN (Cherokee Publishing) 1970

Legg, E., *Country Baskets*, London (Mills and Boon) 1960

# Bibliography

Levinsohn, R., *Basketry, A Renaissance in Southern Africa*, Cleveland Heights OH (Protea Press) 1979

Lopez, R.P., and Moser, C.C., *Rods, Bundles and Stitches: A Century of Southern California Indian Basketry*, Riverside CA (Riverside Museum Press) 1981

Macdowell, L., *Alaska Indian Basketry*, Seattle (The Alaska Steamship Company) 1973

Madsen, S.H., *Flet med pil*, Copenhagen (Klematis) 1994

*Making Weaves*, exhib. cat., Edinburgh, National Museums of Scotland *et al.*, 1998

*Maningrida: The Language of Weaving*, exhib. cat., Victoria, Australian Exhibitions Touring Agency, 1995

Manners, J.E., *Country Crafts Today*, Newton Abbot (David and Charles) 1974

Masako, M., *Ondori: Rattan Work with Complete Diagrams*, Tokyo (Ondorisha Publishers) 1986

Mason, O.T., *Aboriginal American Basketry*, Report of the US National Museum, New York (Smithsonian Institution) 1904

Mauldin, B., *Traditions in Transition: Contemporary Basketweaving of the Southwestern Indians*, Santa Fe NM (Museum of New Mexico Press) 1987

Maynard, B., *Modern Basketry Techniques*, London (Batsford) 1989

McBride, B., *Our Lives in Our Hands: Micmac Indian Basketry*, Halifax, Nova Scotia (Nimbus Publishing) 1990

McCallum, T.M., *Containing Beauty: Japanese Bamboo Flower Baskets*, Los Angeles (UCLA Museum of Cultural History) 1988

McGregor, R., *Prehistoric Basketry of the Lower Pecos, Texas*, Madison WI (Prehistoric Press) 1992

McGuire, J., *Old England Splint Baskets and How to Make Them*, Exton PA (Schiffer) n.d.

McGuire, J., *Basketry: The Shaker Tradition*, Asheville NC (Sterling/Lark Books) 1989

McGuire, J., *Basketry: The Nantucket Tradition*, Asheville NC (Lark Books) 1990

McQueen, J., *The Language of Containment*, Washington DC (Smithsonian Institution/University of Washington Press) 1991

Mead, S.M., *The Art of Taaniko Weaving*, Wellington, Sydney and London (A.H. & A.W. Reed) 1968

Meilach, D.Z., *A Modern Approach to Basketry*, London (Allen and Unwin) 1974

Meilach, D.Z., *Basketry Today with Materials from Nature*, New York (Crown Publishers) 1979

Meittinen, M., and Raatikainen, V., *Pajutyot*, Helsinki (Opetush allitus) 1997

Miles, C., and Bovis, P., *American Indian and Eskimo Basketry*, New York (Bonanza Books) 1969

*Modern Bamboo Craft*, exhib. cat., Tokyo, National Museum of Modern Art, 1985

Morris, E.H., and Burgh, R.F., *Anasazi Basketry*, Washington DC (Carnegie Institute of Washington) 1941

Moser, C., *Native Indian Basketry of Central California*, Riverside CA (Riverside Museum Press) 1986

Moser, C., *American Indian Basketry of Northern California*, Riverside CA (Riverside Museum Press) 1989

Moser, C., *Native Indian Basketry of Southern California*, Riverside CA (Riverside Museum Press) 1993

Mowat, L., Morphy, H., and Dransart, P., *Basketmakers: Meaning and Form in Native American Baskets*, Oxford (Pitt Rivers Museum, University of Oxford) 1992

Mowat, L., and Hill, L. (edd.), 'Baskets of the World', *Journal of Museum Ethnography*, 4, 1993

Mulford, J., *Decorative Marchallese Baskets*, Los Angeles (the author) 1991

Munan, H., *Sarawak Crafts Methods, Materials and Motifs*, Oxford (Oxford University Press) 1989

Munksgaard, J.H., *Kurver*, Oslo 1980

Navajo School of Indian Basketry, *Indian Basket Weaving*, New York (Dover) 1971

Newman, S.C., *Indian Basket Weaving: How to Weave Pomo, Yurok, Pima and Navajo Baskets*, Flagstaff AZ (Northland Press) 1974

Nicolson, A., and Sunderland, P., *Wetland: Life in the Somerset Levels*, Taunton (Taunton Council) 1986

*Objects of Our Time*, London (Penshurst Press/Crafts Council) 1996

Okey, T., *An Introduction to the Art of Basketmaking*, London (Pitman) 1912, reprinted Canterbury (The Basketmakers' Association) 1994

Okey, T.A., *Basketful of Memories*, London and Toronto (Dent) 1930

Okey, T., 'Basket', in *Encyclopaedia Britannica*, 11th edn, vol. 3, 1911, pp. 481–83

Olney, J., *Choctaw Diagonal Twill Plaiting*, Detroit (MKS Publications) 1990

Paul, F., *Spruce Root Basketry of the Alaska Tlingit*, Lawrence KS (Sheldon Jackson Museum) 1991

Pendergrast, M., *Maori Basketry for Beginners*, Wellington, Sydney and London (A.H. & A. W. Reed) 1975

Pendergrast, M., *Feathers and Fibre: A Survey of Traditional and Contemporary Maori Craft*, Auckland NZ (Penguin Books) 1984

Pendergrast, M., *Raranga Whakairo: Maori Plaiting Patterns*, Auckland NZ (Coromandel) 1984

Pendergrast, M., *Te Aho Tapu: The Sacred Thread*, Auckland NZ (Auckland Reed Museum) 1987

Pendergrast, M., *Fun with Flax: 50 Projects for Beginners*

Pepich, B.W., *Threads: Finding a Common Thread in Contemporary American Basketry* (leaflet), London (Barbican Centre) 1998

Piper, J.M., *Bamboo and Rattan*, Oxford (Oxford University Press) 1992

Pollock, P., *Start a Craft: Basketmaking*, London (Apple Press) 1994

Pollock, P., *Basketwork*, London (Lorenz Books) 1998

Porter, F.W., *The Art of Native American Basketry: A Living Legacy*, Westport CT (Greenwood Press) 1990

Pulleyn, R. (ed.), *The Basketmaker's Art*, Asheville NC (Lark Books) 1986

Purdy, C., *Pomo Indian Baskets and Their Makers*, Mendocino CA (Mendocino County Historical Society) n.d.

Ranjan, M.P., *Bamboo and Cane Crafts of Northern India*, New Delhi (National Institute of Design) 1986

Ranjan, M.P., Iyer, N., and Pandya, G., *Bamboo and Cane Crafts*, New Delhi (National Institute of Design) 1986

*Recycling: Forms for the Next Century: Austerity for Posterity*, Birmingham (Craftspace Touring) 1996

Robinson, B., *The Basket Weavers of Arizona*, Albuquerque NM (University of New Mexico Press) 1989

Roffey, M., *Simple Basketry for Homes and Schools*, London (Pitman) 1948

Rossbach, E., *Baskets as Textile Art*, New York (Van Nostrand Reinhold) 1973

Rossbach, E., *The Nature of Basketry*, New York (Van Nostrand Reinhold) 1976

Rowe, A.P., and Stevens, R., *Ed Rossbach: 40 Years of Exploration and Innovation in Fiber Art*, Asheville NC (Lark Books) 1990

Rozaire, C.E., *Indian Basketry of Western North America*, Ana CA (Brook House) 1977

Schanz, J. E., *Willow Basketry of the Amana Colonies*, West Amana IA (Penfield Press) 1986

Schiffer, N., *Baskets*, Exton PA (Schiffer) 1984

Sekijima, H., *Basketry to Grass Slippers*, Tokyo, New York and San Francisco (Kodansha International) 1986

Shaw-Smith, D., *Ireland's Traditional Crafts*, London (Thames and Hudson) 1984

Shermeta, M., 'The Basket, The Mark, The Tree', *Fiberarts*, 17, no. 4, 1991, pp. 37–40

Siler, L., *The Basket Book*, New York (Sterling Publishing) 1988

Siler, L., *Handmade Baskets*, New York (Sterling Publishing) 1992

Simonsen, G., *Pileflet i Haven*, Copenhagen (Olivia Press) 1994

Smith, C.M., 'Material Culture Analysis', http://www.sfu.ca/~cfsmith/genstuff/academic/lab/basketry.html

Smith, J.R., *Taaniko Maori Hand Weaving*, New York (Scribner) 1975

Smith, P.J., and Janeiro, J., *Ties That Bind. Fiber Art by Ed Rossbach and Katherine Westphal from the Daphne Farago Collection*, Providence, RI (Museum of Art, Rhode Island School of Design) 1997

Smyth, P., *Osier Culture and Basket Making*, Lurgan, Co. Armagh (the author) 1991

Société Suisse de Travail Manuel et de Reforme Scolaire, *Vannerie en Rotin*, Switzerland (Leistal) 1979

Stearns, L., *Papermaking for Basketry and Other Crafts*, Asheville NC (Lark Books) 1992

Stephenson, S.H., *Basketry of the Appalachian Mountains*, New York (Van Nostrand Reinhold) 1977

Steven, G.A., *Nets: How to Make, Mend and Preserve Them*, London (Routledge and Kegan Paul) 1950

Stewart, H., *Indian Fishing: Early Methods on the North West Coast*, Seattle (University of Washington Press) 1977

Stewart, H., *Cedar: Tree of Life to the North West Coast Indians*, Seattle (Douglas McIntyre) 1995

Stott, K.G., 'Cultivation and Uses of Basket Willows', *Quarterly Journal of Forestry*, 1956

Stott, K.G., *A Review of the British Basket Willow Growing Industry*, Annual Report for the Agricultural and Horticultural Research Station, Long Ashton, Bristol, 1959

Stott, K.G., *Basket Willow Growing in Northern Europe*, Annual Report for the Agricultural and Horticultural Research Station, Long Ashton, Bristol, 1960

Stowe, E.J. *Crafts of the Countryside*, Wakefield, Yorkshire (E.P. Publishing) 1973

Swannell, M., *Coiled Basketry*, London (George Philip & Son) 1908

Tanner, C.L., *Indian Baskets of the Southwest*, Tucson AZ (University of Arizona Press) 1983

Te Kanawa, D., *Weaving A Kakahu*, Wellington, NZ (Briget Williams Books/Aotearoa Moananui a Kiwa Weavers) 1992

Teleki, G.R., *The Baskets of Rural America*, New York (Dutton) 1975

Teleki, G.R., *Collecting Traditional Basketry*, New York (Dutton) 1979

TerBeest, C., *Wisconsin Willow: Adventures of a Basketmaker*, Baraboo WI (Wild Willow Press) 1985

Thompson, F., *Antique Baskets and Basketry*, New York (Wallace-Homestead) 1985

Thompson, N., and Marr, C., *Crow's Shells: Artistic Basketry of Puget Sound*, Seattle (Dushuhay Publications) 1983

Thorpe, J., *It's Never Too Early: African Art and Craft in Kwazulu-Natal, 1960–1990*, Durban (Indicator Press, University of Natal) 1994

Timmons, C. (ed.), *Fiberarts: Basketry*, 11, no. 1, 1984

Tod, O.G., *Earth Basketry*, New York (Crown Publishers) 1972

Turnbaugh, S.P., and William, A., *Indian Baskets*, Westchester PA (Schiffer) 1986

Turner, L.W., *The Basket Maker*, New York (Atkinson, Mentzer & Co) 1909

Vaughan, S., *Handmade Baskets from Nature's Colourful Materials*, (Search Press) 1994

Verdet-Fierz, B. and R., *Anleitung zum Flechten mit Weiden*, Bern, Stuttgart and Vienna 1993, trans. as *Willow Basketry*, Loveland CA (Interweave Press) 1993

Walpole, L., *Creative Basketmaking*, London (Collins) 1989

Walpole, L., *Weave, Coil and Plait: Crafty Containers from Recycled Materials*, Tunbridge Wells (Search Press) 1997

Wendel, B., *Korgar*, Stockholm (ICA Bokforlag) 1996

Wendrich, W., *Who is Afraid of Basketmaking?*, Leiden (Centre of Non-European Studies, University of Leiden) 1991

Westendorp, A., *Het Vlechten van ronde tenen Manden*, Heerde (Wilg and Mand) 1978

Westendorp, A., van't Hoog, A.D., and Tuinzing, W.D.J., *Het Vlechten van ovale Manden met Teen*, Ijsselstein (Wilg and Mand) 1985

Wetherbee, M., and Taylor, N., *Legend of the Bushwhacker Basket*, Sanbornton NH (Martha Wetherbee Basket Shop) 1986

Wetherbee, M., and Taylor, N., *Shaker Baskets*, Sanbornton NH (Martha Wetherbee Basket Shop) 1988

Wheat, M., *Survival Arts of the Primitive Paiutes*, Reno NV (University of Nevada Press) 1967

Whitbourn, K., *Introducing Rushcraft*, London (Batsford) 1969

Whiteford, A.H., *North American Indian Arts*, New York (Golden Guides) 1973

Wigginton, E. and Garland Page, L. (edd.), *The Foxfire Book of Appalachian Cookery: Regional Memorabilia and Recipes*, New York (E.P. Dutton) 1984

Will, C., *International Basketry*, Exton PA (Schiffer) 1985

Woods, K.S., *Rural Crafts of England*, London (Harrap) 1949

Wright, D., *The Complete Book of Baskets and Basketry*, Newton Abbot (David and Charles) 1992

**Personal communications from**

Don Bailey
Andrew Bird
C. Driver
Susi Dunsmore
Torjan Garbor
Lluis Grau
Caroline Hart
Tessa Katzenellenbogen
Colin Manthorpe
Frank Philpott
Fred Rogers
Michael Thierschmann
Len Wilcox
Felicity Wood
Dorothy Wright

**Picture Credits**
Front cover: Lee Fatheree, on loan courtesy Jonathan Cohen
14 Lee Funnell, Mary Butcher collection
15 Courtesy of Richard Green Galleries, London
17 Mary Butcher
19 left to right: Sandra Newman, Mary Butcher, Mary Butcher, Lee Funnell
20 R.J. Whittick
22 Mary Butcher
23 clockwise: Lee Funnell, Mary Butcher, Mary Butcher
25 Suzanne Maxwell
26 left and right: Lee Funnell, with thanks to Caroline Hart, Joliba
27 Jessica Katzenellenbogen
29 Debbie Booth
30 Catherine Cardarelli, with thanks to Dr Manuel Jordan
31 Lee Funnell, Polly Pollock collection
35 Ian Hunter
43 left: Andra Nelki; top: Uchida Yoshitaka
49 Uchida Yoshitaka
61 Andra Nelki
62 Watanabe Ikuniro, courtesy of Sakura Museum of Art
63 Tom Grotta
67 David Isaacson
68 1–3: Lee Funnell
69 2–4: Lee Funnell
70 Lee Funnell
72 bottom: Lois Walpole
74 left: Lee Funnell
76 bottom: Lee Funnell
78 Lee Funnell
79 Lee Funnell
80 Lee Funnell, with thanks to Prof. Anne Morrell
81 Lee Funnell
83 Lee Funnell
85 right: RED E/F; bottom: Lee Funnell, Mary Butcher collection
87 bottom: Lee Funnell, Mary Butcher collection
88 left: Softlab Ltd, UK, collection
89 top: Shannon Tofts
90 Lee Fatheree, on loan courtesy Jonathan Cohen
92 right: David Bowie, with thanks to Robin Tuppen
93 top: Mike Waterman, British Museum collection; middle: Lee Funnell
94 Lee Funnell
96 top and bottom: Lee Funnell
97 bottom: Lee Funnell
100 Lee Funnell
101 right: Linda Mowat collection
102 top: Lee Funnell, with thanks to Debbie Booth; bottom: Lee Funnell
103 bottom: Lee Funnell, Mary Butcher collection
104 Lee Funnell
105 Lee Funnell
107 Lee Funnell, Debbie Booth collection
108 right: David Kingsbury
109 bottom: Lee Funnell

**Acknowledgements**
I should like to thank the following for their invaluable help with this project:

Jennifer Harris, The Whitworth Art Gallery, for careful, cheerful, constructive editorial comment.

Louise Taylor, Beatrice Hosegood and Diane Young at the Crafts Council, and Lois Walpole, my co-curator, for all their help with the exhibition and catalogue.

Julian Honer, my editor at Merrell Holberton, and Karen Wilks, who designed the catalogue: I have very much enjoyed working with them.

I should particularly like to thank Ann Brooks, Shuna Rendel, Richard Schofield and the following for all their help and information and the spirit in which it was given:

Dr Maurice Bichard, Debbie Booth, Terry Daunt, Irene Edwards, Martin Gardner, Caroline Hart, Maggie Henton, Connie Hilton, Ernie James, Tessa Katzenellenbogen, Gyöngy Laky, Colin Manthorpe, Hubert Pilkington, Frank Philpott, Eva Seidenfaden, Susie Thomson, Len Wilcox and the Worshipful Company of Basketmakers.

Many, many members of the Basketmakers' Association have provided help and information over the years, and I thank them all.

The following organizations have generously provided funding for research in Britain and Eastern Europe: The Winston Churchill Memorial Fellowship Trust, The Queen Elizabeth Scholarships, The British Council, South East Arts.

I should especially like to thank the artists who gave precious time to the consideration of my questionnaire or gave insights through correspondence with the Crafts Council, and generously provided their voices:

Dorothy Gill Barnes, Dail Behennah, Alex Bury, Jenny Crisp, John Garrett, Norie Hatakeyama, Maggie Henton, Tim Johnson, Gyöngy Laky, Kari Lønning, John McQueen, Shuna Rendel, Hisako Sekijima, Norman Sherfield, Noriko Takamiya, Masao Ueno, Lois Walpole, Jiro Yonezawa

It would not have been possible to complete this project without the help of my family.

119

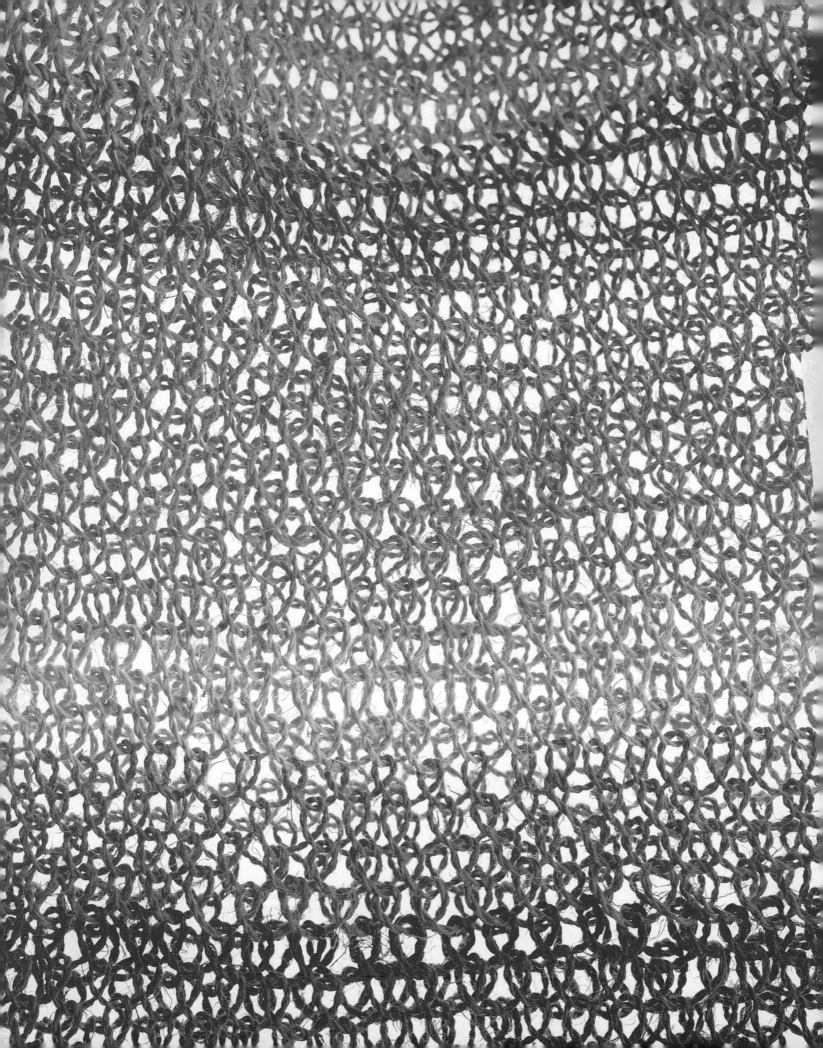